P9-ELW-667

Bad
Girls
Throughout
History

Bad Girls
Throughout
History

100 Remarkable Women
Who Changed the World

Ann Shen

CHRONICLE BOOKS
SAN FRANCISCO

Copyright © 2016 by Ann Shen.

All rights reserved. No part of this book may be reproduced
in any form without written permission from the publisher.

Library of Congress Cataloging-in-Publication Data

Names: Shen, Ann, author.

Title: Bad girls throughout history / Ann Shen.

Description: San Francisco : Chronicle Books, 2016. | Includes
 bibliographical references.

Identifiers: LCCN 2015048600 | ISBN 9781452153933 (hardback)

Subjects: LCSH: Women—History. | Women—Biography. | BISAC: ART / Popular
 Culture.

Classification: LCC HQ1123 .S525 2016 | DDC 920.72—dc23 LC record available
at http://lccn.loc.gov/2015048600

Manufactured in China

Designed by Jennifer Tolo Pierce

20 19 18 17 16 15 14 13 12 11

Chronicle Books LLC
680 Second Street
San Francisco, California 94107
www.chroniclebooks.com

For girls of all ages
who dare to be bad,
and for the people
who stand behind us
when we are...
especially my mom Alice
and my husband Ryan.

Contents

Introduction

This is a book about women. This is a book about girls who had a ton of fear and personal flaws and faced insurmountable obstacles but did amazing things anyway. This is a book about those who came before us, who knocked up against that glass ceiling and made a tiny fissure or a full-on crack.

When I first started this project five years ago, someone remarked that the title of this book didn't make sense. That none of these girls were *bad*. That ax murderers were *bad*. Not Harriet Tubman. Yet she escaped slavery and snuck into the South nineteen times to illegally free slaves. To be a bad girl is to break any socially accepted rule. For some women, it's the way they dress. For other girls, it's the act of going to school. At one point, it was fighting for the right to vote. Anything we do outside the lines is immediately up for persecution. Just ask Mata Hari, an internationally famed exotic dancer who was accused of being a spy and executed by firing squad. Everything we've gained has been hard-won by a woman who was willing to be bad in the best sense of the word.

When I set out to write this book, I thought I knew what I was getting into. But after spending time with every single one of these ladies, I am profoundly changed. I feel the gravity of their courage and accomplishments, these women on whose shoulders we stand today. Through the process of writing the book, I

came to realize that we all come from this daring tribe of women, and that like them I need to use my voice to do better in this world. I hope that in some small way this book changes you too.

This is by no means a definitive list of *the* one hundred bad girls in history, nor an exhaustive detail of their personal stories. The book presents a broad world of women coming from all eras, countries, backgrounds, races, and ethnicities. They're rabble-rousers from all sorts of disciplines: artists, activists, astronauts, daredevils, outlaws, scientists, warriors, writers, and everything in between. The short essays are meant to whet your appetite for exploring more on your own. Finding out how Annie Edson Taylor became the first female daredevil at sixty-three is a starting point. Consider Harriet Beecher Stowe and her little book that started the Civil War the flint to light your own fire. Let four-foot-seven, sniper-trained Dr. Ruth and her sex ed radio show inspire you. You are never too old, too small, or too late to live the life you're meant to lead. Especially if it means rewriting the rules to do it.

Lilith

It all began with Lilith, the lesser-known first wife of Adam who was kicked out of the Garden of Eden. Adam insisted she lie beneath him, but she wanted to lie next to him and be equal. Because she refused to be subservient to Adam, Lilith left the Garden of Eden and became associated with the archangel Samael. We know of Lilith because she is represented as a demon in many religious mysticism texts; she is never mentioned in the Bible. It doesn't get much more badass than getting rejected from the Bible, does it?

Kicked out of paradise for demanding equality

Tomyris

Tomyris (sixth century B.C.E.) was a widowed queen who ruled over a nomadic Eastern Iranian tribe called the Massagetae. They were a warrior tribe notable for their battle skills and cannibalistic tendencies (they had an honored ritual of sacrificing their elderly and eating them in a stew). The tribe occupied what became modern-day Iran, and in 529 B.C.E. they were the next targets in Cyrus the Great's Persian empire expansion. At first, Cyrus proposed to Tomyris in a thinly veiled attempt to seize her land. She rejected him, and he declared war. Cyrus set up a trap by sending his weakest soldiers to lay out a fancy banquet, luring the Massagetae warriors into drinking themselves into a stupor. Led by Tomyris's son Spargapises, the Massagetae troops took the bait—hook, line, and sinker— and were slaughtered in their wine-fueled haze by Cyrus's soldiers. Spargapises managed to avoid being killed, but Tomyris was pissed. She sent Cyrus a warning message to release her son and leave their lands, which Cyrus ignored. After he was captured, Spargapises killed himself, which further fueled Tomyris's rage. She retaliated in a fiery rampage that resulted in Cyrus's decapitation and crucifixion. Legend says that she stuffed his head into a wine bag full of human blood and laughed, "I warned you that I would quench your thirst for blood, and so I shall."

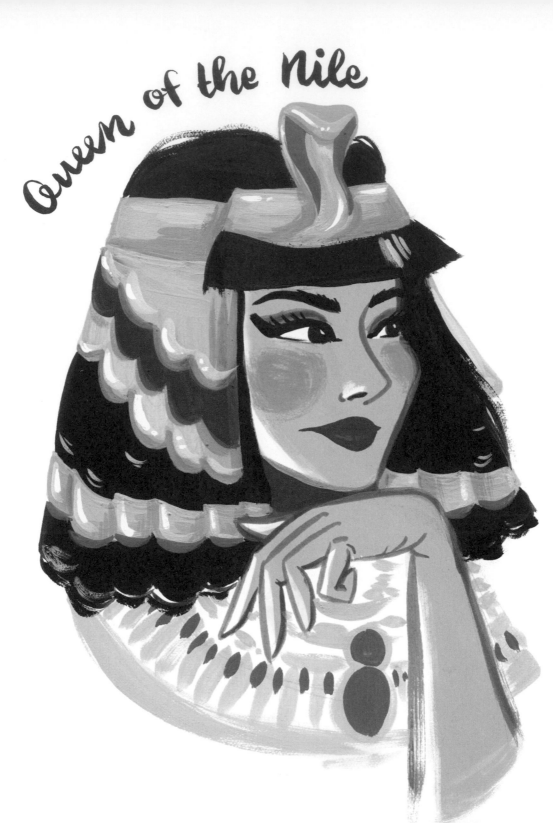

Cleopatra

The last pharaoh of ancient Egypt, Cleopatra VII (69-30 B.C.E.) was crowned at eighteen and became a ruler legendary for her intellect and beauty. Characterized as a cunning seductress who secured lovers (including Julius Caesar and Mark Antony) to ensure her political power, Cleopatra quickly overthrew all other claimants to the throne in a time when it was customary for siblings to marry and co-rule. It was rumored that the twenty-two-year-old Cleopatra had herself wrapped in a rug and smuggled into Caesar's bedroom after he was appointed dictator of Rome, to win his allegiance for the Egyptian civil war. It worked: the fifty-two-year-old Roman ruler fell for her and she was appointed sole ruler of Egypt after he defeated the pharaoh. When Antony summoned her after Caesar's assassination, she floated down the river to him in a gilded ship filled with flowers and servants, presenting herself in the likeness of the goddess Venus. Legend has it he was captivated as soon as he saw her. Now there's a woman who knew the importance of branding.

Cleopatra held Egypt together in a time of political turmoil. She was the last ruler during Egypt's defiance of the Roman Empire's expansion, she spoke Egyptian in a time when all other rulers spoke only Greek, and she successfully claimed she was the reincarnation of the goddess Isis. Her life ended as dramatically as she lived it, in a double suicide with Mark Antony—he by his own sword, upon hearing a false rumor of her death; she by inviting a poisonous asp bite while in captivity after the Roman Octavius successfully defeated Egypt.

Boudica

Boudica was a British queen of the Iceni tribe during the golden age of the Roman Empire in 60 C.E. After the death of her husband, King Prasutagus, the alliance between the Roman Empire and the British island tribe fell apart and the Romans moved in, pillaging the island. Boudica was flogged and her two daughters were raped; this drove her to a bloody rampage for revenge. She rallied more than two hundred thousand from the British tribes to battle the Roman forces. Brutal tactics—decapitating and mounting enemies' heads onto their chariots—became a hallmark of her army. Boudica's forces left an estimated eighty thousand dead in its wake and burned three major cities to the ground—including what is now London. After Rome got over its disbelief that a woman could lead such a rebellion, their soldiers took down her mob, yet Boudica disappeared, never to be heard from again.

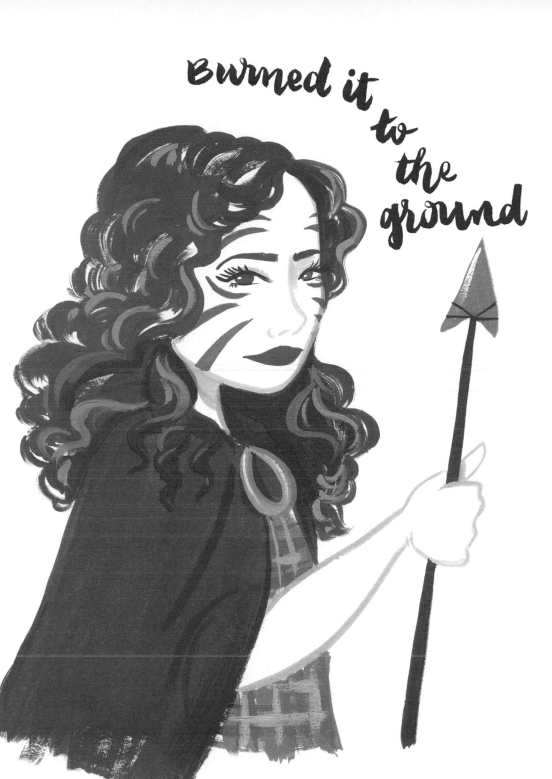

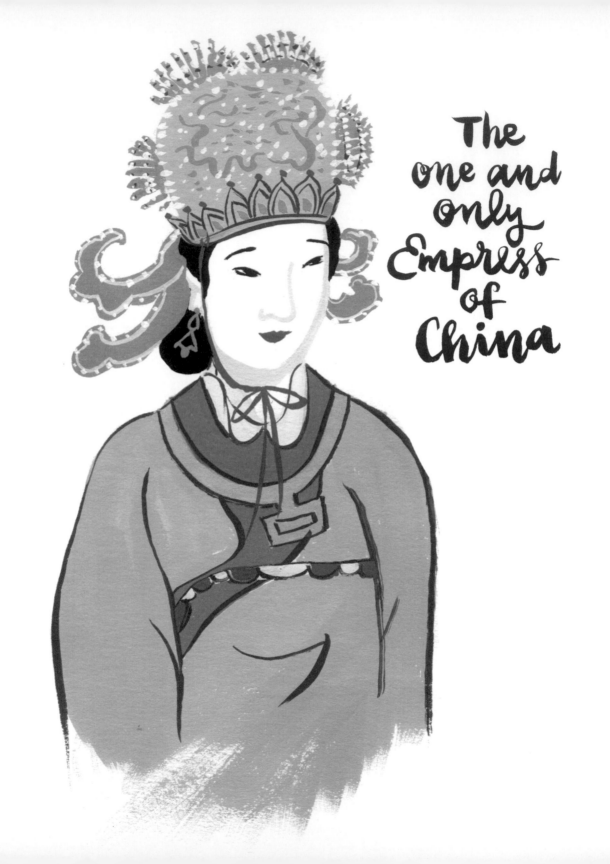

The
one and
only
Empress
of
China

Empress Wu Zetian

Empress Wu Zetian (624–705) rose to become the first and only female Emperor of China after joining the palace at the age of fourteen as a junior concubine to Tang emperor Taizong. Known for her ruthless political ambition, Zetian was said to have begun her ascent by murdering her infant daughter and charging the crime to the existing empress—who was then executed by dismemberment and drowned in a vat of wine (no, Zetian was not messing around). She eradicated most of the opposing old aristocratic guard and at least fifteen claimants to the throne by forcing them to fall on their own swords in front of her as punishment for treason.

First acting as the empress dowager when her own son ascended to the throne, Zetian threw out the title (and her son) and declared herself the sole Empress of China, founding her own dynasty (Zhou) at the age of sixty-five. Despite literally dismembering her challengers, Zetian gained the loyalty of the men she recruited by expanding the imperial service test to include men of diverse backgrounds, so they were promoted for their talents instead of by birthright. Her power grab was met without resistance, and during her short rule of fifteen years China expanded both globally and socially in a positive manner. Since the level of her power and ambition was unseen in women of the time, it's possible that the claims of her ruthlessness are greatly exaggerated—then again, who isn't afraid of a powerful woman who knows what she wants?

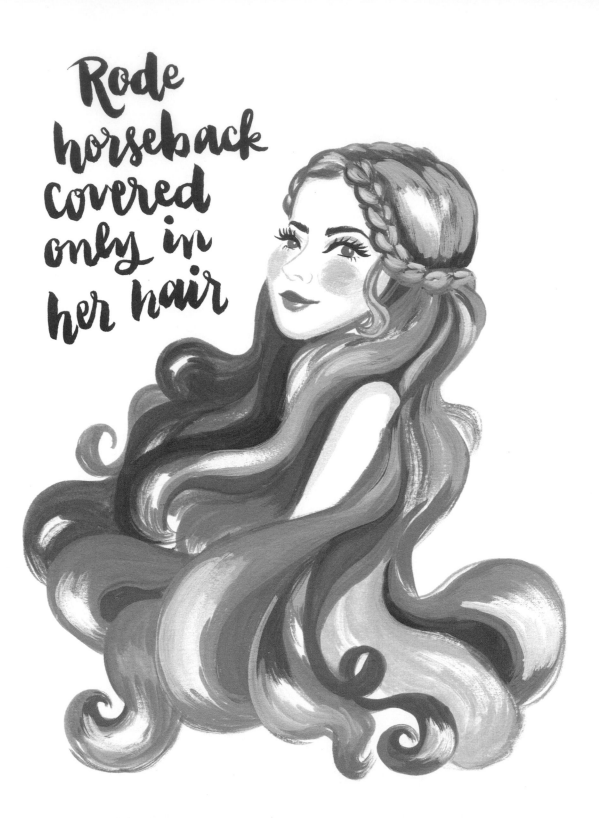

Rode horseback covered only in her hair

Lady Godiva

Lady Godiva (1040–1067) was an eleventh-century English noblewoman who ponied up for her people, literally. Born into a wealthy family, she was one of the few female landowners of her time. Godiva married the Earl of Mercia, Leofric, who was not a very nice lord over the tenants of their land. When Leofric levied an additional tax on the people of Coventry just to pay for the king's guard, Godiva pleaded with him to lift the debt. He challenged her that if she rode through the town naked, he would cancel the tax. So she mounted a white horse and rode through the town with only her long golden hair as a cover, to save the people of Coventry. Legend has it Leofric then lifted all the taxes. Once again, a woman's courage saves the day.

Khutulun

Great-great-granddaughter of Genghis Khan, Khutulun (1260–1306) became a legend among the nomadic Mongol people as an undefeated wrestler of suitors. Khutulun was also known for her impressive athleticism in horsemanship, archery, and wrestling. At the time, women in Mongolian culture were trained to participate in battles on the field; archery on horseback was their combat style of choice. As a princess, Khutulun challenged every suitor to a bet of one hundred horses on a wrestling match, promising to marry the man who could defeat her. No man ever did, and it's rumored that she collected a coterie of ten thousand horses along the way. Because of her athletic talent and political savvy, her tribe believed that she was blessed by the heavens, so she rode into battle alongside her father, Khaidu, and they never lost. She finally married a follower of her father's, a man of her choosing, and when Khaidu passed on, he named her as his successor over her fourteen older brothers.

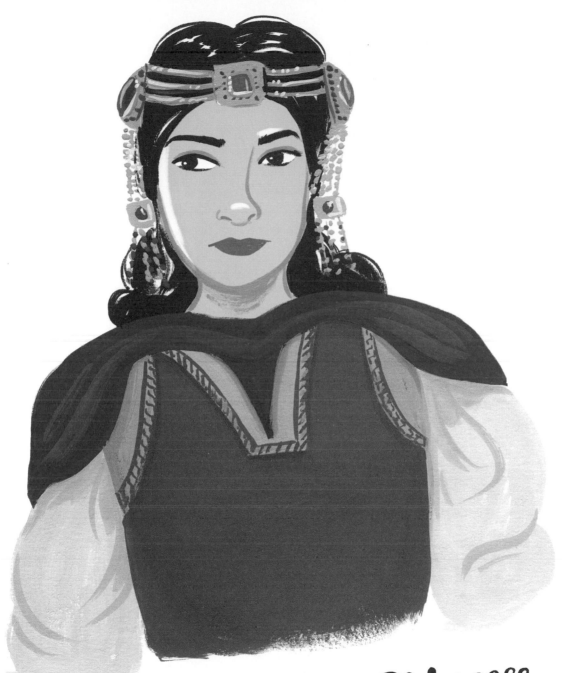

The Wrestler Princess

Jeanne de Belleville

Pirates are made in different ways, but the path to piracy of Jeanne de Belleville (1300–1356) was a classic tale of revenge-driven fury. Born a noblewoman and coming into power at the dawn of the Hundred Years' War between England and France, Jeanne and her wealthy Breton husband, Olivier de Clisson IV, had five children at their home in western France. When the war came, Clisson was accused of supporting the English (not an unfounded accusation, since he easily surrendered the town of Nantes), and King Philip VI of France had him beheaded in public, shaming the family. Enraged, Jeanne turned on the French monarchy. She took her two sons, sold all of her land, and bought three warships that she painted black and outfitted with red sails, forming her Black Fleet. She built up a loyal force; with them, she attacked the French military by land and then by sea in the English Channel. Jeanne was known for personally decapitating any French nobility they captured at sea. The legend goes that for thirteen years she sailed the seas on the wind of revenge, her red sails bringing fear to the hearts of any Frenchman.

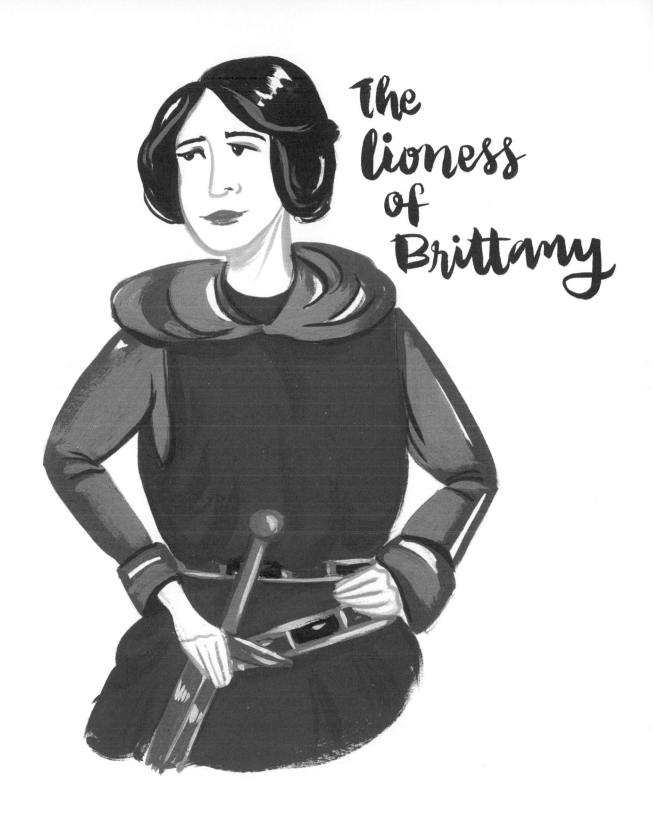

The lioness of Brittany

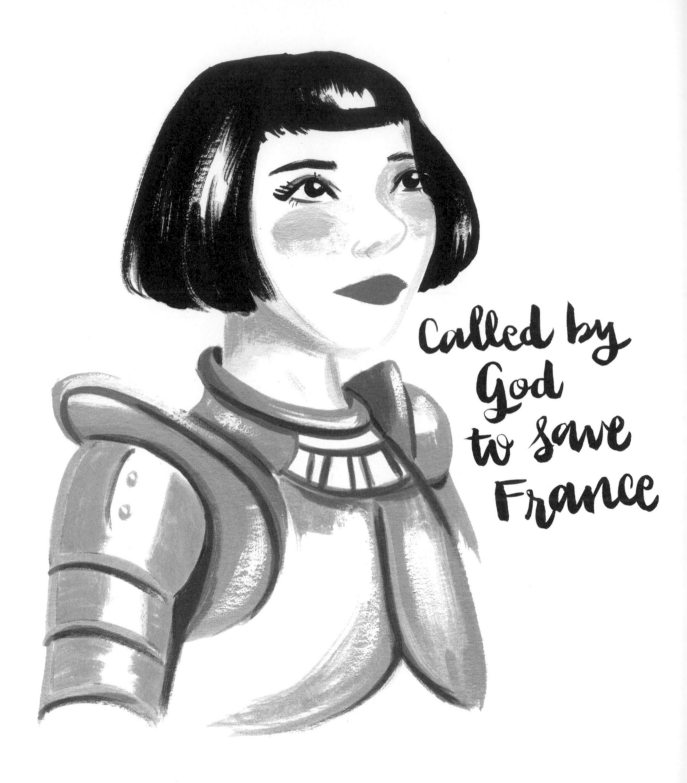

Called by
God
to save
France

Joan of Arc

Born during the middle of the Hundred Years' War between England and France, Joan of Arc (1412–1431) was an illiterate peasant girl from a small French village. England was winning the war at the time, occupying most of France through an alliance with Burgundy. At thirteen, Joan experienced visions of saints in her father's garden. The saints told her to help the French drive out the English and instate the rightful French heir, Charles VII, to the throne in the coronation town of Reims, which was currently under English siege. Three years passed before Joan finally persuaded a relative to take her to the nearest military commander, Robert de Baudricourt, to petition for a visit to the royal French court. It took several months of persistence and convincing two soldiers of her visions—she predicted a military reversal in an area far from where they were, days before messengers delivered a report of the action—before Baudricourt took her to Charles VII.

By then, the French military was in such poor shape that Charles VII was willing to give a sixteen-year-old girl the reins to ride with the military, taking her predictions as direct messages from God. With her guidance, the commanders finally turned the tide when they won back the city of Orléans. She joined the French military, dressed in men's clothes to prevent harassment (men's dress at the time had twenty fastenings that attached everything from top to boots), and they steadily took back their country, including Reims, where Charles VII was finally crowned. Joan and her family were ennobled as a reward for her courage. However, a year later Joan was captured by the English during battle and tried for heresy and cross-dressing. She was convicted by a biased jury and burned at the stake at the age of nineteen. The Hundred Years' War continued for twenty-two years after her death, but the French prevailed after the turning point her military tactics created. Posthumously, Joan was retried and found innocent after the war ended. She became a heroic symbol of France and was canonized in 1920.

Grace O'Malley

A chieftain of the Irish O'Malley clan, Grace O'Malley (ca. 1530–ca. 1603) inherited the family piracy business and a fortune from her parents and her first husband. Scores of Irishmen joined her ranks to evade the growing English inroads into Irish territory. Her strengths as a sea captain were speed and agility as well as a talent for disappearing into the mist, thanks to her intimate knowledge of the Irish coast. Legend has it that she married her second husband, "Iron Richard" Burke, only to expand her property. He lived in Rockfleet Castle, in an area full of sheltered harbors—perfect for pirates. At the time, marriages could be easily annulled before the first anniversary, so one day when he returned to the castle from a trip, he found all the gates locked and O'Malley calling down to him, "Richard Burke, I dismiss you." She kept the castle.

Another O'Malley legend claims that she attempted to visit the eighth Baron Howth at his home, Howth Castle, but was turned away because the family was at dinner. Offended, O'Malley retaliated by abducting the heir. Lord Howth negotiated his return by offering O'Malley a permanent extra setting at the table just for her; this is still honored today. O'Malley was so respected and feared in the British Isles that she was even granted a request to visit Queen Elizabeth I to petition for the release of her two sons and half-brother from the clutches of an English lord. After they were freed, the lord was removed from his post. That's some serious pirate clout.

The pirate queen

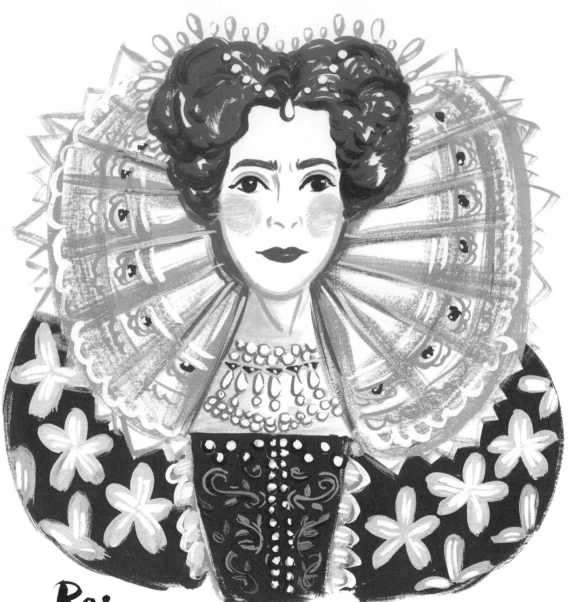

Reigned for forty-five years and gave her name to an era

Queen Elizabeth I

Crowned queen of England at the age of twenty-five, Elizabeth I (1533–1603) had one of the longest reigns in history. She never married, earning the nickname the Virgin Queen, and she brought great unity and prosperity to an England and Ireland divided after the bloody reign of her father, Henry VIII. Queen Elizabeth I was the second modern female monarch of England, after her sister, Bloody Mary, who ruled for a brief and turbulent five years.

Famously intelligent, cunning, and hot-tempered, Elizabeth quickly established herself as a courageous queen. She decided to never marry, on the grounds that God had given her alone the divine right to rule; thus she never divided her power. She solidified her father's establishment of England as a Protestant country and became public enemy number one to the Pope and the Catholic Church. With this new, more progressive perspective on religion, Elizabeth was able to rule over the dawn of the English Renaissance and bring about a cultural revival of arts and literature that nurtured writers such as William Shakespeare and Christopher Marlowe.

Elizabeth made England the leading world power when she defeated the Spanish Armada and ousted the French from Scotland. England became a leader of world trade through her aggressive tactics in commissioning adventurers to establish new trade routes. This included engaging Walter Raleigh and Francis Drake, whose explorations led to England's establishing the American colonies—thus influencing the future of an entire continent. Her era is romanticized as the golden age of England—and she did all of it solo.

First professional successful female painter

Artemisia Gentileschi

Artemisia Gentileschi (1593–ca. 1656) was an Italian Baroque painter who made a name for herself by portraying strong mythical females in positions of power—a rare representation for women in the seventeenth century. She was the daughter of an established artist who trained her in the style of post-Renaissance art, dominantly influenced by Caravaggio. At seventeen she debuted her first painting, *Susanna and the Elders*, depicting the biblical story of a woman tormented by two older men after she rejects their advances, though it was suggested that her father had helped her because of the level of skill the piece demonstrated. Rejected by art academies, Gentileschi was privately tutored by her father's friend Agostino Tassi, who ended up taking advantage of her. Her father pressed rape charges against Tassi, and a highly publicized seven-month trial followed. This traumatic event is said to have dramatically affected the subjects of Gentileschi's work. She became known for her fearless and confident painting style, along with portraying courageous, rebellious, and powerful females as protagonists in her paintings. For example, in multiple paintings she depicted the story of Judith violently murdering the Assyrian general Holofernes and saving the Jewish people, and she often used herself as a reference for the portrayal of her heroines. Gentileschi experienced great success with her work in her lifetime and became the first woman accepted into Florence's Academy of Design (Accademia delle Arti del Disegno).

Aphra Behn

Aphra Behn (1640–1689) was a British writer of mysterious origin who became the first professional female playwright, poet, and author. Little is known about her background before her 1664 marriage to Johan Behn, who either died or separated from her soon after. She rose to a prominent enough position in the courts to be recruited as a spy for King Charles II in Antwerp during the Second Anglo-Dutch War. Her assignment was to get close to a suspected spy in the English service and turn him into a double agent with her wiles. Charles II never paid her for her services or travel expenses abroad, so she did what all freelancers worth their salt do: she found other work. She became a playwright for a few theater companies and produced several popular and profitable plays—a total of over nineteen in her lifetime. Behn also wrote prose that would become the model for the English novel. Her most famous work, *Oroonoko*, published in 1688, broke cultural barriers by telling the love story of an enslaved African prince and a general's daughter. Additionally, Behn continued to write poetry that included social commentary on her political beliefs and touched on women's sexuality—both audacious topics for a writer, much less a female writer, to cover in her era. Behn's literary achievements created a seat for women at the writers' table, and she's famously remembered in Virginia Woolf's *A Room of One's Own* for doing so: "All women together, ought to let flowers fall upon the grave of Aphra Behn . . . for it was she who earned them the right to speak their minds."

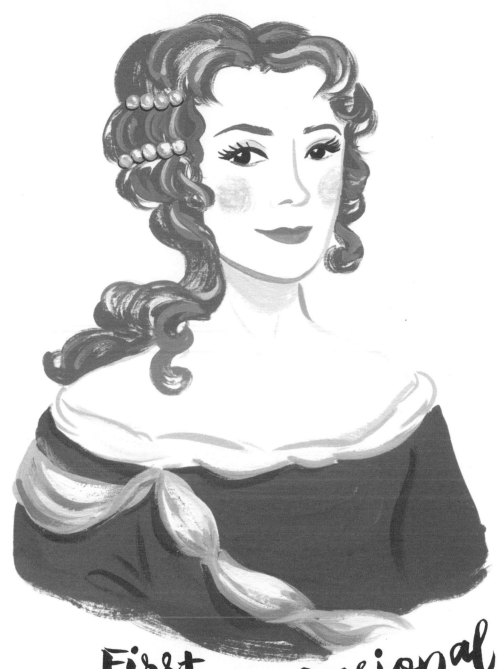

First professional
female writer

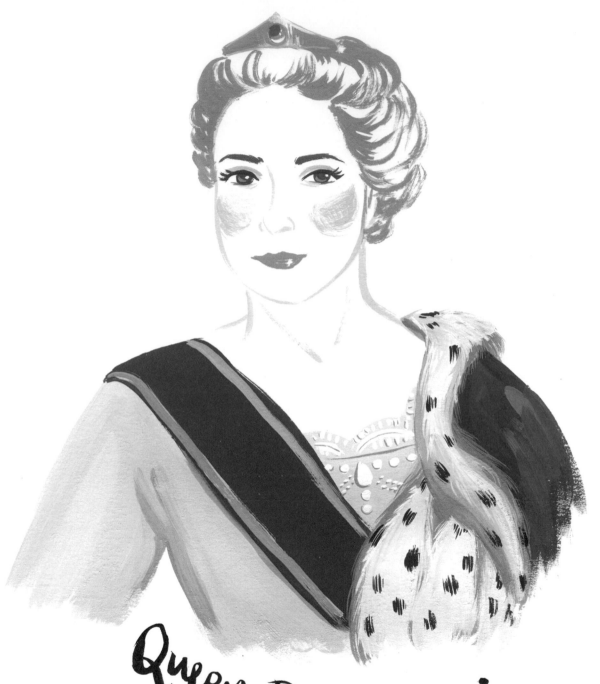

Queen B of Russia

Catherine the Great

Catherine the Great (1729–1796) became the longest-ruling empress of Russia through a series of lucky coincidences, but she grew into a legendary ruler through her own actions. Born a German princess, Catherine was recruited by the reigning Russian Empress Elizabeth to be a wife for her nephew and heir-apparent, Peter III. The marriage was an unhappy one, and when it was Peter's turn to rule, he was so cruel and unpopular that Catherine had no trouble leading a bloodless coup that instated her as the sole ruler of Russia. (Well, a little blood was shed after Peter was murdered by one of her lover's brothers, but it's unknown whether she had any role in that.)

A confident and charming ruler, Catherine was credited with modernizing her country by ushering in the Russian Enlightenment. She expanded Russia's borders with aggressive military force. Additionally, she reeled back the Orthodox Church's power in the state and passed an act that allowed religious freedom. Catherine was a strong supporter of the arts and education, and she established the first state-funded schools for girls. The empress never remarried, and she was as famous for her many lovers as she was for her power, with at least twenty-two documented affairs. Never one to hold a grudge, she often rewarded her men with power and jewels before sending them off to bring her the next one; she even made one of them king of Poland.

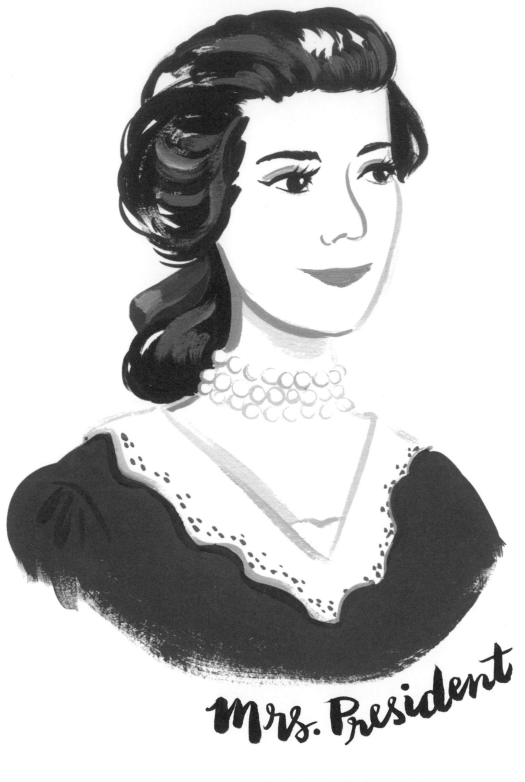

Mrs. President

Abigail Adams

The second First Lady of the United States, Abigail Adams (1744–1818) was a true equal to her husband, John Adams. Denied a formal education because of her sickly childhood, Adams was educated by her mother and became well-versed in poetry, politics, and philosophy—unusual for a woman at the time. She was the first First Lady to reside in the President's House in Washington, D.C. (before the White House was built), and there she held down the fort, raising six children and sheltering wounded soldiers from the Revolutionary War. Legend has it that she melted down her silverware to make bullets for the troops. John and Abigail were true loves and partners; she read all of his speeches and formal documents before he delivered them. Since he often traveled for work, they wrote more than a thousand letters to each other during the lifetime of their relationship. All of these letters demonstrated the ideals that Abigail impressed upon John—she was a devout feminist before the word even existed, strongly urging John to always "remember the ladies" in the development of the new country. Additionally, she was strongly against slavery, believing it would threaten the very core of the democracy that was being established. She was so politically active that people often referred to her as "Mrs. President."

Marie Antoinette

Born an Austrian princess in a turbulent time, Marie Antoinette (1755–1792) was married to Louis XVI of France at the age of fourteen to end hostilities between Austria and France. When she first arrived in France, she was received like a teen idol. Her peaches-and-cream complexion and innovative fashion sense—including wearing a miniature replica of a battleship in her hair at a palace party—earned her the favor of the style-loving French. Politically, Marie Antoinette held little influence over her husband and mainly served as a pawn for her mother, the empress of Austria. So instead she worked her influence to modernize the French court, which garnered great criticism from court elders. For example, when she was painted in a portrait wearing a casual muslin dress, this was viewed as improper for a queen; she also hired a female portrait painter, which was unheard of at the time.

As the French Revolution gained force, Marie Antoinette was scapegoated as "Madame Deficit," as her extravagant displays of style, for which she was so loved by some, became the personification of aristocratic excess. While we all know her miserable fate, she must be exonerated from ever saying "Let them eat cake"—that statement first appeared in a text by Jean-Jacques Rousseau, describing a Spanish princess long before Marie Antoinette was even born. It should be noted, she was ever the gentlewoman. Her actual last words were "Pardon me sir, I meant not to do it," after she accidentally stepped on the foot of her executioner.

The
fallen
teen
idol
queen

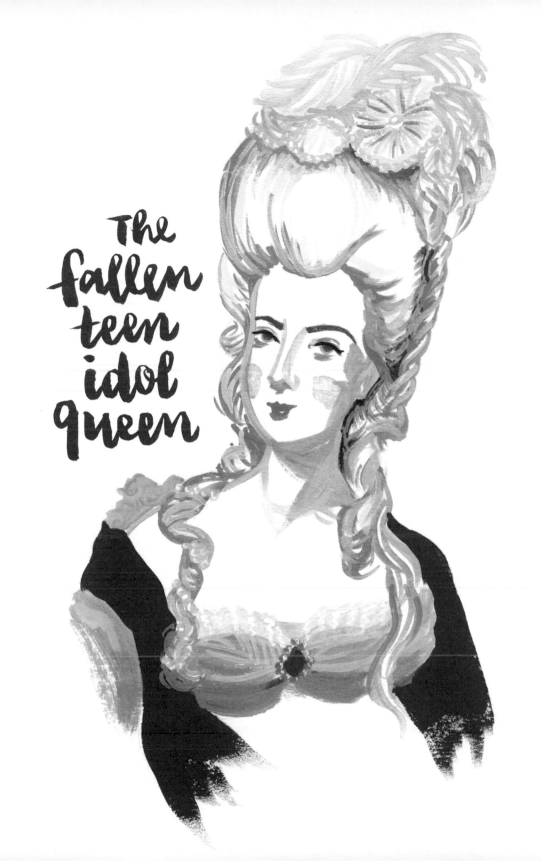

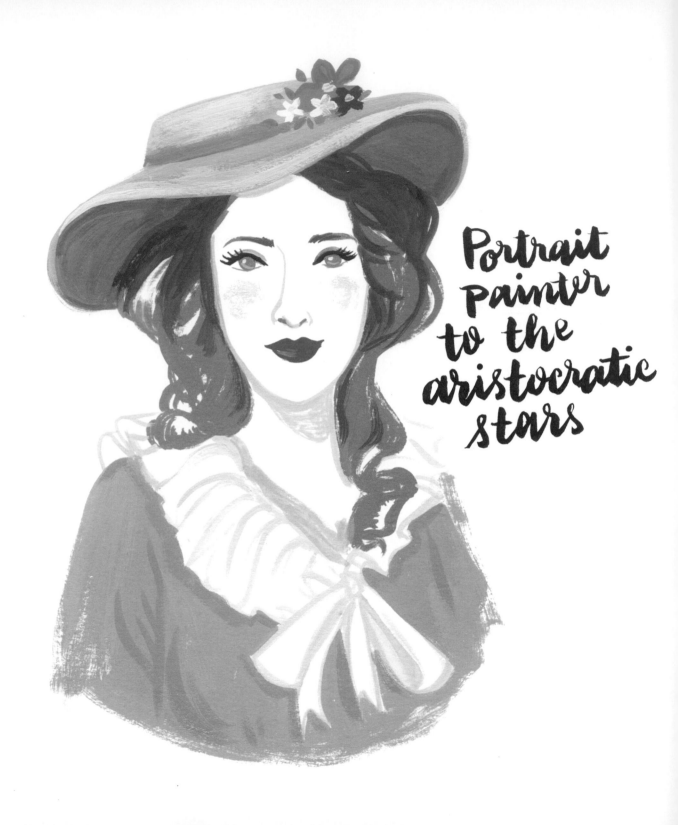

Portrait painter to the aristocratic stars

Élisabeth Vigée-Lebrun

Best known for being Marie Antoinette's portrait artist, Élisabeth Vigée-Lebrun (1755–1842) was a Parisian painter who left a legacy of over 660 portraits and 200 landscape paintings. She started painting professionally as a teen, but her studio was seized because she was practicing without being a member of any of the *académies*; at the time, the *académies* accepted very few women, and her work didn't fall within their guidelines. Vigée-Lebrun then married a fellow painter and art dealer who provided many valuable contacts for her. In 1781, she caused a public scandal when she painted a self-portrait that showed her teeth in an open mouthed smile, which was strictly taboo at the time.

As her career grew and she painted more nobility, Vigée-Lebrun was invited to Versailles to paint Marie Antoinette. The queen was so pleased with the artist's style that she commissioned over thirty portraits. Over the next six years, Vigée-Lebrun helped reinvent the image of Marie Antoinette as a loving maternal figure. With the queen's help, in 1783 Vigée-Lebrun was finally accepted into the prestigious Académie Royale de Peinture et de Sculpture. Her relationship with the queen became problematic after the French Revolution overthrew the monarchy and aristocracy, however, and Vigée-Lebrun fled to Russia with her daughter. There she continued her career of painting aristocrats, including commissions from Catherine the Great, and became a member of the Academy of Fine Arts of Saint Petersburg before finally returning to France, where she continued to paint prominent figures. Many of her paintings are on display at the Louvre, London's National Gallery, and major museums around the globe. Vigée-Lebrun was able to achieve great popularity and enjoy success with her work in her lifetime, which was rare for any artist at that time, let alone a female artist.

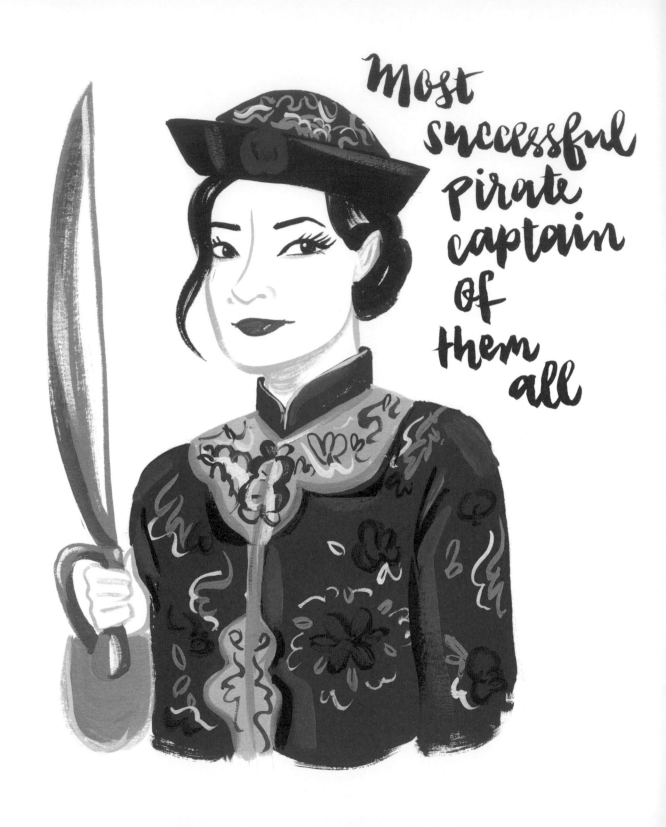

Most successful pirate captain of them all

Ching Shih

From prostitute to pirate captain, Ching Shih (1775–1844) lived an extraordinary life that far surpassed expectations for a woman of her time and place. Abducted by pirates from a Canton brothel, Shih married their notorious captain, Cheng I, and oversaw his crew, the Red Flag Fleet, beside him. When he died in a typhoon a few years later, Ching Shih maintained her leadership position and married Cheng I's right-hand man, Cheung Po Tsai, to cement her authority. Shih commanded over seventy thousand pirates, including many additional small fleets that had joined up with her own. The Red Flag Fleet controlled the Southern China seas and made their profits from merchants paying for safe passage through the lucrative trade route.

Shih ran a tight ship, as she nailed a strict code of conduct to every boat in the fleet. The laws required her approval for all raids, fair distribution of loot, and a no-tolerance policy on rape or even consensual sex between pirates and female captors unless the pirate chose to marry the female prisoner and be faithful to her. Violators of her edicts could be punished by being clapped in irons, flogged, quartered, or beheaded. If anyone was caught trying to desert the fleet, their ears were cut off and passed around to shame them. These surprisingly civil laws kept her fleet in line, and they became the "Terror of South China." When the Chinese navy attempted to take down the Red Flag Fleet in 1809, Shih sailed straight into their army and swiftly defeated the ships. Their loss was so bad that the leader of the expedition committed suicide when captured. Shih offered the survivors a choice: join her ranks, or be nailed to the boards of the ship by their feet and flogged to death. After nine years of her terror, the Qing emperor decided to offer her an amnesty deal, which she negotiated to allow her tens of thousands of pirates to return to life on land with a tidy sum and without prosecution. At thirty-five, Ching Shih achieved a rare accomplishment in the pirate world: she retired from the life to spend the rest of her days on land running a gambling house and brothel.

Jane Austen

English writer Jane Austen (1775–1817) may have invented the modern romantic comedy. The author of six wildly popular novels, and the cult idol of a devout following who call themselves either "Janeites" or "Austenites," Austen lived a quiet life and wrote prolifically in a genre that bridged the romantic movement of her time with a fresh perspective of realism. Born into a close-knit upper-class family that had lost most of its wealth, Jane experienced firsthand the social etiquette and expectations placed upon women of the gentry. Though her creative life was steeped in romance, Austen experienced only a short-lived affair with a barrister-to-be who was equally poor and expected to marry up. So she turned to her writing.

With the help of her brother Henry, Jane's first novel *Sense and Sensibility* was published when Jane was thirty-six. She chose to publish it anonymously, with the byline "By a Lady." In fact, all her work was published as "By a Lady" during her lifetime. Royalty and literary scholars alike became big fans of her work, and she sold enough books near the end of her life to support herself, her mother, and her sister. After a brief hiatus, Austen's books have continuously been in print since 1833. In 1869, her nephew's publication of *A Memoir of Jane Austen* finally revealed her as the author of her novels.

Her work remains deeply influential on popular culture, as much as it was when it was first published, and has spawned continuous adaptations, rewrites, and sequels, including the famous modern-day versions of *Pride and Prejudice* (*Bridget Jones's Diary*) and *Emma* (*Clueless*). Austen's stories retain a cult status equal to Shakespeare's in timelessness and reinvention.

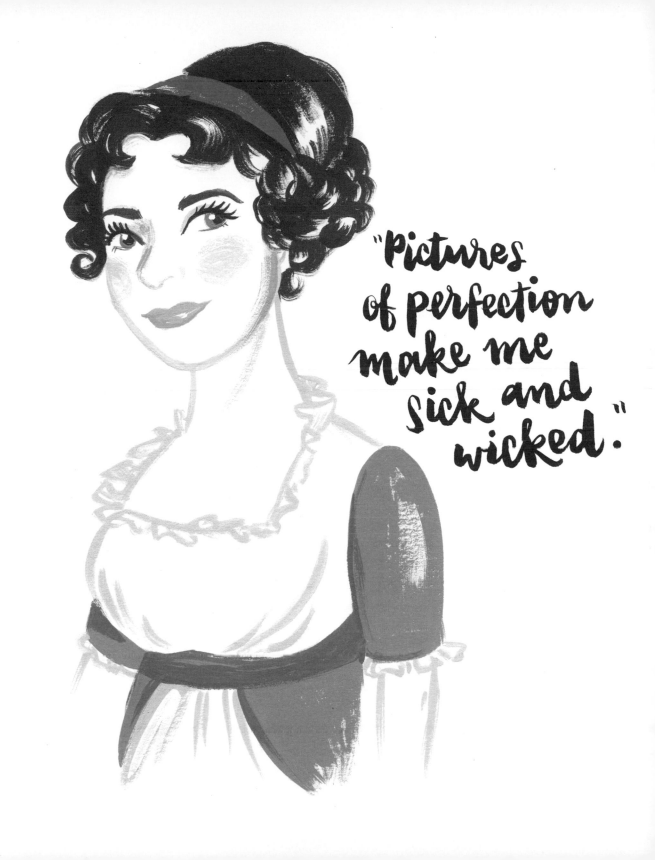

"Pictures of perfection make me sick and wicked."

Sojourner Truth

Activist Sojourner Truth (ca. 1797–1883) was born Isabella Baumfree into a family of slaves in New York. She escaped to freedom with her infant daughter a year before the state abolished slavery in 1827, and she became the first African-American woman to win a case against a white man when she sued her former master for selling her five-year-old son. She became a Methodist and adopted the name "Sojourner Truth," seeing it as a mission statement for her life. The illiterate former slave toured the country, speaking passionately for the political equality of women and the abolition of slavery, including at the 1850 first National Women's Rights Convention and in 1851 at the Ohio Women's Rights Convention, where she delivered her famous "Ain't I a woman?" speech. Her views were revolutionary even for her time, and she became a national figure for civil rights before the Civil War even began. Truth used her influence to help recruit black troops for the Union Army and to work steadily for desegregation immediately after the Emancipation Proclamation, even attempting to ride a whites-only streetcar in Washington in 1865. She was a fervent advocate for the equality of the sexes and was turned away from the polls in 1872 for attempting to vote in the presidential election. Truth passed away in her own home at the age of seventy-six, almost forty years before women would finally be given the vote. More than three thousand people attended her funeral. She left a legacy of defying expectations and gave a voice to the most overlooked populations by representing slaves as a female and women as an African-American.

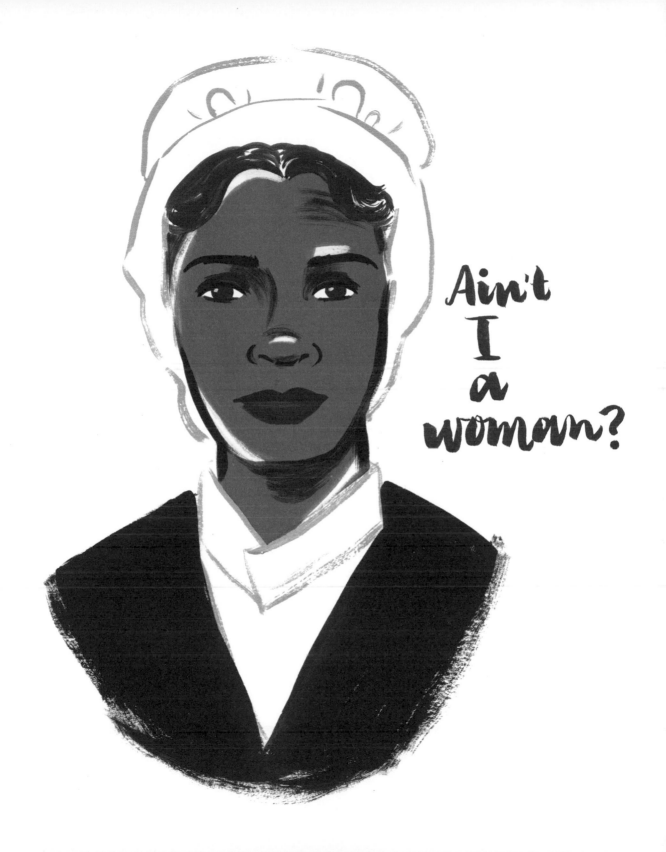

Anna Atkins

Anna Atkins (1799–1871) was a British botanist and photographer who self-published the first book of photography, *Photographs of British Algae: Cyanotype Impressions*, in 1844. Atkins was raised by a father who was prominent in the scientific community, connecting her early on with photography inventor William Henry Fox Talbot and cyanotype inventor Sir John Herschel. Benefiting from a more extensive education than that of most women in her era, Atkins applied the skills she learned from Talbot and Herschel and decided to record all the specimens of algae found in the British Isles in a scientific publication. With that, she became the first person to publish photography in the field of scientific research, proving with her skillful compositions that photographs could be both educational and beautiful. Because of this publication, Atkins is arguably also the first female photographer; Talbot's wife Constance, a contemporary of Atkins, is also often credited with this achievement, but no existing works of either party can conclusively award either one the title.

published the first book of photography

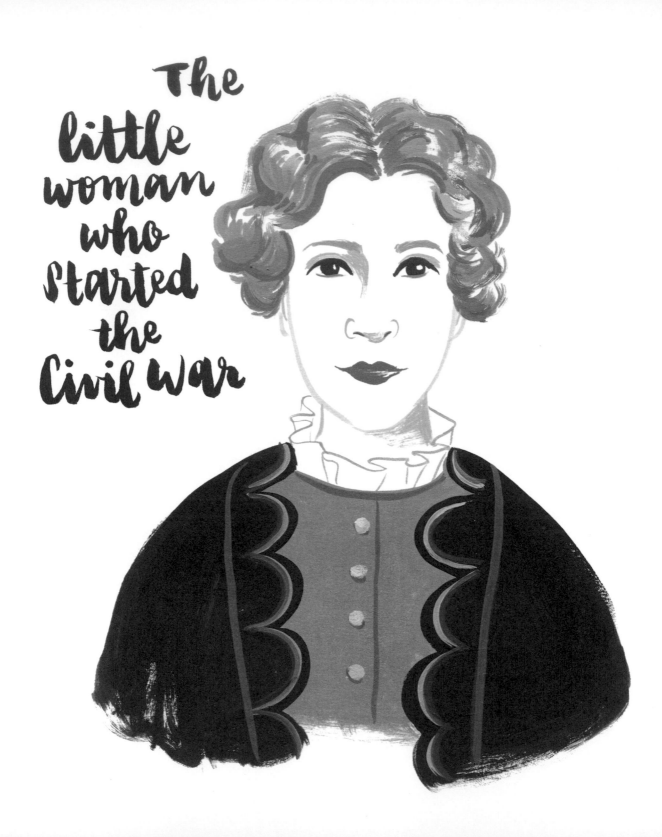

The little woman who Started the Civil War

Harriet Beecher Stowe

According to legend, President Abraham Lincoln said to Harriet Beecher Stowe (1811–1896) upon their first meeting, "So, you are the little woman who wrote the book that started this great war." Stowe certainly earned that reputation with her bestselling anti-slavery novel, *Uncle Tom's Cabin*. One of thirteen children born to a famous religious leader, Lyman Beecher, Stowe and her siblings all rose to prominent social reform roles. Seven of her brothers became preachers, one became a famous abolitionist, and one of her sisters cofounded the National Woman Suffrage Association. When she was twenty-one, Harriet moved to Ohio with her father and met her husband to be, Calvin Ellis Stowe, a professor and supporter of the Underground Railroad.

After Congress passed the Fugitive Slave Law in 1850, prohibiting anyone from assisting runaway slaves even in free states, Stowe took up her pen at the age of forty and started writing a serial for an anti-slavery newspaper. This serial, though fictional, worked to educate the North on the realities and horrors of slavery and to foster empathy in the South for those forced into slavery. It was published in book form as *Uncle Tom's Cabin* two years later and became an instant cultural icon: the year after the book was released, three hundred babies in Boston alone were named Eva (for one of the main characters), and the story was adapted into a play that opened in New York. The Civil War began eight years later. Now that is seriously powerful writing! Throughout her life, Stowe wrote over thirty books on a diverse range of topics and campaigned for the expansion of married women's rights to control their own finances.

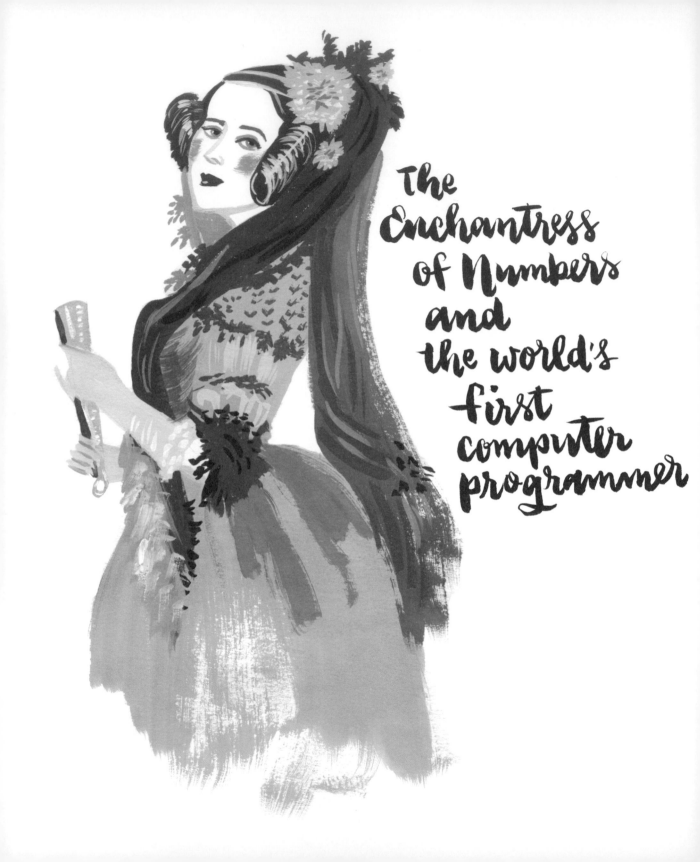

The Enchantress of Numbers and the world's first computer programmer

Ada Lovelace

Ada Lovelace (1815–1852) is known as the Enchantress of Numbers. The only legitimate child of famed Romantic poet Lord Byron and his wife, Anna Isabella Byron, Ada exhibited extraordinary mathematical talent early in her life. Her talent led to a working relationship with fellow British mathematician Charles Babbage, who invented the first programmable computer, the Analytical Engine. Lovelace's book of notes on a translation of Italian engineer Luigi Menabrea's article about the engine included an algorithm that became the world's first computer program in 1843.

Lovelace was also famous in Victorian society for her family name and scandalous behavior. She was a regular in the court, had many working relationships with men who were not her husband, and had a love for gambling that led her to form a syndicate with male friends that created a mathematical model for winning large bets. Unfortunately, it failed and left her thousands of pounds in debt, forcing her to admit the scheme to her husband, the Earl of Lovelace. On her deathbed, she confessed something to her husband that resulted in his leaving her side just two days before her passing, never to return. What she said is a secret she took to her grave. She also had pacts in place with her friends to burn all of her letters upon her death, so the full details of Lovelace's fascinating life may never be known.

Maria Mitchell

Born into a Quaker family based in Nantucket, Massachusetts, the first female American astronomer, Maria Mitchell (1818–1889), was raised in a community that was rare in that it valued equal education for boys and girls. She took her education far, exhibiting early signs of brilliance at the age of twelve when she helped her father calculate the exact time of a solar eclipse. At twenty-seven, she opened her own school and admitted non-white children, despite the segregation of public schools at the time. The next year, Mitchell became the first American woman to discover a comet by telescope, which earned her a gold medal prize from the king of Denmark. The comet was dubbed "Miss Mitchell's Comet." She became the first professional female astronomer in the United States and the first female member of many science academies. Mitchell also became the first female professional employed by the U.S. government when she was hired by the Coastal Service to be a celestial observer in 1849. Six years later, she became the first astronomy professor ever at Vassar College. When she discovered that she was getting paid less than many of her younger male coworkers, she demanded a pay increase—and got it. Along with Mitchell's contributions to the field of astronomy, she was also an active suffragette and abolitionist, boycotting cotton clothing in protest of slavery.

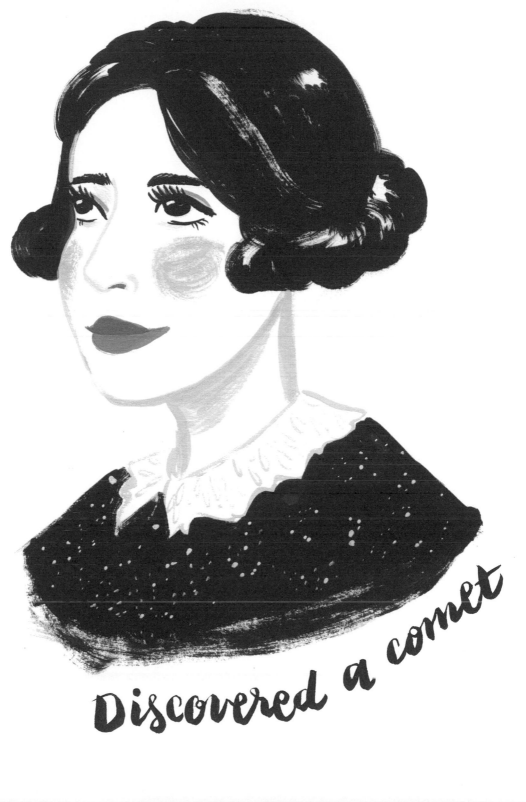

Discovered a comet

Susan B. Anthony

Without Susan B. Anthony (1820–1906), the United States might have become a very different place. This extraordinary woman made her living as a speaker at a time when women were not allowed to publicly speak on stage. In fact, her attempts to do so at several teachers' conventions sparked debate among men that allowing a woman to speak in public would disrupt the very institution of marriage—a fear that Anthony found laughable. The issue of a woman's speaking was more hotly debated than women's suffrage, thus proving the power of a woman who speaks her mind.

Anthony was a leader in social reform, contributing significantly to both the abolitionist and the women's rights movements. As a founder of the Women's Loyal National League with her best friend and professional partner, Elizabeth Cady Stanton, Anthony organized a petition drive that brought in four hundred thousand signatures in support of the abolition of slavery—the largest petition drive of the time. She worked with Harriet Tubman on the Underground Railroad, and she was arrested for attempting to vote and later convicted in a widely publicized trial. Her organizational and speaking work both directly led to the passage of two U.S. Constitutional Amendments: the Thirteenth, abolishing slavery, and the Nineteenth, granting women the right to vote. She was also the first woman to appear on a U.S. coin—a one-dollar coin minted in 1979.

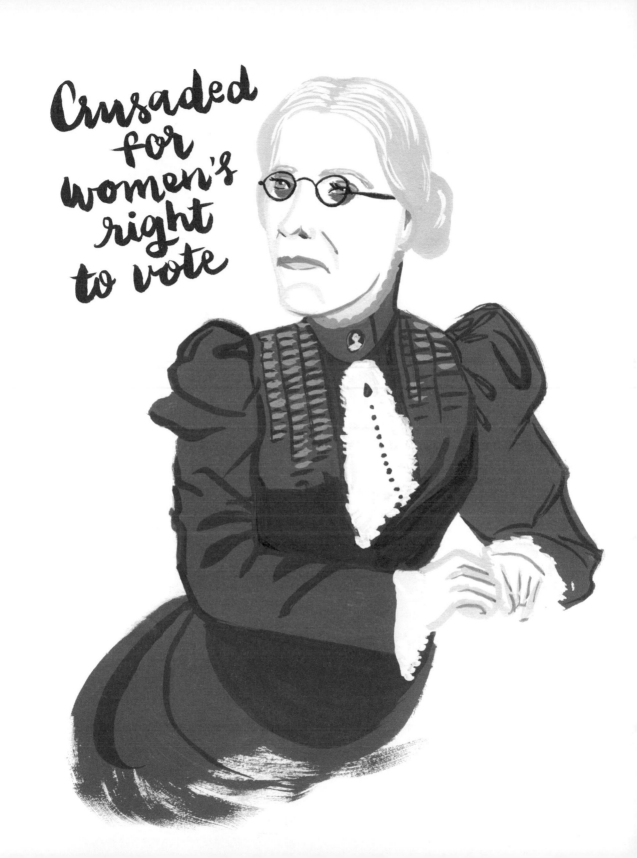

Crusaded for women's right to vote

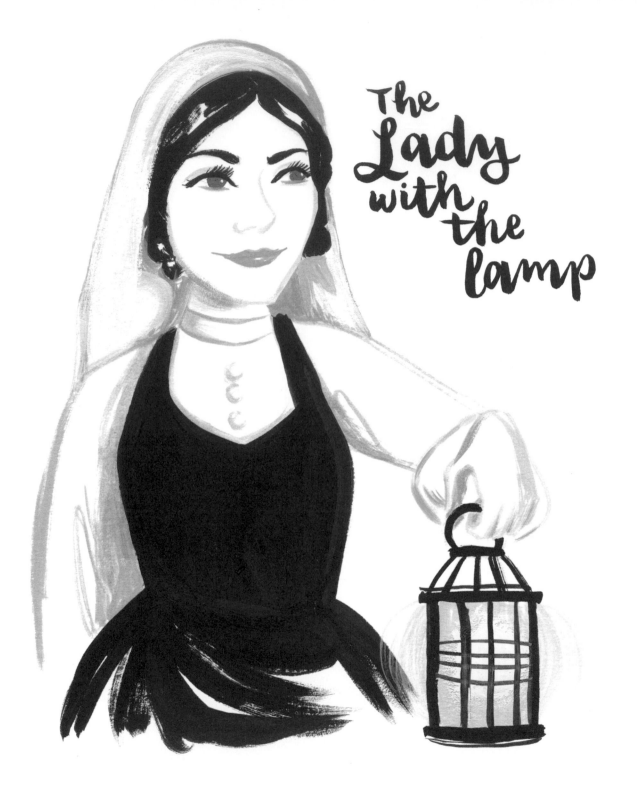

The Lady with the lamp

Florence Nightingale

Florence Nightingale (1820–1910) is the founder of modern nursing and compassionate care worldwide. Before she established it, there was no formal education for nursing practices. She found her calling early in life and worked hard to educate herself in the field of nursing, despite being born into a wealthy upper-class family that disapproved of her decision to work. Nightingale came to prominence when she and thirty-eight nurses she had trained were sent to a British base in the Ottoman Empire during the Crimean War. There, horrified by the state of the medical tents and overworked medical staff, she developed a reputation as a compassionate caretaker and a brilliant statistician who observed that the care and sanitation conditions of the patients directly correlated with their mortality rate. It's recorded that with her intervention, the medical camp mortality rate went from 42 percent to 2 percent. Her pie charts depicting death rates and the spread of disease began the practice of evidence-based medicine; her diagrams were so significant that the British government established a statistical branch of the Army Medical Department a year after her return from Crimea. She spearheaded campaigns for sanitation and care practices in hospitals, with guidelines as basic as establishing hand-washing rules, and she wrote the textbook on modern nursing, *Notes on Nursing*, that is still used today. Perhaps most significantly, Nightingale established the first formal school of nursing, the Nightingale Training School at St. Thomas' Hospital in London. She went on to write extensively on her medical knowledge and mentor other nurses who went out and established her methods globally.

Anita Garibaldi

Anita Garibaldi (1821–1849) was the legendary love who shaped the life of Giuseppe Garibaldi, the father of modern Italy. Born to a poor family in Brazil, Anita met the young revolutionary Garibaldi when he came to the country for the Ragamuffin War. A skilled and courageous horsewoman, she taught him the gaucho way of life and joined him on the battlefield. They fought together with many rebel groups across South America, including in the Battle of Curitibanos, where she was captured by their adversaries and told that Giuseppe had died. She searched the battlegrounds, and when she didn't find his body, she escaped on horseback and crawled through the woods for four days without food or water until she was reunited with the rebels and Giuseppe—all while pregnant with their first child. Together in 1848 they traveled to join the war for a liberated and united state of Italy. Anita passed away a year later during a defeat; when Giuseppe rode out to hail the new king of a united Italy in 1860, he wore Anita's striped scarf as tribute.

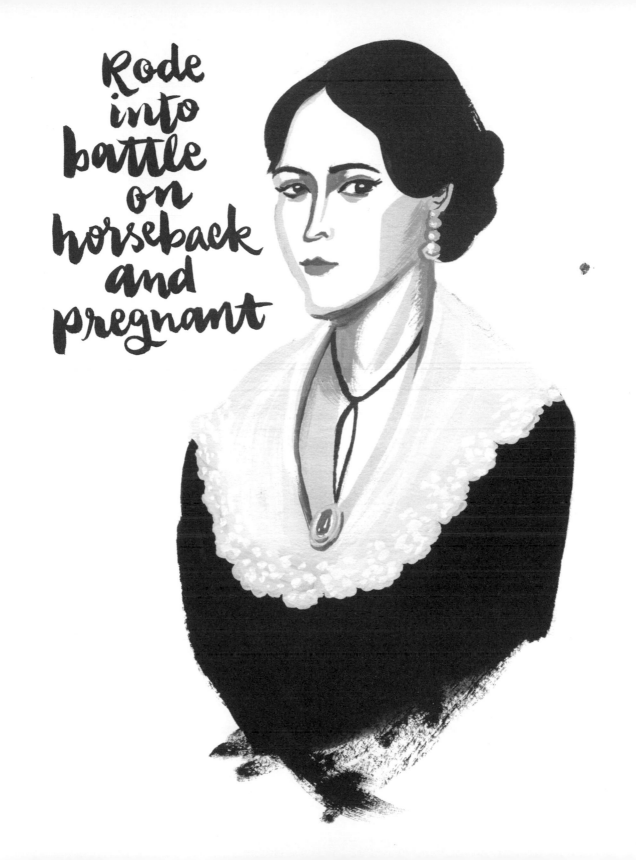

Rode into battle on horseback and pregnant

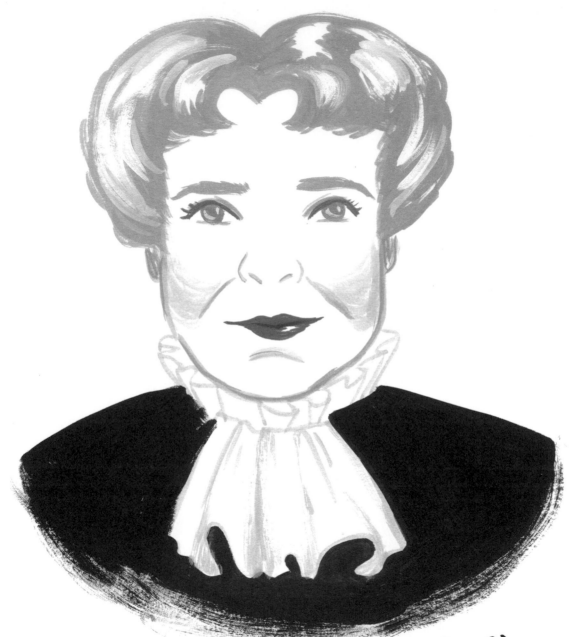

The United States' first female doctor

Elizabeth Blackwell

On January 23, 1849, Elizabeth Blackwell (1821–1910) became the first woman to receive a medical degree in the United States. Her journey there was nurtured by the liberal ideologies introduced by her father, Samuel Blackwell, who moved the family from the United Kingdom to America and worked with the abolitionists.

Blackwell decided to apply to medical school after hearing a dying friend exclaim that her experience would have been better with a female physician by her side. At the time, the term "female doctor" referred only to abortionists. Her application to Geneva Medical College in upstate New York was so unusual that the administrators put her admission up to a vote by the class of 150 male students. Thinking it was a joke, all of them voted in favor of her admission. When she arrived, her presence had a positive impact on the class, turning boisterous young men into well-mannered gentlemen. After graduation, she traveled throughout the country and Europe to further her education and was often confronted by male physicians who refused to work with her. In response, Blackwell opened her own practice, which employed only female physicians and had an all-female board of trustees. She assisted in the Civil War effort, became good friends with Florence Nightingale, and helped establish a women's medical school in London to mentor up-and-coming female doctors. Blackwell viewed her work in bringing women into the medical profession as a way of creating social and moral reform, bringing feminine perspectives and strengths to the field.

Harriet Tubman

Born into slavery, Harriet Tubman (ca. 1822–1913) was easily one of the most courageous people who ever lived. Abused daily by her masters, Tubman became disabled after one threw an iron weight at her head, then left her unconscious and without medical care for two days. She survived, but suffered seizures and narcolepsy for the rest of her life. Tubman escaped slavery in 1849, yet returned to the South at least nineteen times over the next eight years, even with a bounty on her head, to usher over seventy runaway slaves to freedom through the Underground Railroad. When the Civil War broke out, Tubman served as a nurse, scout, and spy, even becoming the first American woman to lead an armed assault. She worked with Colonel Montgomery and his troops to raid plantations along the Combahee River, where they rescued over 750 slaves. Tubman received no compensation for her war services and lived in poverty most of her life because she gave so much away.

She managed to buy property in Auburn, New York, where she housed anyone who needed help getting back on their feet. Later in her life she worked alongside Susan B. Anthony and other suffragettes to fight for the vote, even though she had to sell a cow to buy a train ticket to speak at receptions honoring her service. In 1903, she donated her own real estate to a church in Auburn to open a care facility for elderly African-Americans, a place she called home a decade later. She passed away at the age of ninety-one, surrounded by friends; her last words were reportedly, "I go to prepare a place for you."

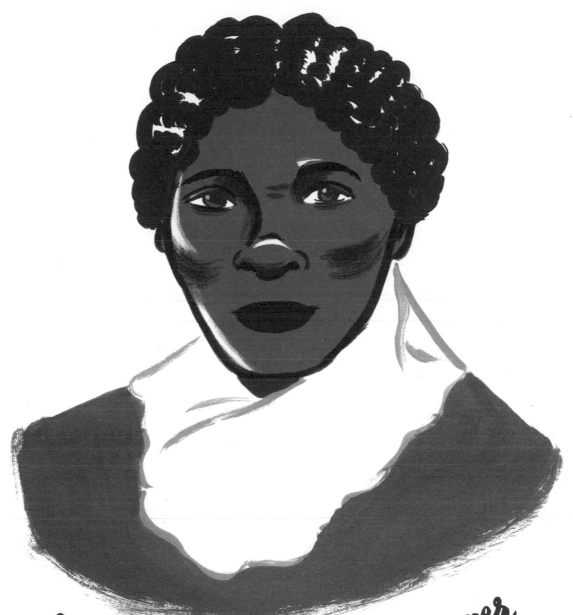

Never lost a passenger

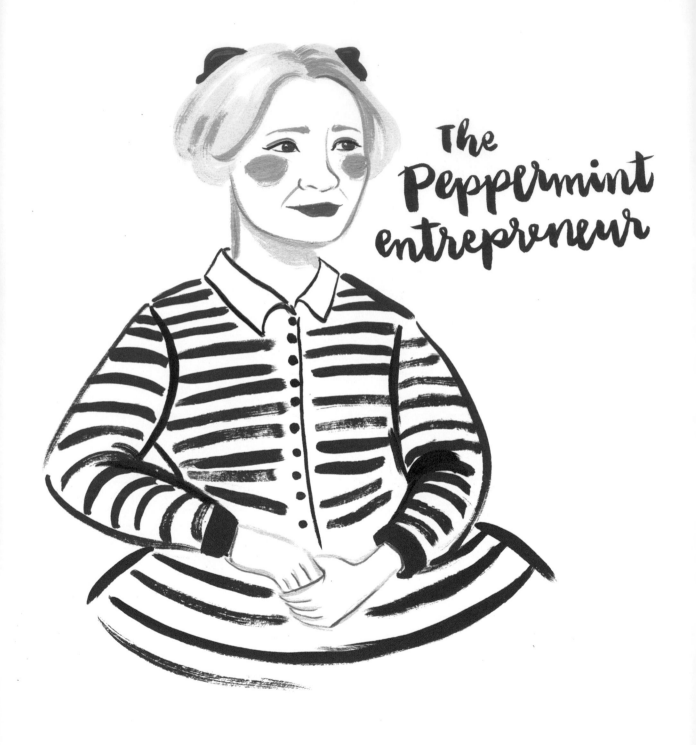

The Peppermint entrepreneur

Amalia Eriksson

Amalia Eriksson (1824–1923) was a Swedish entrepreneur who overcame great personal tragedies, including the death of her entire immediate family due to cholera when she was ten, to invent a treat that continues to be one of the most popular candies today: the peppermint stick. At the age of thirty-one, she moved to Gränna from her hometown to work as a maid. Two years later, she married and had twins; sadly, one was stillborn, and her husband died a week later. Widowed, poor, and now a single parent, Amalia applied for a permit to open a bakery and candy shop in her town. She soon became the first female entrepreneur to successfully open a business in Sweden. The story goes that in 1859, when her daughter Ida was sick with a cold, Amalia bought a bottle of peppermint oil and made her own homemade cough drops. This developed into her secret recipe for a red and white swirled candy she would call *polkagris*. The polka was a popular dance at the time, and the swirls in the candy reminded Amalia of the dance's motion; *gris* is the Swedish word for "pig," which was then slang for candy. She had great success with her new innovation, and her shop became so popular that it was visited by royalty. Eriksson died a wealthy woman at the age of ninety-nine, and the secret to her polkagris was finally passed on to other candy makers, who continue to manufacture the peppermint stick today.

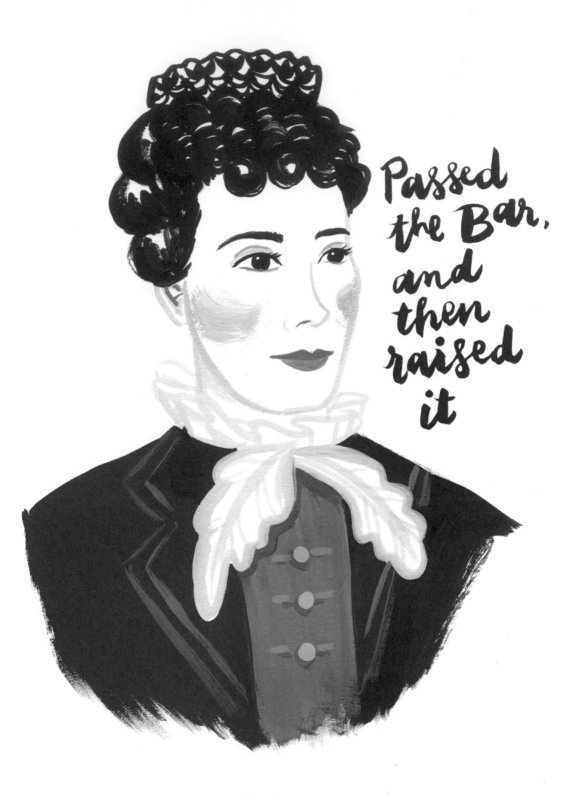

Passed the Bar, and then raised it

Belva Lockwood

Born a farmer's daughter in New York, Belva Lockwood (1830–1917) rose to prominence as the first female lawyer to argue in front of the Supreme Court. When she was widowed at twenty-two and became a single mother, she put herself through college and earned a bachelor's degree. She opened a co-ed private school—a rare institution in the 1880s—in Washington, D.C., before she turned her focus to the law. Lockwood lobbied for and helped pass an equal pay act for women in federal government. After that, at the age of forty-one, she decided to go to law school; she studied privately until she was accepted to National University Law School. After finishing her coursework, when she was denied a diploma because of her gender, she appealed directly to President Ulysses S. Grant, who helped her secure her degree. Lockwood became the second woman in D.C. to pass the bar; six years she later helped pass legislation that allowed female lawyers to appear before the Supreme Court. She became the first woman to be admitted to the Supreme Court bar and argued many cases for women and minority rights; a victory in one case awarded the Cherokee nation five million dollars. Four years after her entry into the Supreme Court bar, she raised the stakes even more by running as the first female presidential candidate with a full-fledged campaign. She had a glimmer of hope that her bid for presidency would help secure women's suffrage. Although she garnered just over four thousand votes, she had this to say: "I have not raised the dead, but I have awakened the living . . . the general effect of attempting things beyond us, even though we fail, is to enlarge and liberalize the mind."

Annie Edson Taylor

In a time when burly male daredevils were making a living by performing death-defying stunts around the world, a sixty-three-year-old woman dared to join their ranks. Annie Edson Taylor (1839–1910) made her mark in history as the first person to survive a trip over Niagara Falls—and in a barrel, no less. Widowed at a young age, Taylor wandered North America teaching music and dance while working on ideas to secure her own financial future. On her sixty-third birthday, she packed herself and her lucky heart-shaped pillow into a custom-made barrel lined with a mattress and made that renowned trip over Niagara Falls. Hundreds of bystanders stood by to watch her feat. After the event, Taylor made a short-lived splash speaking about her experience and traveling around with the barrel that had carried her safely over the falls. Her courageous act opened up the daredevil arena to female adventurers.

First person to survive a trip over Niagara Falls, at the age of sixty-three

Got consistent results

Fannie Farmer

The Fannie Farmer Cookbook has been in print since 1896 and is currently in its thirteenth edition. The namesake of the cookbook, Fannie Farmer (1857–1915), was a feisty redhead who had a stroke in her teens that paralyzed her for years, yet she became the woman who revolutionized cooking throughout the United States. At age thirty-one, when she had recovered enough to walk with a limp, Farmer attended the Boston Cooking School, which focused on science-based learning. She excelled there and was hired as principal of the school just two years after her graduation. While principal, she significantly revised the Boston Cooking School Cookbook to standardize exact measurements. Prior to her updates, recipe measurements were approximations like "amount of butter the size of an egg," and the likelihood of recipe success was disclaimed with "results may vary."

When she approached a publishing house in 1896 to publish the revised book, they made her front the money for a limited run of three thousand books. This, however, allowed her to keep the copyright. The cookbook (now known as *The Fannie Farmer Cookbook*) became a huge success, selling over four million copies in her lifetime and remaining in print to this day, well over a hundred years after the first edition. At the age of forty five, Farmer opened Miss Farmer's School of Cookery to train housewives and nurses. Through the school, she developed techniques and equipment for serving the sick and disabled. She lectured on her innovations at hospitals, women's clubs, and even Harvard Medical School. A lifelong hero·to the disabled population, Farmer had another paralytic stroke later in life, yet continued to give lectures from her wheelchair—even up to ten days before her death. That is true devotion to a mission.

Annie Oakley

"Little Sure Shot" Annie Oakley (1860–1926) was born in rural Ohio, where her father taught her to shoot small game while her sisters played with dolls. Her skilled marksmanship supported her family after her father's untimely death when she was ten. At the age of fifteen, she beat touring shooting champion Frank Butler, who was ten years her senior. He fell in love with her immediately, and they married the following year. They traveled together as a performance duo and joined the vaudeville circuit. Her specialties included splitting cards on their edges, snuffing candles, popping corks off bottles, and shooting a cigarette out of her husband's mouth.

In 1887, Oakley became the first female American international entertainment superstar when she crossed the Atlantic to join Buffalo Bill Cody's show at the American Exposition in London. She performed for Queen Victoria and Kaiser Wilhelm II—even shooting a cigarette out of the Kaiser's mouth. During World War I, Oakley offered to train a regiment of women sharpshooters, but the government ignored her. Instead, she set out to assist the war effort by performing at army camps to fund-raise for the Red Cross. Because of her impoverished upbringing, she was extremely frugal with her earnings and generous to charities.

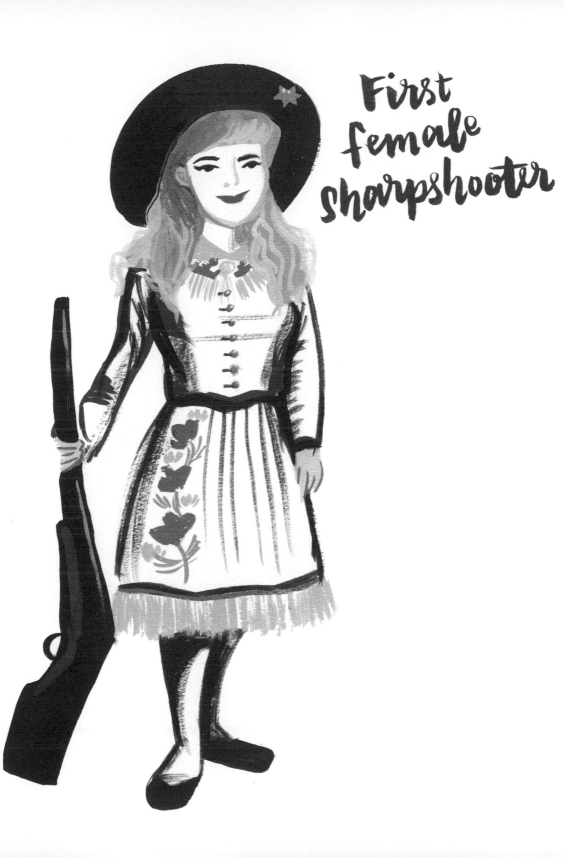

First female sharpshooter

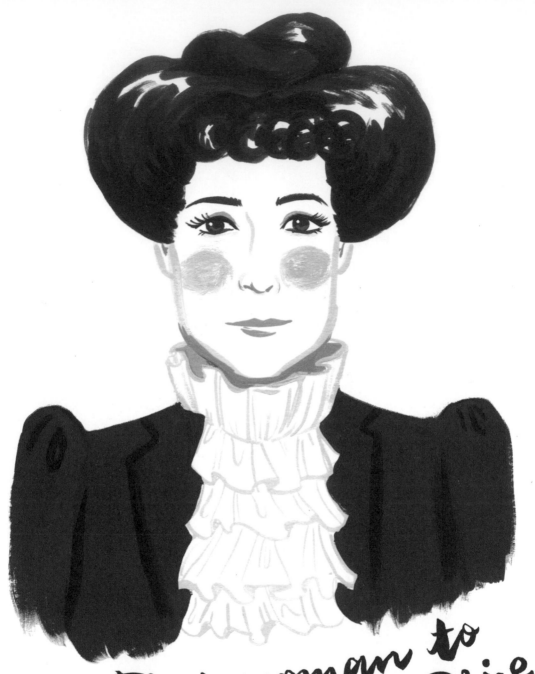

First woman to win a Pulitzer Prize

Edith Wharton

Author and interior designer Edith Wharton (1862–1937) was born into such an established, old-money New York family that legend has it the phrase "keeping up with the Joneses" originally referred to the family of her father, George Frederic Jones. Educated privately by governesses and having toured through Europe for most of her young life, Wharton resisted the traditional female roles of the time: wife and mother. She had a tenuous relationship with a controlling mother—her mom forbade her to read novels until she was married, so Edith would sneak books from her father's library. Wharton started writing poetry and fiction, including a novella, at the age of eleven. Her first published work appeared when she was fifteen, but it was printed under the name of her father's friend because her family believed that ladies' names should appear in newspapers only for birth, marriage, and death announcements.

Wharton married at twenty-three and moved to a country house in the Berkshires named The Mount. There she eschewed the traditional duties of a Victorian wife, instead designing the interior and the landscaping of the grounds, and then publishing her first book, *The Decoration of Houses*, at the age of thirty-five. With it, Wharton invented the genre of interior design books. She didn't publish her first literary novel until age forty; she went on to produce fifteen more novels, seven novellas, and eighty-five short stories in addition to books of poetry, design, travel, and literary and cultural critique. Her works, known for their dramatic irony, were nominated for the Nobel Prize in Literature three times, and at the age of fifty-eight Wharton became the first woman ever to win the Pulitzer Prize, for her novel *The Age of Innocence*. Later in her life, Wharton moved to Paris and became an ardent supporter of the French cause during World War I, earning her a Chevalier of the Legion of Honor, the country's highest award.

Nellie Bly

American journalist Nellie Bly (1864–1922) started her journalism career when she wrote a scathing letter to the editor of the *Pittsburgh Dispatch* in response to a misogynistic column called "What Girls Are Good For." The editor was so impressed with her writing that he assigned her a piece for the paper. She soon became a staff member, but rebelled against the puff pieces that women were typically given. Instead, she traveled to Mexico and made herself a foreign correspondent, reporting on the lives and customs of the Mexican people; these articles were published in her first book, *Six Months in Mexico*. Bly became a household name after she went undercover in a New York insane asylum and wrote an exposé about the inhumane conditions, entitled "Ten Days in a Mad-House." With her new-won fame, Bly persuaded her boss at the *New York World* to sponsor her on a trip around the world. She set a record for traveling around the world by completing the journey in seventy-two days, and she did it mostly alone by rail or sea. While on her journey, she visited a leper colony in China and picked up a monkey in Shanghai. Later, she married a millionaire and became an inventor, with two U.S. patents under her belt. All of this before the age of fifty-seven—talk about a go-getter!

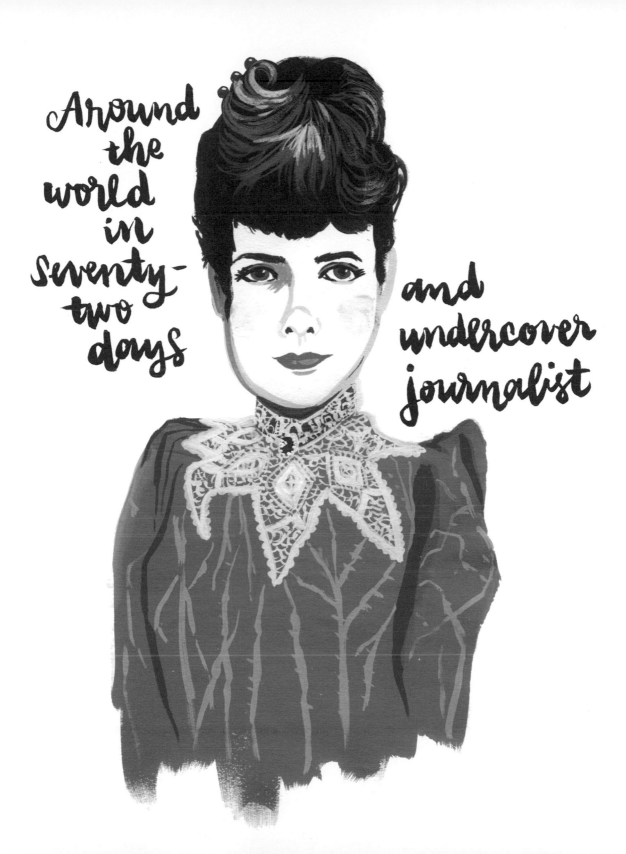

Around the world in seventy-two days

and undercover journalist

Rabbits and squirrels and mice, oh my!

Beatrix Potter

The creator of *The Tale of Peter Rabbit* and many books that followed, Beatrix Potter (1866–1943) was raised in a wealthy, creative family in Victorian England. As was traditional for the time, Potter was privately educated by governesses and exposed to a broad range of subjects in literature, science, history, and the arts. She fell in love with watercolor and nature early on, and started her artistic career with scientific illustrations. She was particularly interested in the study of fungi and mushrooms—mycology—and even went on to submit an illustrated paper with her theory on their germination to a taxonomy and natural history group, the Linnean Society.

After sending letters to her former governess and close friend's children with little stories like *The Tale of Peter Rabbit*, she was encouraged to write children's books. When Potter turned thirty-six, *The Tale of Peter Rabbit* was published and became an instant success. It's widely credited as the world's first picture book for children. Walt Disney even offered to make it into a film, but Potter refused so that she could keep the rights. Potter went on to create spin-off merchandise of her storybook characters and licensed them to her publisher long before merchandising was commonly done in publishing. Potter wrote and published over thirty-three children's stories in her lifetime, all focused on the celebration of animals and British country life. Along with her publishing work, she maintained her passion for the countryside and used her newly earned wealth to buy farms around Windermere. She became a prize-winning breeder of Herdwick sheep and a land preservationist. Upon her death, she bequeathed her estate to the National Trust, and most of her property became the Lake District National Park in England. Potter planted her own garden in life and happily opened it up to everyone to enjoy long after her death.

Madam C.J. Walker

The first child in her family born into freedom, Madam C.J. Walker (1867–1919) overcame being orphaned and widowed before the age of twenty to become America's first female self-made millionaire. Her success is even more extraordinary given that it occurred in the face of the worst Jim Crow laws of the time. As a single mother, she worked for $1.50 a day as a laundress and cook so she could send her daughter to school. Lacking access to regular bathing facilities, she started losing a great deal of hair. At the 1904 St. Louis World's Fair, she met a woman, Annie Malone, who was selling cosmetic products for African-Americans. Among the products was "The Great Wonderful Hair Grower." Madam Walker quickly became a client, and then a sales agent for Malone. A year later she relocated to Denver for family and started her own namesake hair product line. There's debate as to whether Annie Malone or Madam Walker was the first to cross the millionaire line, but there is no arguing that Walker had the advantage of being a marketing genius. She sold "The Walker System" of hair products and with them, the image of a new lifestyle and hair culture. For example, she used black women in the before-and-after photos for her product—prior to her ads, the after photos would show a white woman. Within five years, she expanded her company to include over three thousand sales agents, and her detailed training pamphlets taught them skills to develop a refined personal image. At her business conventions, she gave awards to not only the top sellers but also the saleswomen who gave the most to charity. She became the first large employer of African-American women and was a generous philanthropist during her life and after—she left two-thirds of future net profits of her estate to charity.

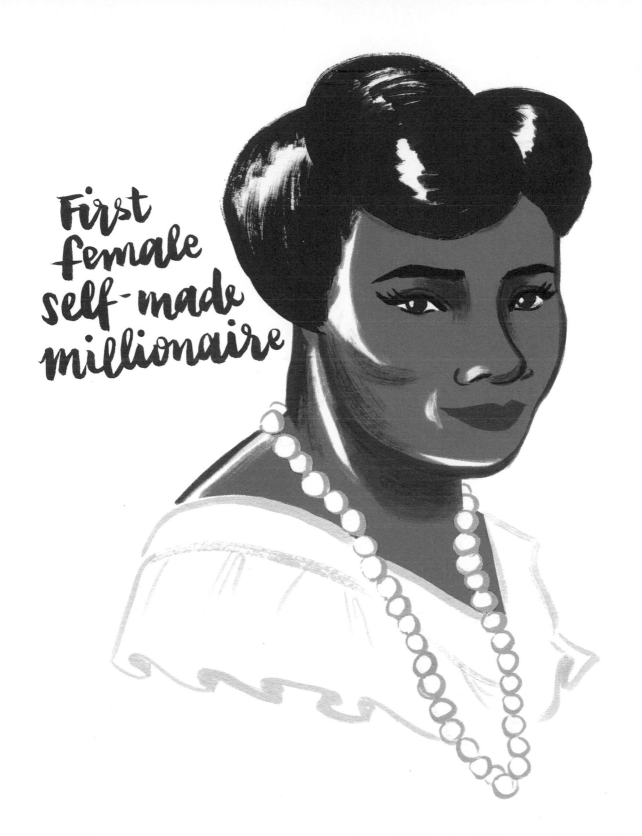

First female self-made millionaire

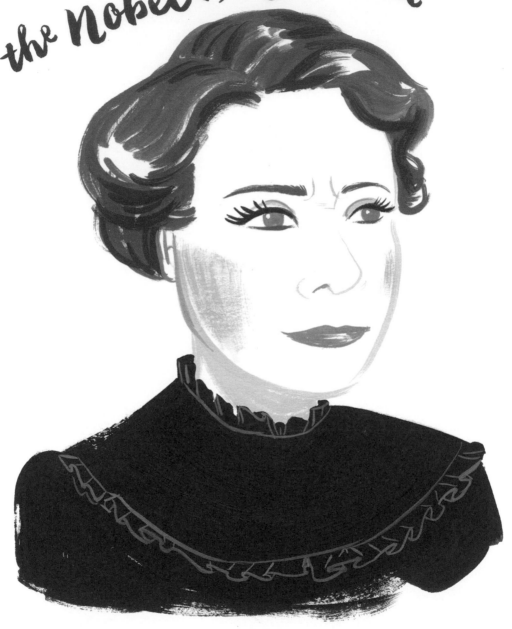

First woman to win the Nobel Prize - twice

Marie Curie

Polish physicist and chemist Marie Curie (1867–1934) was the first woman to win a Nobel Prize, and the first *person* to win it twice, in two different sciences. She started her studies in an underground "floating university" in Warsaw because Polish colleges were then men-only. Making her way to Paris, Curie earned master's degrees in physics and mathematics from the Sorbonne, all while subsisting on buttered bread and tea and tutoring at night to pay her way through school. Curie stayed in Paris after she was rejected for work at Krakow University because she was a woman. There she met her perfect match in fellow physicist Frenchman Pierre Curie, and together they furthered her work in radioactivity (a term she coined) and discovered two new elements, named polonium (after her native land) and radium. In 1903, together they won their first Nobel Prize in physics.

Tragedy struck when her husband was killed by a horse-drawn wagon in 1906. Despite her grief, she took over his teaching position at the Sorbonne and became their first female professor. In 1911, at the age of forty-four, she won her second Nobel Prize, in chemistry. When World War I broke out, Curie established the first on-site radiology centers to help surgeons in the field. She founded two Curie Institutes, in Paris and in Warsaw, which are still major medical research labs today. Curie overcame many barriers in her community to achieve history-making success, and even then still stayed grounded—Albert Einstein was quoted as saying that she was probably the only person who could not be corrupted by fame.

Alice Guy-Blaché

Alice Guy-Blaché (1873–1968) was the world's first female film director and is often credited with inventing narrative film. She began her journey in France as a secretary to Léon Gaumont, founder of the first French motion-picture company. Upon viewing the world's first film projection, invented by film-making pioneers the Lumière brothers, Guy-Blaché saw the potential for film as a medium. She asked Gaumont if she could borrow equipment to make her films on her own time. Guy-Blaché's first film, *La Fée aux Choux*, based on a French fable about a fairy growing children in a cabbage patch, was the world's first narrative film. From there, she quickly ascended to head of production at Gaumont Film Company before moving to New Jersey and forming her own pre-Hollywood independent film studio, the Solax Company, with her husband, Herbert Blaché. Over her twenty-five-year record-setting career, she directed, wrote, and produced over a thousand films, including twenty-two feature-length movies. She innovated groundbreaking techniques of acting, sound syncing systems, color tinting, special effects, and experimented with interracial casting—all as the only woman alongside the male pioneers of film.

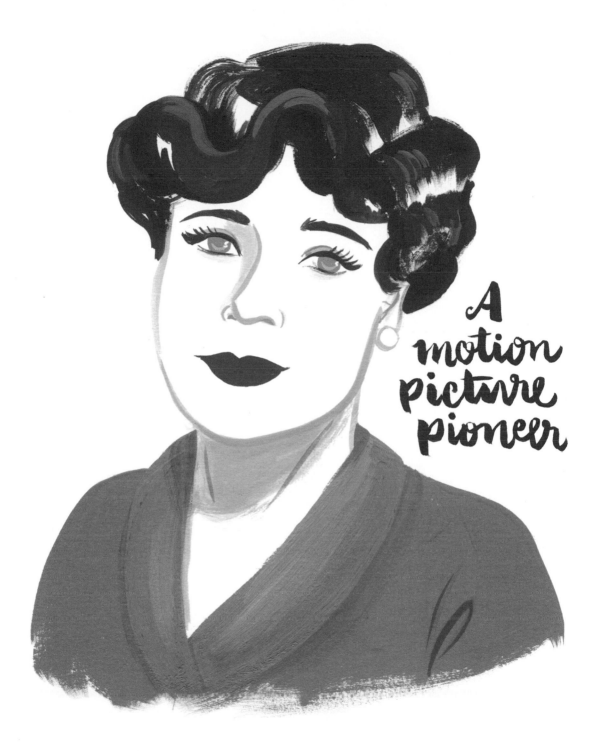

A motion picture pioneer

Mata Hari

Mata Hari (1876–1917) was born Margaretha Geertruida Zelle to Dutch parents in the Netherlands. From a young age, she knew the power of her feminine sexuality and used it to parlay her way into exotic adventures when she answered a lonely hearts ad by a Dutch captain looking for a wife. They married when she was nineteen; he was twenty-two years older than she, and she wore a bright yellow gown instead of a traditional white dress. They lived in the East Indies, where they had two kids and carried on multiple affairs with other people—leading to a bitter divorce.

When they returned to Holland, her ex-husband ran a newspaper ad warning shops not to give her credit, which left her in dire straits. So she moved to Paris and used her talents to become the world's most famous exotic dancer and courtesan. In the early 1900s, the French were obsessed with Orientalism, so she adopted the name "Mata Hari"—Indonesian for "eye of the day"—and invented an exotic origin story of being raised in the jungle. She created an East Indies–influenced striptease involving strategically placed scarves and a bejeweled bustier. She mingled with aristocracy, taking many wealthy lovers.

When World War I broke out, she still moved freely between borders because of her Dutch citizenship. Before long, however, French secret agents followed her and hired her to spy on the Germans—based on a suspicion that she was already spying for the Germans. It's possible that she worked as a double agent, with her true allegiance only to large sums of money. There was no solid evidence of her guilt (perhaps the sign of a truly skilled spy), but the French intelligence service prosecuted her anyway, and she was executed by firing squad. She wore a tailored suit and tricorn hat and refused to be bound or blindfolded as she faced the firing squad. In death, just as in life, she boldly stared down her fate.

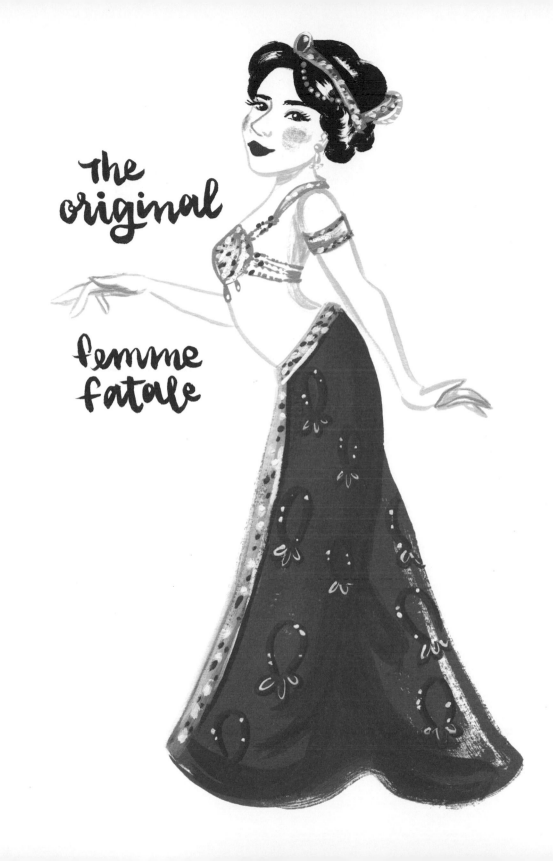

the
original

femme
fatale

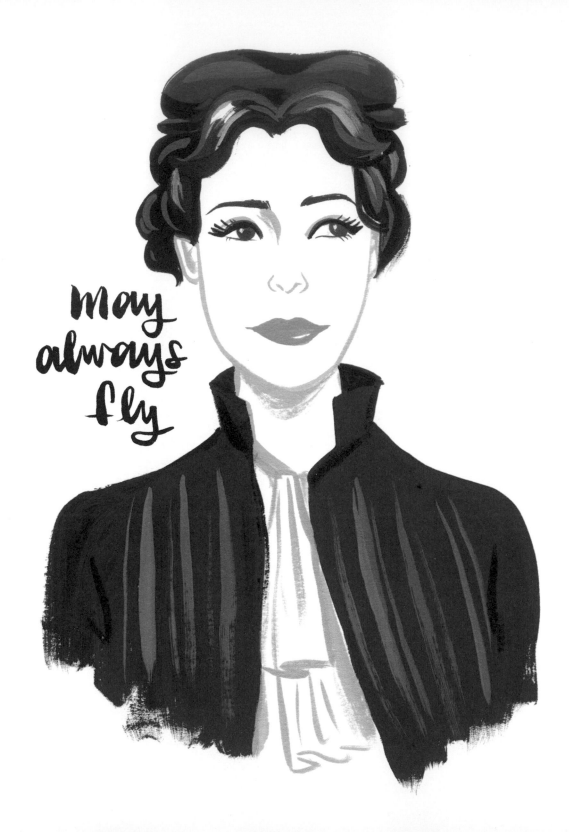

Lilian Bland

Irish journalist and aviator Lilian Bland (1878–1971) never fit the mold for females of her era—she wore trousers, smoked, practiced jiujitsu, and even swore a little. Bland had a habit of adopting unconventional careers; she began as a sports and wildlife photographer for British newspapers before she was inspired by seeing Frenchman Louis Blériot make the first flight over the English Channel in 1909. Bland became the first woman to design, build, and fly her own aircraft, the *Mayfly*. It was wryly named because Bland said it "may fly, may not fly." She tested and modified the glider herself; when she fitted the engine into the plane before receiving the fuel tank, she improvised a tank with a whiskey bottle and an ear trumpet. Her impatience and ingenuity paid off: just a year after she decided to build and fly a plane, she became the first woman to do so, in 1910. Bland flew over thirty feet, just a little short of the distance of Orville Wright's first flight in 1903. Bland continued to improve and fly the *Mayfly* until her dad, fearing for her safety, bribed her with a new car if she'd stop flying. Since she felt the aircraft had reached its limits, she decided to accept the bribe, having made her point that women could also be aviators. She then married a Canadian man and moved to Vancouver, where her pioneering spirit led her to establish new farmland in wild territory.

Margaret Sanger

The pioneer of birth control, Margaret Sanger (1879–1966) altered the course of history with her achievements. To this day, Sanger remains a controversial figure. Born into a poor family in New York, Sanger grew up with an outspoken, liberal father who rallied for equality of the sexes. Her own mother was also an inspiration for Sanger's later work—she was pregnant eighteen times, yet had only eight live births, and she was ill with tuberculosis for most of her life. Sanger saw the inability of families to control their reproductive destinies as a direct cause of keeping poor families poor.

When Sanger later became a labor and delivery nurse, she often cared for women who asked her how to prevent another pregnancy. In the late nineteenth century, the topic of reproduction was so taboo that the Comstock Law was passed, prohibiting dissemination of any contraceptive information on the grounds of obscenity, even between doctors and patients. To help women, Sanger started a column in a monthly magazine, *The Call*, entitled "What Every Girl Should Know," discussing basic female public health issues. After a month of publication, the column was banned by the censors. This spurred Sanger to start her own magazine, *The Woman Rebel*, which got her arrested.

In 1916, Sanger opened the first birth control clinic in New York, which led to another arrest and conviction. The judge in her case stated that women do not have "the right to copulate with a feeling of security that there will be no resulting conception." Subsequent appeals resulted in a landmark 1918 trial in which a judge finally ruled to allow doctors to prescribe contraception. The publicity of these trials garnered a groundswell of public support for Sanger, propelling her into her next project: the American Birth Control League, which would evolve into the Planned Parenthood Federation of America. She was openly against abortion her entire life, opting to instead educate people about available contraceptive options so they could take control of their own futures.

Gave the world vision

Helen Keller

Born into an affluent Southern family in Alabama, Helen Keller (1880–1968) contracted an illness as a baby that rendered her deafblind. Through a series of fortunate meetings, her parents secured her a governess named Anne Sullivan, who would turn Keller's life around. Sullivan was also visually impaired and had attended the Perkins Institution for the Blind in Boston, where she also trained as a teacher. Her no-nonsense approach and patience with teaching Keller forged a forty-nine-year-long relationship that ultimately changed the world. Keller went from a wild and unruly child to becoming the first deafblind person to earn a bachelor's degree. After working on learning to speak for twenty-five years, Keller became a prolific author and professional speaker. She published over twelve books in her lifetime, including autobiographies that continue to inspire readers to this day. Keller advocated tirelessly for people with disabilities and for socialist causes like women's suffrage, pacifism, and birth control, even though her socialist leanings garnered harsh criticisms, with some suggesting that her disabilities limited her perspective. Her influence was broad—Keller was one of the cofounders of the American Civil Liberties Union (ACLU), and she introduced the Akita dog breed to America when she was gifted one by the Japanese government. Her miraculous life gave vision to the rest of the world.

Eleanor Roosevelt

There's not a lot that Eleanor Roosevelt (1884–1962) didn't do in her thirty-three active years in public service, and for that we love her. She overcame a dark personal life—both her parents passed away before she was nine, and her husband, President Franklin D. Roosevelt, had a longtime affair with her personal secretary—to triumph as one of the most influential female figures of the twentieth century.

Roosevelt was the longest-serving First Lady, given that FDR was elected president four times before the two-term limit was passed. Together they brought America through the Depression with the New Deal, and then through World War II with the Allies. In between, Roosevelt became an active public figure herself, expanding a role that had been largely relegated to hostessing and picking out china. With the support of her husband, Roosevelt was the first First Lady to give public press conferences and speak at a national party convention. She was a strong advocate for women's rights and women in the workforce; for example, she permitted only female reporters to attend her press conferences, which forced publications to keep female journalists on staff.

Roosevelt was also a vocal advocate for the civil rights movement. She lobbied for a bill that made lynching a federal crime, and she flew with the Tuskegee Airmen, bringing nationwide attention to their cause of training black combat pilots. After the attack on Pearl Harbor, Roosevelt spoke publicly against anti-Japanese hysteria and privately opposed her husband's executive order of internment camps. She served as the first chairperson of the UN Commission on Human Rights. After her husband's death, she continued to work as a leader in human rights issues. She was so beloved that there was widespread support in the Democratic party for her to run for president, but she quickly shuttered the idea.

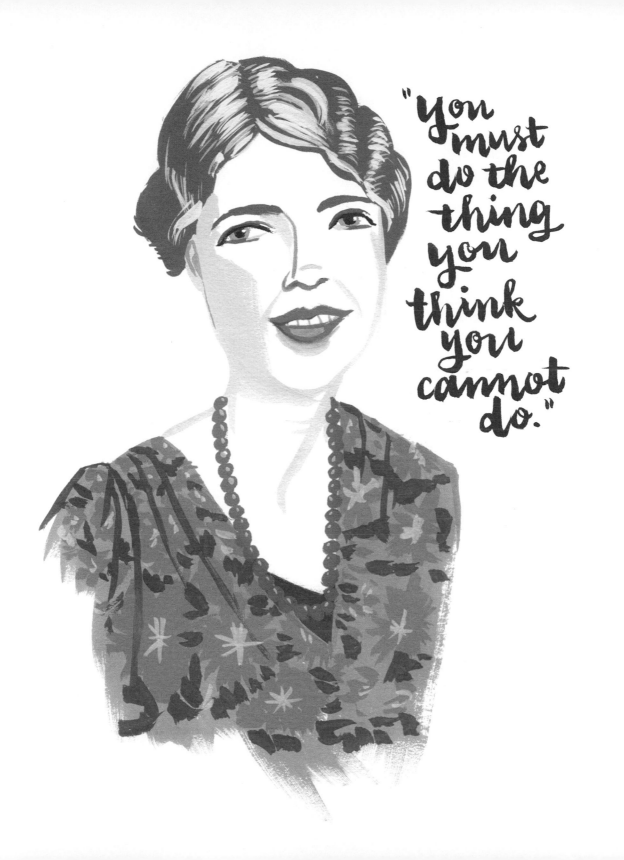

"You must do the thing you think you cannot do."

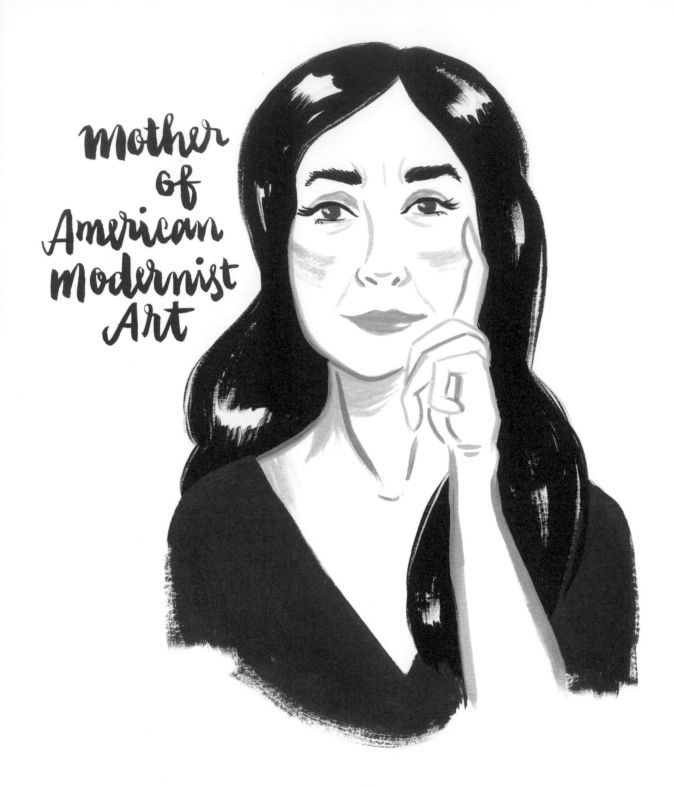

Mother of American Modernist Art

Georgia O'Keeffe

Georgia O'Keeffe (1887–1986) was one of the most influential artists in the United States, ushering in a new movement of American modernism with her abstract paintings. Educated as an artist, O'Keeffe gave it up for a while after college because she was exhausted by the strict formalism of academic painting. Five years later, she took a summer class with Arthur Wesley Dow, who taught painting as expression instead of merely copying what you see, and her work was revolutionized. She started with charcoal abstractions while working as an art teacher and her work took off when she was introduced to influential New York photographer and gallery owner Alfred Stieglitz. In 1916, Stieglitz began exhibiting her work, and she officially arrived on the art scene. Stieglitz and O'Keeffe became lovers, though he was twenty-three years her senior and still married (once his divorce was final, they got married). She evolved her abstract work to representational close-ups of nature, an approach interpreted by feminists as celebrations of female iconography. Even though O'Keeffe denied that she was painting female genitalia, her work still stands alone as the first fine art to depict imagery that invites that interpretation. By the mid 1920s, O'Keeffe was selling her artwork for the highest price ever paid to a living artist.

She had a nervous breakdown in the early '30s, propelling her to leave New York for the Southwest and a different pace of life (although she stayed married to Stieglitz, who remained in New York until his death in 1946). After buying a ranch in New Mexico, she began to thrive again, painting a large body of work representing the landscape of the desert. In the 1940s she had two retrospectives of her work, including the first retrospective for a female artist at the Whitney Museum of American Art. In 1977 she was awarded the highest honor for American civilians, the Presidential Medal of Freedom, by President Ford.

Elsa Schiaparelli

A pussy bow-tie collar knit into the sweater pattern. Cardigans with candlestick-shaped buttons. Gloves with painted red fingernails. A dress featuring a Salvador Dalí–painted lobster, garnished elegantly with sprigs of parsley. These seemingly modern clothes were actually the brainchildren of fashion designer Elsa Schiaparelli (1890–1973). Born to wealthy Italian parents, Schiaparelli escaped to America at an early age instead of marrying the wealthy Russian suitor her family had lined up for her. In the United States, she married a vaudeville charlatan who posed as a doctor and practiced fortune-telling and get-rich-quick schemes. After her husband left her and their infant daughter (nicknamed "Gogo"), Schiaparelli went to Paris and took up with the Surrealist and Dadaist social circle.

Never one to rely solely on her parents' money, Schiaparelli got a job assisting Man Ray with his Dada magazine *Société Anonyme* and was mentored by famed couturier Paul Poiret. She began making her own clothes with Poiret's technique of draping directly on the figure, since she had no formal fashion training. In 1927, she launched a collection of knitwear that applied a trompe l'oeil (illusion of reality; literally "trick of the eye") to clothing for the first time. Her line thrived in the era between the two world wars, when individuality was celebrated, and her innovative designs changed the course of fashion for women. She invented the wrap dress, the divided skirt (forerunner to shorts), swimsuits with built-in bras, and an evening dress with a matching jacket (which became very popular as the "speakeasy dress" during the U.S. Prohibition era). After World War II ended and Christian Dior's "New Look" swung the fashion pendulum back to conformity, Schiaparelli's business closed, but her influence endures—in 2013, her brand was revived as an haute couture house by Italian fashion magnate Diego Della Valle.

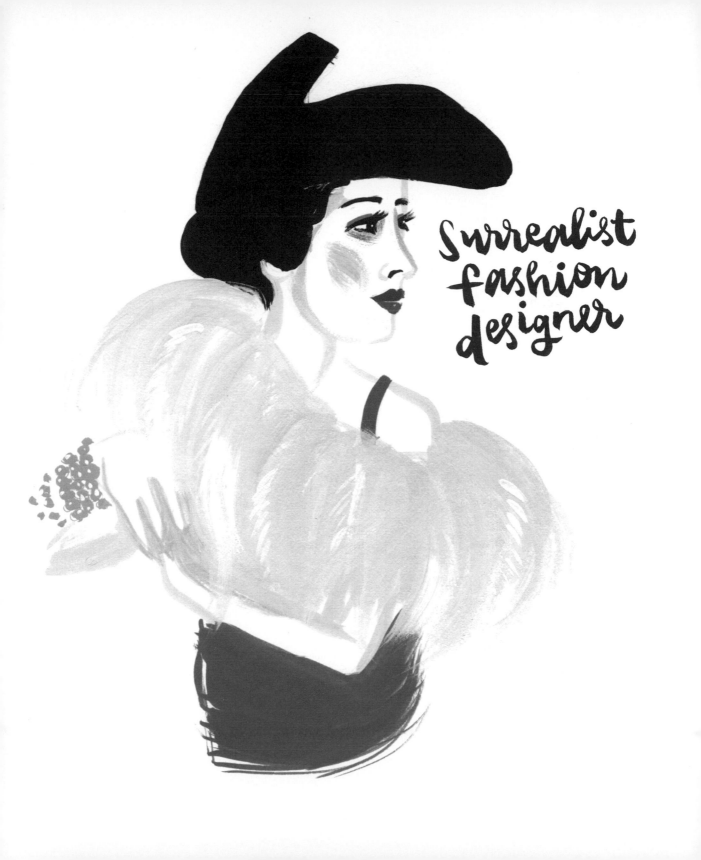

surrealist
fashion
designer

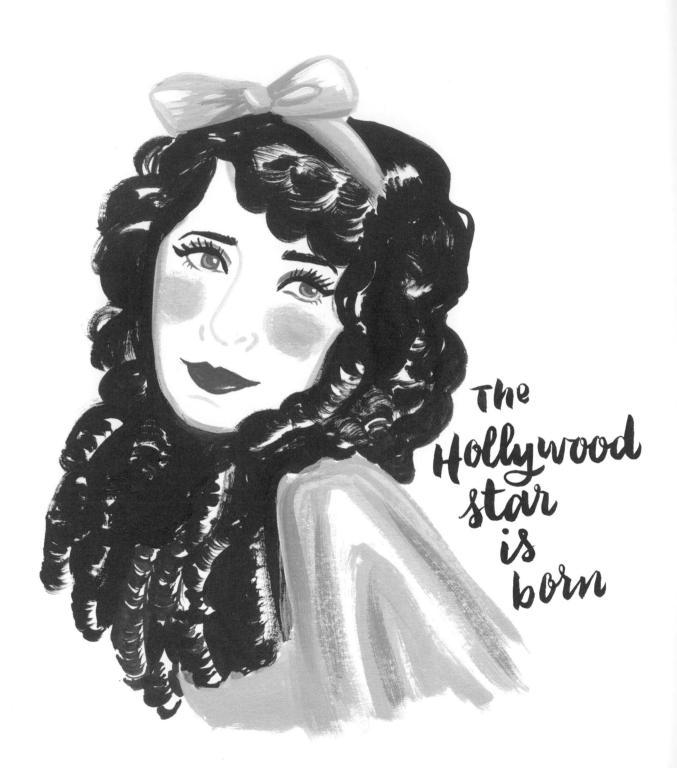

The Hollywood star is born

Mary Pickford

There were no movie stars in Hollywood before Mary Pickford (ca. 1892–1979) came along and became one. Born in Canada and raised as a child stage actor, Pickford and her family moved to Manhattan so she could make it on Broadway. After her last play closed in 1909, Pickford decided to try out the motion pictures and landed a small part with D. W. Griffith's short-film company Biograph. Exhibiting a phenomenally dedicated work ethic, Pickford acted in fifty-one short films during her first year with Biograph. She created the virtuous yet sassy girl-next-door archetype that would make her a household name.

Before she came along, there were no actor credits in films for fear of inflating egos and salaries. Pickford knew her value, though, and made sure those credits appeared—and in the process, invented the Hollywood star. She studio jumped, each time getting a substantial pay raise equal to the highest-paid male star's, until she became the first actor in history to become a millionaire. Then Pickford pulled the ultimate power play: she formed her own studio, United Artists, with her husband, Douglas Fairbanks, and their best friends, Charlie Chaplin and D. W. Griffith. As America's first movie sweetheart, Pickford was savvy enough to leave her name off the executive producer and director credits in order to play to the public's perception of her as a sweet, innocent young girl, but industry insiders knew that she called all the shots.

Pickford won her first Academy Award in her first talkie, *Coquette*. She also used her star power for philanthropy, selling eighteen billion dollars in Liberty Bonds during World War I, cofounding the Motion Picture Relief Fund, and establishing a foundation that still supports the preservation of film and provides scholarships for education today. She essentially invented star power.

Mae West

Before Marilyn and Madonna, there was Mae West (1893–1980). The first iconic sex symbol of Hollywood, West was an American actor, singer, playwright, and screenwriter whose career spanned seven decades. She was known for her signature wiggle walk and writing all of her own lines, particularly her memorable double entendres.

With a start in vaudeville, West made a name for herself by writing and starring in her own plays—the first, in 1926, was entitled *Sex*. Enforcing a moral code in entertainment was big in that era, and she served time for corrupting the morals of youth—a theme that would follow her for her entire career. She continued to write racy comedic plays that touched on subjects of pleasure and sexuality, including her 1928 play *Diamond Lil;* it became a Broadway hit, and she took that luxury-loving persona all the way to Hollywood.

West got her first studio contract from Paramount Pictures at the age of forty—and became a silver screen icon shortly after. Her starring roles in *She Done Him Wrong* and *I'm No Angel* were rumored to have saved Paramount from bankruptcy and made her the second-highest-paid person in the United States at the time (just after William Randolph Hearst).

West was a longtime advocate for equality for all people; when one of her boyfriends, boxing champion Gorilla Jones, was denied entry to her apartment building because of segregation, she bought the building and lifted the ban. In the 1950s, she performed in her own Las Vegas stage show, surrounded by bodybuilders. One of those muscle men, Paul Novak, thirty years her junior, became her longtime companion until her death.

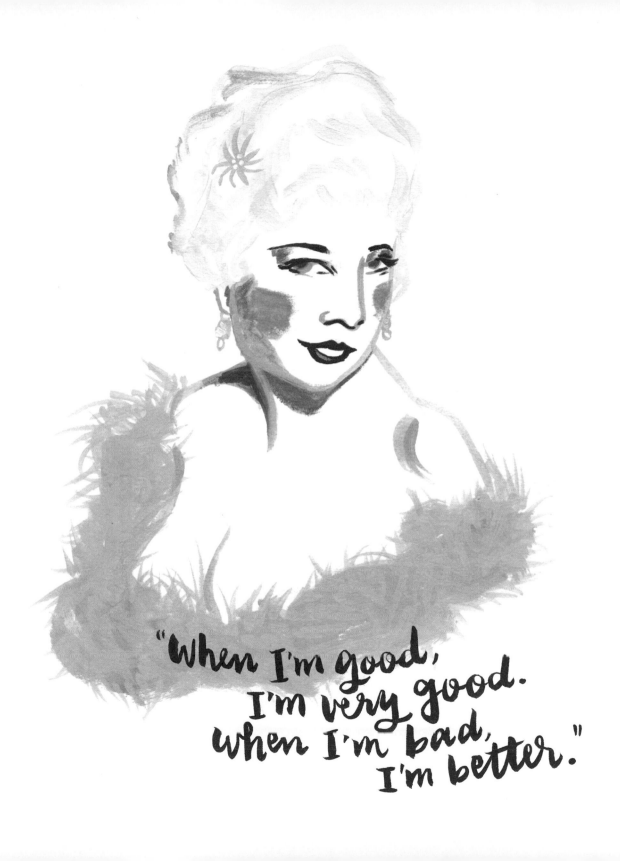

Martha Graham

The most influential dancer of the twentieth century, Martha Graham (1894–1991) almost didn't become one. Her parents were strict Presbyterians who didn't support her studying dance; it was only after her father passed away that she enrolled at the innovative Denishawn School of Dancing and Related Arts in Los Angeles. At the age of twenty-two she opened her own studio in Manhattan, the Martha Graham Center of Contemporary Dance. She choreographed and debuted her first independent concert that same year. Graham's style ushered in a new era of dance, creating a method dubbed "the Graham technique," which taught dancers to magnify expressive and dramatic motions with their bodies.

Teaching and dancing for over sixty years, Graham choreographed nearly a hundred dances, and her influence was international. She was the first dancer to perform at the White House; she received the Presidential Medal of Freedom, the Key to the City of Paris, and Japan's Imperial Order of the Precious Crown. Graham was so in love with dance that she last performed at the age of seventy-six. Her devotion to education inspired students like Alvin Ailey and Twyla Tharp, who would build on her legacy. With her unique talent for expressing emotion through her body, Graham changed the direction of dance forever.

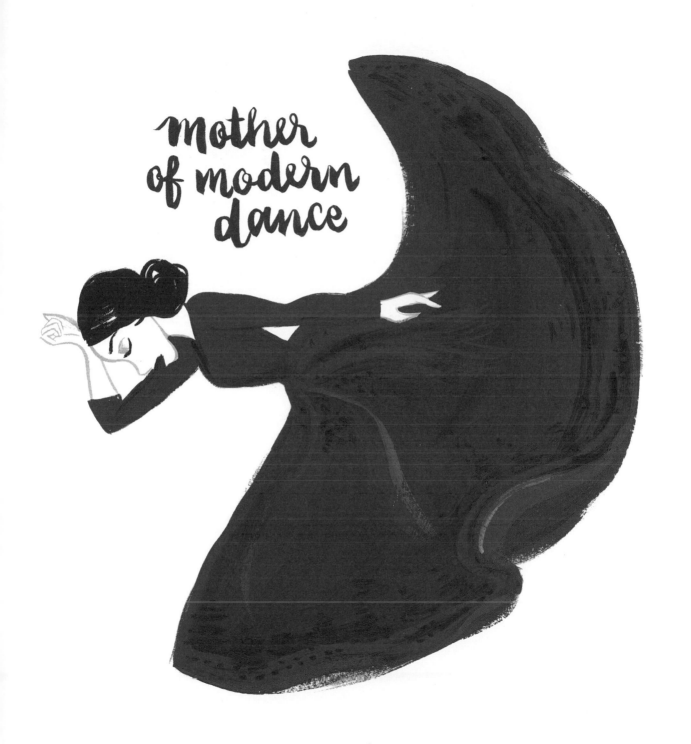

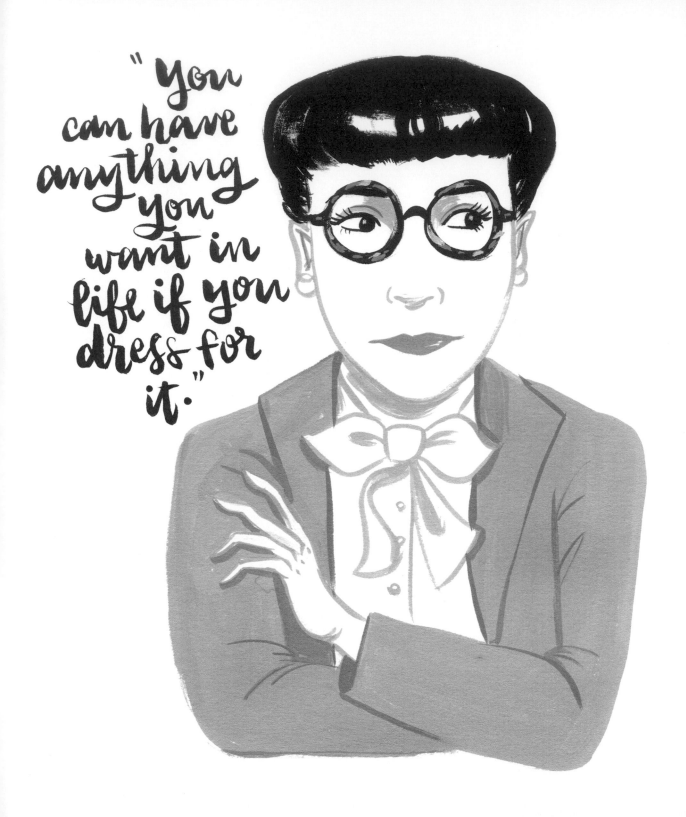

Edith Head

The most legendary costume designer in Hollywood, Edith Head (1897–1981) actually lied her way into her first sketch artist position at Paramount Studios. With a bachelor's from Berkeley and a master's in romance languages from Stanford, Head was working as a French teacher and taking night classes at Chouinard Art Institute (now CalArts) so she could teach art classes to make more money. In 1923, she climbed the first rung of the designer ladder—with a portfolio of other students' sketches, she would later admit. Two decades after that, Head became the chief designer at Paramount at forty-one, and she stayed for twenty-nine years before leaving for Universal. During that time, she dressed almost every actor of the Hollywood golden age, working on over 1,100 films and earning thirty-five Oscar nominations for her costuming work. She won eight Oscars and still holds the record for most awards won by a female. Some of the most famous and iconic films she designed for include *All About Eve*, *Roman Holiday*, *Sabrina*, *Funny Face*, *To Catch a Thief*, *Rear Window*, *The Birds*, and *The Ten Commandments*. Head was known for a low-key working style and consulting extensively with her female stars, which was not a common practice among her nearly all-male contemporaries. This made her a favorite among the leading ladies, and they often requested her for their films. She also left her legendary wit behind in several books, most amusingly in *The Dress Doctor: Prescriptions for Style, From A to Z.*

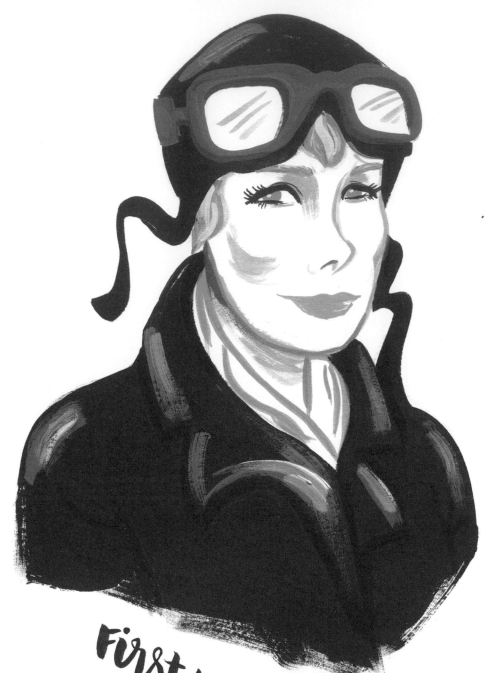

First woman to fly solo across the Atlantic

Amelia Earhart

Few trailblazers capture the imagination like Amelia Earhart (1897–1937), a world-famous pilot who broke records weekly and led a group of revolutionary female aviators. After a nomadic childhood in the United States with her family, Earhart found her calling at the age of twenty when she took a ten-minute ride in a plane at an air circus. It cost her father ten dollars and started her legendary career. She worked odd jobs until she saved up one thousand dollars for flying lessons from Neta Snook—the first woman graduate of the Curtiss School of Aviation. Earhart was the sixteenth woman to be issued a pilot's license. A year after her first lesson, she set her first record for highest women's altitude flight in her first plane, the *Canary*. She would go on to set many more records, including first solo female transatlantic flight in 1932.

But before that, she made a name for herself as the first female flight logger to make a transatlantic flight, with pilot Wilmer Stultz and copilot/mechanic Louis Gordon. Her records from that flight became her first published work—*20 Hrs., 40 Min.*—and made her a star. She became the face of many promotional campaigns, including one for the Transcontinental Air Transport in which she endorsed the then-fledgling commercial air industry. Earhart also directed her celebrity status toward creating professional opportunities for women in the aviation industry. She formed and served as president of The Ninety-Nines, an organization of female pilots, and she became a visiting faculty member at Purdue University to mentor young female aviation students. When she married George Putnam, the publicist who brought her into her name making transatlantic flight, she had a letter delivered to him on their wedding day, stating her terms for their marriage and demanding to retain their status as equal partners. She refused to change her name, even at the *New York Times'* insistence on the proper etiquette format. Earhart's life ended too soon when she vanished during an attempted record-making flight around the world in 1937. Her mysterious disappearance only cemented her legend.

Tallulah Bankhead

The flamboyant, divine Tallulah Bankhead (1902–1968) made a name for herself in Hollywood circles as a wild party girl with a ravenous sexual appetite and a penchant for sharp one-liners. An American actor who became a star on the stages of London, Bankhead returned to Hollywood to make films despite not having a taste for the slow pace of filmmaking. She was publicly outspoken about her sexuality, even claiming that she only came to Hollywood to "f*ck that divine Gary Cooper." (She later did work with Cooper on *Devil and the Deep*). But there was more to her than partying and pleasure; she gave generously to children's hospitals in the United States and Britain and spoke tirelessly for Finnish refugees during World War II. She wrote a pamphlet, *Human Suffering Has Nothing to Do with Creed, Race, or Politics*, and read it on the radio to fifty million people.

Bankhead's exuberant personality garnered her enough attention to make her a fixture on television up to the end of her life. In 1950, NBC Radio gave Tallulah a variety show to host, where she shone with her trademark wit and playful put-down banter with her famous friends (and some foes). One of her last public performances was on the 1967 series *Batman*, in which she portrayed the Black Widow. When TV producer Bill Dozier approached her for the cameo and mentioned that it would need to be campy, she reportedly replied, "Don't talk to me about camp, dahling; I invented it!" It's also rumored that the classic Disney villain Cruella de Vil was based on Tallulah Bankhead.

Played the wild and free single girl

Norma Shearer

Canadian-born Norma Shearer (1902–1983) used her sheer determination and charm to overcome the fact that she didn't fit the Hollywood ideal of beauty to become one of the leading ladies at MGM in the 1930s. Before that, she emerged from a riches-to-rags childhood with fearless courage to pursue her acting dreams, even when faced with years of bit parts, small ads, and being called a dog by Florenz Ziegfeld after she met him for a role in his Ziegfeld Follies. Shearer finally got a ticket to Hollywood in 1923 when her role in a B movie caught Louis B. Mayer's attention and landed her a contract. In two years, she went from being a contract player to one of MGM's biggest stars, often playing the role of a spunky, sexually liberated ingenue. Shearer was the first American actress to make it socially acceptable to portray a single girl who was not a virgin on screen.

Exceptionally savvy with her career, Shearer was tireless in her work commitment: she practiced her best angles in front of the mirror, worked with an eye doctor to uncross her eyes, and trained her voice for two years to get it ready for the talkies. And it *was* ready—her first talkie was a huge success and set the bar for actresses who followed. She was one of the few actors who transitioned seamlessly from silent films to talkies. Shearer took boudoir photos to convince her studio VP husband that she could be cast as the sensual lead in *The Divorcee*, a role that led to her first Oscar win. When the 1930 Motion Picture Production Code (a guideline of industry moral standards that were enforced by the Motion Picture Association of America) came into effect, she evolved again, becoming a serious actress who took on heavy-hitting roles in period dramas. Over the course of her twenty-three-year career, she was nominated for eight Oscars.

Anaïs Nin

Possibly the most frank female author in history, Anaïs Nin (1903–1977) was a prolific writer who lived a salacious life and recorded all of it in a diary that, even expurgated, ran to seven published volumes. Born to Cuban parents in France, Nin spent most of her life in the United States. She married a banker-turned-artist, Hugh Parker Guiler, and moved to Paris with him for a few formative years. There she lived a bohemian lifestyle and developed many friendships with men, often taking them as lovers—including psychotherapist Otto Rank and author Henry Miller.

In the 1940s, she moved to New York City and began writing erotica with Miller and fellow author friends for an anonymous collector who paid them a dollar a page. Nin's works of erotica later became a breakthrough for female sexuality by representing the feminine perspective for the first time in the genre. These writings were published posthumously in two collections: *Delta of Venus* and *Little Birds*. Nin took on a second husband, Rupert Pole, in a marriage that she had to annul in 1966 because she was technically still married to Guiler. She continued her bicoastal bigamy, though, remaining with Pole in California for the rest of her life.

Though Nin was a fixture on the literary scene, she didn't find success with her own writing until she was sixty-three and *The Diary of Anaïs Nin* was published by Harcourt Brace. Soon after, she was the toast of the feminist scene, traveling around the United States to give lectures on her writing that covered her experiences with illegal abortion, multiple love affairs with famous men, and examination of the female self in contemporary culture.

"Life shrinks or expands in proportion to one's courage."

Diana Vreeland

The fabulous and flamboyant Diana Vreeland (1903–1989) was a genius fashion editor who became an American fashion icon herself. Raised in a wealthy family that spent a lot of time abroad, Vreeland returned from a stint in Paris in 1936 and was offered a job at *Harper's Bazaar*. She started writing a column called "Why Don't You?" that encouraged people to step outside of their norm and embrace their own ingenuity. Suggestions included "Why don't you . . . paint a map of the world on all four walls of your boys' nursery so they won't grow up with a provincial point of view?" Vreeland had a tenuous relationship with her mother, which made her look outward for role models—when she couldn't find any, she decided she would *be* that role model. When she became fashion editor at *Bazaar*, she reinvented the entire position—she chose the clothes and models and oversaw the photography. Prior to her tenure, the job was basically a society lady's pet project.

A visionary eccentric at heart, Vreeland had her Park Avenue apartment decorated completely in red, claiming that she wanted the place to "look like a garden, but a garden in hell." In 1962, after being passed over for a promotion, she left *Bazaar* for *Vogue*, where she was instated as editor-in-chief. Using her influence, she discovered and launched the careers of many fashion photographers and models, including Richard Avedon, Edie Sedgwick, and Ali MacGraw. Vreeland truly lived a one-of-a-kind life that is a model for marching to the beat of your own drum for generations to come.

Anna May Wong

Born in Los Angeles, Anna May Wong (1905–1961) was a third-generation Chinese-American actress who became the first internationally renowned Asian star, appearing in over sixty films. As a child, Wong often ditched school to visit Hollywood film sets and ask for bit parts. Without her parents' knowledge, Wong landed her first extra role at age fourteen, then her first screen credit at sixteen alongside Lon Chaney in *Bits of Life*. From there, she blazed into Hollywood, appearing in one of the first Technicolor films, *The Toll of the Sea*, and becoming a bona fide star in Douglas Fairbanks's *The Thief of Bagdad*.

Even as Wong's star burned brighter, Hollywood didn't know what to do with an Asian-American actress. She was often relegated to stereotypical roles of Dragon Lady or submissive Butterfly, and she was limited in her choice of leading lady roles because the Hays Code had censored interracial relationships. Wong grew tired of fighting the system for positive roles; she was especially battle-scarred after being denied the leading Chinese role in *The Good Earth*, losing out to an all-white cast and instead being offered an offensive role as the only deceitful character in the movie, which she declined.

Wong finished her contract with Paramount Pictures with a string of B movies that actually gave her the freedom to portray nonstereotypical Asian-American roles, including *Java Heart*, in which her character kissed the lead white male character. Then she moved to Europe and grew her film career, toured China to learn about opera but was rejected for being "too American," and rallied in support of China's struggle against Japan during World War II. In the 1950s, Wong starred in a television series written for her, *The Gallery of Madame Liu-Tsong*; it was the first U.S. show starring an Asian-American lead. Though her struggles in a career that spanned the Roaring Twenties and World War II are eerily similar to what many Asian-American entertainers still face today, Wong opened the door just a little bit wider for everyone who came after her.

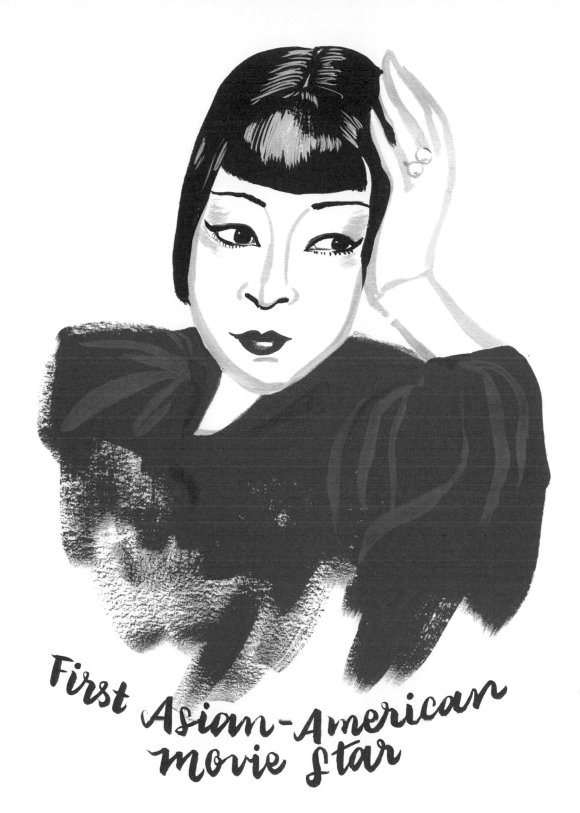

First Asian-American movie star

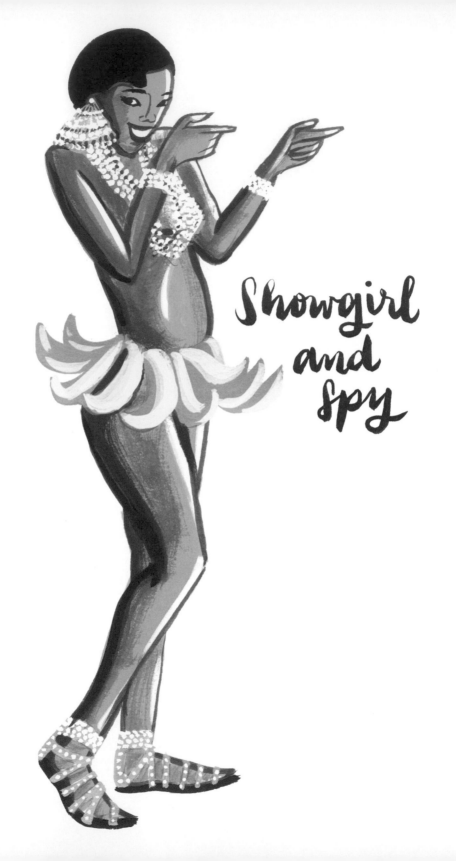

Showgirl and Spy

Josephine Baker

Black Pearl. Bronze Venus. Creole Goddess. These are just some of the names that showgirl, activist, and spy Josephine Baker (1906–1975) was given in her life. Born into poverty in St. Louis, Baker was on her own at thirteen and danced her way onto the chorus lines of Broadway, quickly followed by the Paris revues. She had a pet cheetah named Chiquita who wore a diamond collar and paraded around the stage during her acts. France loved Josephine Baker, and she became a huge star on the stage and screen. Her influence in Europe was so big that the French government asked her to work as a spy for the Allies during World War II—just by socializing as she did at high-level parties with German, Italian, and Japanese officials. She carried secret notes written in invisible ink on her music sheets as she freely toured across borders.

When she returned to America for a performance at a New York club, she was enraged by the segregation laws still in place. She became a civil rights leader and marched alongside Martin Luther King, Jr., in the March on Washington. She was the only official female speaker that day. After King was assassinated, his widow, Coretta Scott King, asked Baker to lead the movement— but Baker declined, stating that her children were too young to lose their mother. To fulfill her dream of showing the world that people of different ethnicities and religions can live in peace, Baker adopted twelve children from different countries, forming a family she would come to call her "rainbow tribe," and raised them in her French castle, Château des Milandes.

Rachel Carson

Rachel Carson (1907–1964) was an American marine biologist, conservationist, and writer best known for her seminally influential book, *Silent Spring*. Raised in rural Pennsylvania, Carson became a published writer at the age of eleven, with her work appearing in the children's magazine *St. Nicholas* (she was in good company; future famous writers printed there included F. Scott Fitzgerald, E. E. Cummings, and E. B. White). She was the second woman to be hired into the U.S. Bureau of Fisheries. Because she wasn't paid enough for this job, she pursued additional freelance work that led to the publication of her first two books: *Under the Sea Wind* and *The Sea Around Us*. These books garnered her multiple accolades and scientific credibility, which gave her the confidence to research the damaging effects of synthetic pesticides in widespread use after their creation by the military during World War II. The results of her research were detailed in *Silent Spring*.

Despite family tragedies and personal health complications, Carson published *Silent Spring* in 1962 to much fanfare. Her critics, largely chemical manufacturing companies, decried her research by putting their own scientists on TV and attacking her personally, calling her a spinster and a communist. Nothing was more threatening than an educated professional woman in this post–World War II society, which had demanded that all Rosie the Riveters return to the kitchen. Despite the harsh critical campaign against her, Carson was supported by the U.S. government and the larger scientific community. The Environmental Protection Agency was formed in 1970 as a direct result of the calls in *Silent Spring*, and in 2012 the book was designated a National Historic Chemical Landmark by the American Chemical Society.

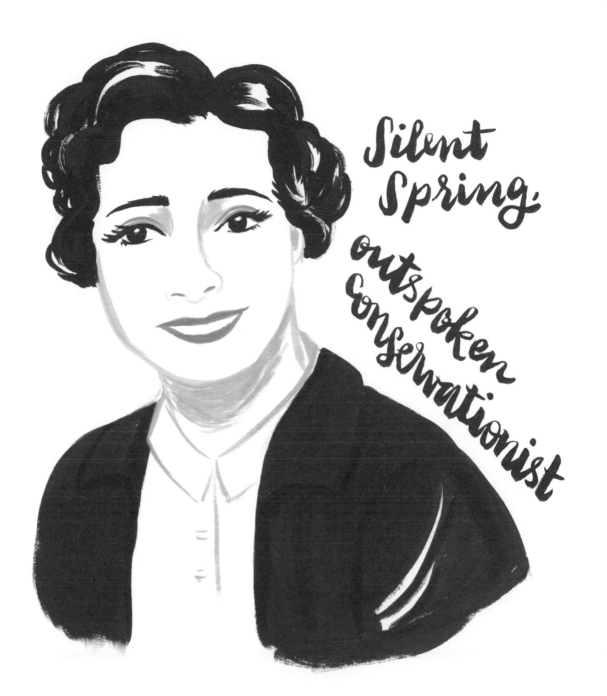

Silent Spring, outspoken conservationist

Carmen Miranda

Carmen Miranda (1909–1955) was born into a deeply Catholic family that moved from Portugal to Brazil when she was a young child. Though her mother supported Miranda's pursuit of a performance career, Miranda was beaten by her strict father after he found out she had auditioned to be on a radio show. She persisted and was soon discovered by a music producer, which led to her making records and films and becoming a Brazilian star. After six years of success in Brazil, Miranda was discovered by Lee Shubert, who brought her to New York to star in his Broadway musical *The Streets of Paris*. She refused to go without her band, wanting to maintain the integrity of the Brazilian sound. Brazil's President Vargas took advantage of that opportunity to pay the band's way to America, thereby turning Miranda into an ambassador for Brazil.

In 1939, Miranda developed her signature look of a flowing dress and fruit-and-flower turban, modeled after the style of the poor black girls from Bahia. She discovered the costume after appearing in a film in which she sang a song about empowering the lower social class of Afro-Brazilians. When she arrived in the United States that same year, Miranda and her costume became the symbol for all of South America. The Americans drank up her exuberant personality, exotic dance moves, and rapid speech. She was quickly signed by 20th Century Fox and became an international star, making over fourteen films and bringing the rhythm of samba to Technicolor life. Miranda was the first Latin woman to imprint her hands in front of Mann's Chinese Theater and became the highest-paid woman in the United States in 1949. Unfortunately, the more she was loved by America, the more she was criticized by Brazil for becoming too "Americanized," representing a stereotype of a Latina bimbo. Ever the showwoman, Miranda worked right up to her dying day: a recorded appearance on a 1955 episode of *The Jimmy Durante Show* shows her kneeling down unexpectedly, then jumping back up to finish her dance number. Durante said she reported being out of breath. She died later that night.

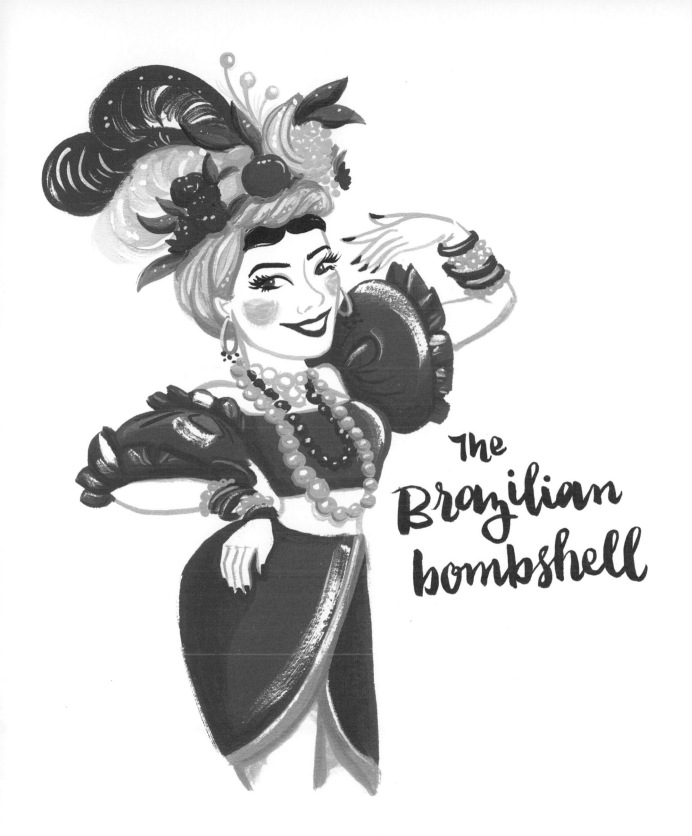

The Brazilian bombshell

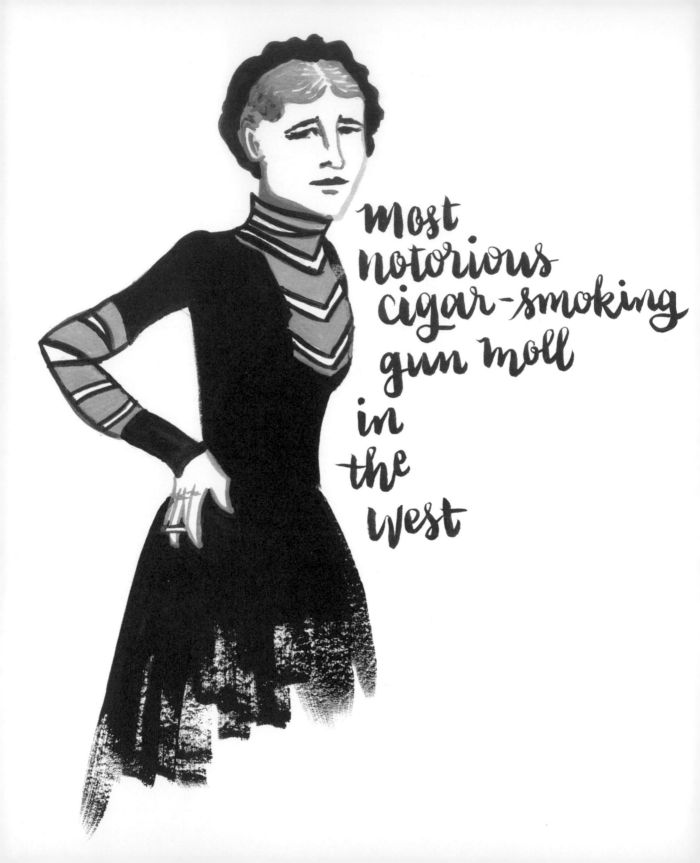

Bonnie Parker

Caught up in a youthful romance gone wrong, there's arguably no female outlaw more infamous in the West than Bonnie Parker (1910–1934). Raised in Texas and married at fifteen to a high school sweetheart, Parker was soon separated when her husband went to jail for robbery. At the age of twenty, Parker met ex-con Clyde Barrow through a friend, and it was love at first sight. Two weeks after they met, Clyde was imprisoned for five counts of auto theft, and the smitten Parker smuggled a gun into jail to break him out. Thus began their two-year crime spree that lit up headlines across a Depression-worn country. Together with their gang, they committed over a hundred robberies, burglaries, and murders across the Southwest. In a police raid, photos were found of Parker posing with a cigar hanging out of her mouth and a gun at her hip, cementing her image as a cigar-smoking, heartless murderer, though she smoked only cigarettes, and multiple reports have suggested that Parker never once pulled the trigger. The nation was riveted by her image because the pair's lawlessness also demonstrated her sexual liberation—Parker's running around with Clyde while remaining legally married to another man was considered just as outrageous as the crimes themselves. She died in a blaze of police gunfire alongside Clyde in their now-iconic Ford during a high-speed chase.

Mary Blair

One of the most influential artists in Walt Disney Animation Studio's history, Mary Blair (1911–1978) and her unparalleled color and design skills have continued to inspire generations that followed. Blair had fine-art dreams upon her graduation from Chouinard when the reality of the Great Depression compelled her and her soon-to-be husband, Lee Blair, to seek day jobs in the animation field. After brief stints at the MGM and Ub Iwerks studios, Mary joined the male-dominated Disney Animation Studio as a concept artist and colorist.

As part of the United States' Good Neighbor policy at the dawn of World War II, Disney and a select group of his artists headed down to South America for a research tour to work on their next two films, *Saludos Amigos* and *The Three Caballeros*. When Mary heard of the trip (because her husband had been invited), she marched into Disney's office and demanded she be on it too. And so she was. There her work flourished under the influence of folk art—and in the eyes of Walt Disney. He promoted her to art supervisor on those films, and her career took off. She went on to create the defining looks of Disney's most iconic films, such as *Cinderella*, *Alice in Wonderland*, and *Peter Pan*.

After a decade with the studio, she left for a prolific freelance career that spanned fashion, advertising, and illustrations for multiple Little Golden Books, which are still in print today. In 1963, she was personally asked by Disney to design their newest attraction—the now classic "It's a Small World"—for the 1964 New York World's Fair. She developed the happiest work of her career in the darkest times of her life; Disney's death in 1966 and Mary's tumultuous personal life eventually led to alcoholism that sealed her fate. As is true of so many artistic geniuses, her incredible gift to the world came at a stiff personal price.

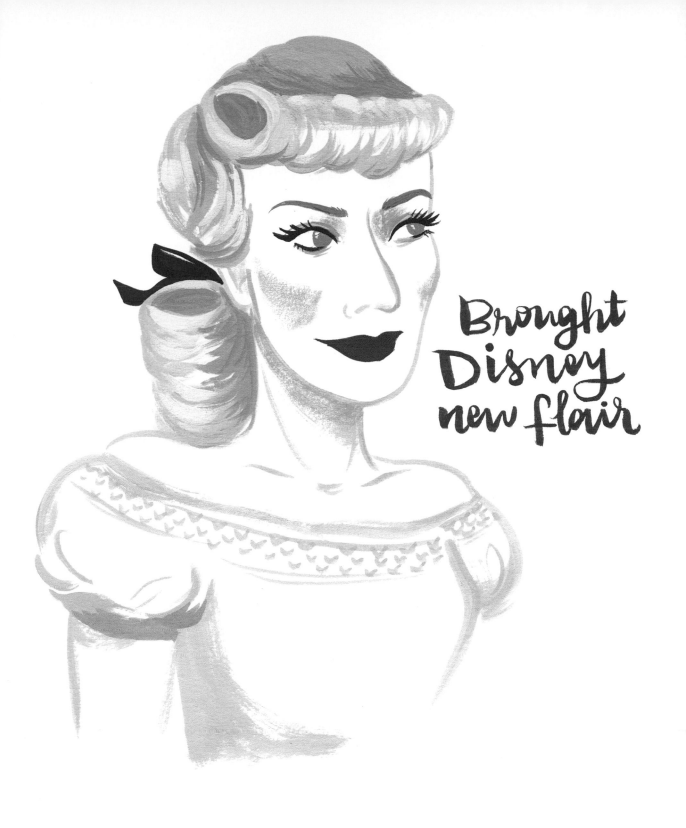

Brought
Disney
new flair

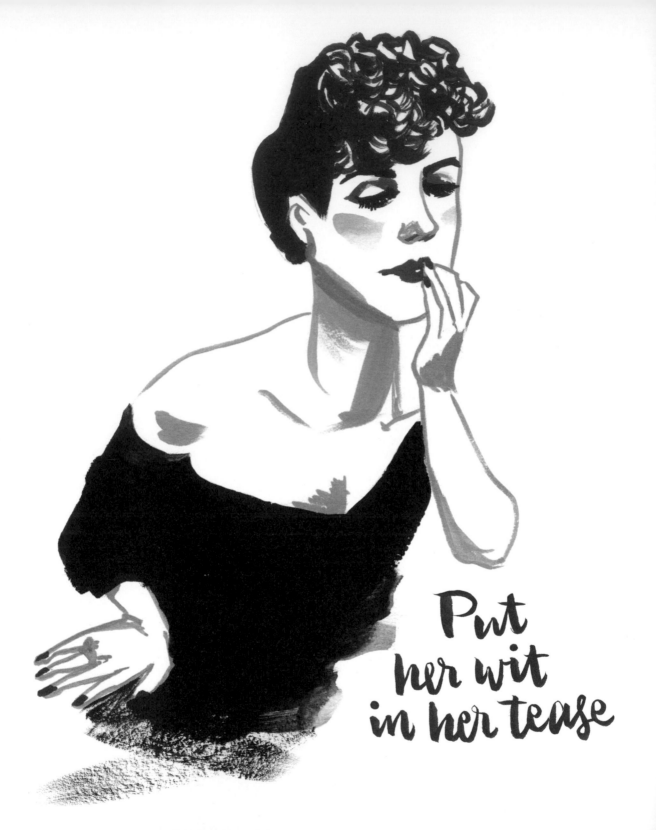

Put
her wit
in her tease

Gypsy Rose Lee

The world's most famous stripper, Gypsy Rose Lee (1911–1970) made her debut in one of New York's top burlesque clubs at the age of nineteen after previously playing second fiddle to her talented dancer sister June. Her sister June had run off with a dancer from her troupe, leaving their domineering stage mother with sister Gypsy to support the family. Lee innovated a new, casual striptease style and became just as famous for her onstage wit and banter as for her stripping. Lee was smart with her career, building on her stardom to appear in five feature films; she also wrote a series of successful mystery novels including *The G-String Murders*. After her mother died, Lee wrote her memoir, *Gypsy*, which was made into one of the most popular Broadway musicals of all time, and a subsequent film starring Natalie Wood. At thirty-eight, she took her two-year-old son on the road with her for a cross-country tour with the world's largest carnival, Royal American Shows. She was paid ten thousand dollars a week to appear—which pretty much epitomizes Lee's brilliance with her business. Lee was so beloved by the people that she was voted over Eleanor Roosevelt in a popularity poll—and Roosevelt sent her a congratulatory note that read, "May your bare ass always be shining."

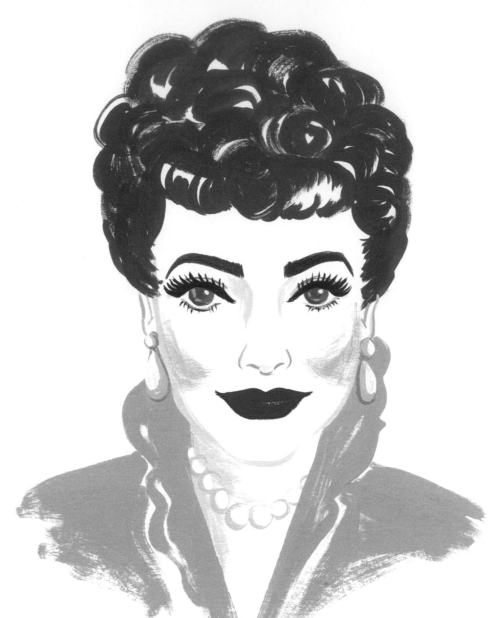

The founding queen of television

Lucille Ball

The first lady of comedy, Lucille Ball (1911–1989) broke many barriers for women in entertainment. Ball discovered her love for performing on Broadway, and she moved to Hollywood in the 1930s to become a contract player for RKO Radio Pictures. In the '30s and '40s, Ball became the Queen of the Bs, appearing in over seventy-five motion pictures but never as a starring lead.

In 1950, Ball took the role of a zany housewife on a radio program called *My Favorite Husband*. When asked to adapt the role for the new venue of television, Ball insisted that her real-life husband, Desi Arnaz, portray her on-screen husband. The studio was initially resistant to an interracial couple portraying the American dream in people's homes every week, but the two took the vaudeville act on the road and made it a huge success, which calmed the studio's fears.

In 1951, *I Love Lucy* premiered on CBS. Ball was forty-one and had just given birth to their first child. The show defined the golden age of television and broke new ground—along with televising the first interracial couple, it was the first television show to portray a pregnancy and birth. When Ball was pregnant with her second child, her character Lucy was also pregnant, which caused an uproar in the country. Pregnant women were not allowed to be shown on screen; the network demanded that the word "expecting" be used instead of "pregnant." Both Lucys gave birth on January 19 and forty-four million people tuned in to celebrate. In contrast, that same day, twenty-nine million watched President Eisenhower's inauguration.

I Love Lucy also invented the sitcom format, the live audience, and the rerun, and it was the first to be shot on film so that it could be filmed in Hollywood, where Ball and Arnaz lived. To make the costly compromise, they formed Desilu Productions and produced the show themselves. With Desilu, Ball became the first female head of a major television studio, and the studio went on to produce multiple hit series including *Star Trek* and *Mission: Impossible*. She remained a mainstay on television for the next thirty years.

Julia Child

One of the most famous chefs in history, Julia Child (1912–2004) lived a life that proved you're never too old to find your calling. A late bloomer, Child started out as a secretary in the Secret Intelligence department of the Office of Strategic Services (a precursor to the CIA). While working for the OSS, she met her husband, Paul Child. They married when she was thirty-six and moved to Paris. She didn't know what she was doing with her life then, until she had a revelatory meal in Rouen that set her on her history-making path. Child decided to become a chef, attending Le Cordon Bleu and studying privately with master chefs until she met two friends in a cooking club. Together, they started a cooking school of their own and wrote *Mastering the Art of French Cooking*. The cookbook was first rejected by publishers for being too much like an encyclopedia; eventually a publisher picked it up, and it became an instant bestseller that introduced French cuisine to American kitchens everywhere. Child was forty-nine when it was published, and it's still in print today.

She went on to publish over eighteen books in her lifetime. The Childs moved back to the United States, and at fifty-one she became a television star in a number of her own cooking shows, bringing the gregarious, six-foot-two chef into American homes and hearts. Child became the first woman inducted into the Culinary Institute of America's Hall of Fame. She attributed her long life to red meat and gin.

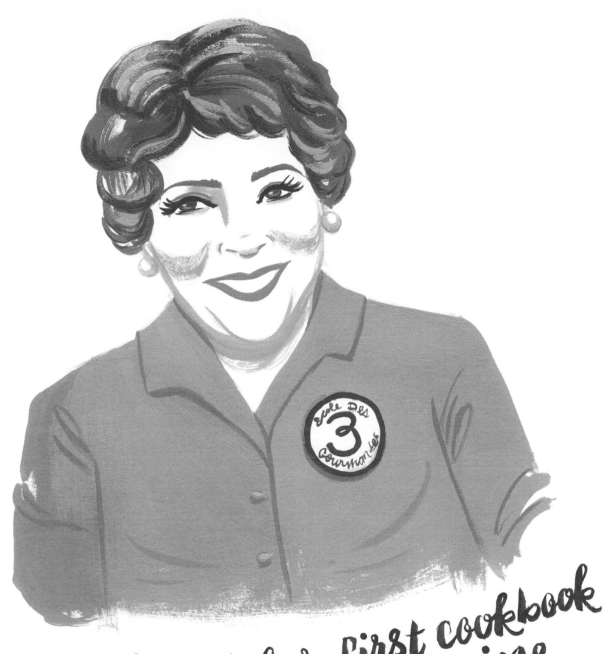

Published her first cookbook at forty-nine

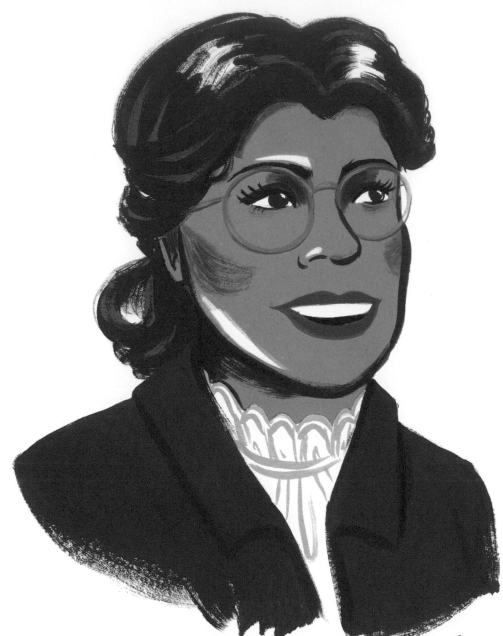

Isn't riding by
your rules

Rosa Parks

Born and raised in segregated Alabama, Rosa Parks (1913–2005) sparked a movement when she refused to move to the back of the bus, even though she wasn't the first to do so. Though revisionist history has labeled her as being old and tired at the time, she cleared the record and stated that the only thing she was tired of that fateful day was giving in. The night after her arrest in 1955, the seminal event of the civil rights movement was born: the Montgomery Bus Boycott.

Over the next 381 days, instead of taking the bus, forty thousand African-Americans in Alabama carpooled, taxied, and walked to work and school. As a result of the boycott, a civil suit finally ruled Alabama's bus segregation laws unconstitutional. Parks became a national hero and the face of the civil rights movement, although at great personal cost—she was fired from her job and menaced with death threats for the rest of her life. The boycott gave impetus to the formation of a new civil rights organization, the Montgomery Improvement Association, and they elected a young and unknown minister as its president— Martin Luther King, Jr.

Throughout her life, Parks worked with the NAACP and the Black Power Movement and as a secretary for a U.S. representative, John Conyers. While working for Conyers, Parks was a strong advocate for desegregating housing and the defense of political prisoners. Rosa Parks acted with courage in the wrong place at a bad time, and that turned out to be the perfect move at the right time.

the most beautiful woman in the world
—who also invented Wi-Fi.

Hedy Lamarr

Hedy Lamarr, born Hedwig Eva Maria Kiesler (1914–2000), was an Austrian actress who started her film career in Germany and gained fame for the 1933 film *Ecstasy*, in which she had several nude scenes and was the first woman to simulate an orgasm on screen. She escaped a domineering arms-dealer husband, Friedrich Mandl, and left Europe by boarding a cruise liner to America. After initially meeting Louis B. Mayer in London, Lamarr knew that he would also be traveling on that ship—and by the end of the cruise, she had a five-hundred-dollar-a-week contract with MGM Studios and a new name. Mayer reinvented her in America as Hedy Lamarr, "the most beautiful woman in the world."

While her new film career garnered attention, Lamarr was given mostly objectifying roles, so she eventually turned to inventing. Back when she was Mandl's trophy wife, she had often sat in on dinner party discussions with national leaders (including Stalin and Hitler). After gaining knowledge about German submarines torpedoing cruise liners and killing civilians, she used her free time between movies, working with her friend and composer George Antheil, to invent an alternative to existing radio wave technology. They gave the patent to the American government for free, but it was buried in bureaucracy when the government shifted its focus after the bombing of Hiroshima. This technology was declassified, implemented in submarines in the 1960s, and is the precursor to what we now use every day as WiFi and Bluetooth.

Billie Holiday

Billie Holiday (1915–1959) was one of the most influential American jazz singer-songwriters in musical history. Cutting her first record at eighteen, the torch singer overcame a painful childhood—including a stint as a prostitute alongside her mother—to change the jazz scene and become a musical supernova. Holiday had no formal musical training and could barely read music, but she worked hard to break in, singing at nightclubs around New York for tips. Soon she was touring with Artie Shaw and his orchestra—the first female African-American singer to tour with an all-white band, though she had to enter through the back door of venues. Her distinctive vocal style changed the vocal jazz world and made an indelible impression in songs like "Strange Fruit," "God Bless the Child," and "The Man I Love," which showcased her knack for emotional intensity and tempo manipulation. She recorded over a hundred songs in her lifetime and performed sold-out shows at Carnegie Hall, but Holiday succumbed to her own demons and heroin addiction at the early age of forty-four. She left behind an impressive volume of work that continues to influence music today.

Iva Toguri D'Aquino

In a clear case of being in the wrong place at the wrong time, Iva Toguri D'Aquino (1916–2006) was an American citizen who was stranded in Japan after the bombing of Pearl Harbor in World War II. When she refused to renounce her U.S. citizenship, she and other captured POWs were forced to work at Radio Tokyo, a station that broadcast in English to the Allied troops in the South Pacific. D'Aquino was soon a minor celebrity, with thousands of GIs tuning in to her show, *The Zero Hour*. She performed comedy sketches, played pop songs, and delivered Japanese war propaganda intended to lower the morale of the soldiers, but with a tongue-in-cheek attitude that demonstrated she was not a Japanese sympathizer. Her reports actually raised the morale of the U.S. army soldiers. "Tokyo Rose" was a moniker that the soldiers came up with to put a name to the seductive and mysterious female voice on the radio. It became most closely tied to D'Aquino after the war, when the United States charged her with eight counts of treason upon her return. She served six years in prison. But in 1976 a reporter investigated further into her case and unearthed two witnesses who admitted they had committed perjury under threat from the FBI that they would be charged with treason themselves if they didn't turn her in. The following year, President Ford granted D'Aquino a full pardon.

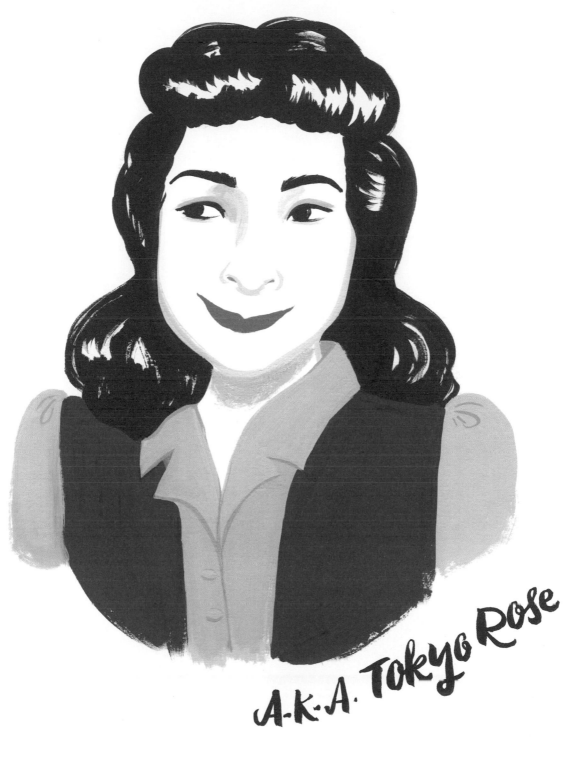

A.K.A. Tokyo Rose

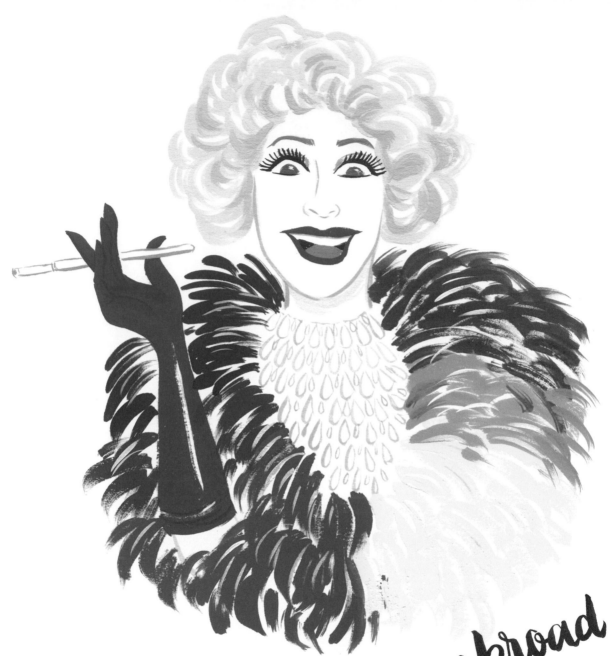

One funny broad

Phyllis Diller

One of the first and most influential female stand-up comics, Phyllis Diller (1917–2012) began her comedy career at thirty-seven after regaling fellow bored housewives at the local laundromat with stories of her home life. Her husband encouraged her comedy career, and she soon began writing her own material and working with a drama coach. Diller built up her mileage performing everywhere that would have her: hospitals, women's halls, church halls, and PTA meetings. In 1955, Diller made her comedy club debut at the Purple Onion in San Francisco and offered the first glimpse of the wild, wicked housewife who would become her onstage persona. She started making television appearances everywhere, most notably on *The Tonight Show*, often outfitted in a long lamé housecoat, rhinestone-studded boots, and clownish makeup. That witchy physical persona was vital to her success; it provided an access point for her audience to instantly like her and believe her bits. With her look nailed and her rapid-fire delivery of one-liners rivaling that of male comedians like Bob Hope, the audience response was wildly positive—and enduring; she kept working well into her eighties. Diller's success was an essential part of the new wave of personal emancipation for women: now they could be loud and brash, self-deprecating yet clever, and, most important, funny.

Sister Corita Kent

Sister Corita Kent (1918–1986) was an American pop artist and politically active nun who taught art classes throughout her life. In 1941, she entered the Roman Catholic order of Sisters of the Immaculate Heart of Mary in Los Angeles. While studying there, she also took classes at Otis Art Institute and Chouinard before earning an M.A. in art history at USC. Taking inspiration from an Andy Warhol exhibit and a serigraph technique, Kent joined the pop art movement with her own signature silkscreen style. After the ultra-conservative Cardinal MacIntyre dismissed all the nuns of the order in a clash over their progressive views (as in, he didn't have any), Kent moved to Boston and became a full-time artist.

Her work often expressed values of love and peace that were founded on her religious background, and they were very popular during the political unrest of the time. Many of her prints, which she always made affordable for ordinary people, were displayed at marches and demonstrations. In 1985, Kent designed a United States Postal Service "Love" stamp, which has sold over seven hundred million copies—making her possibly the bestselling artist of all time.

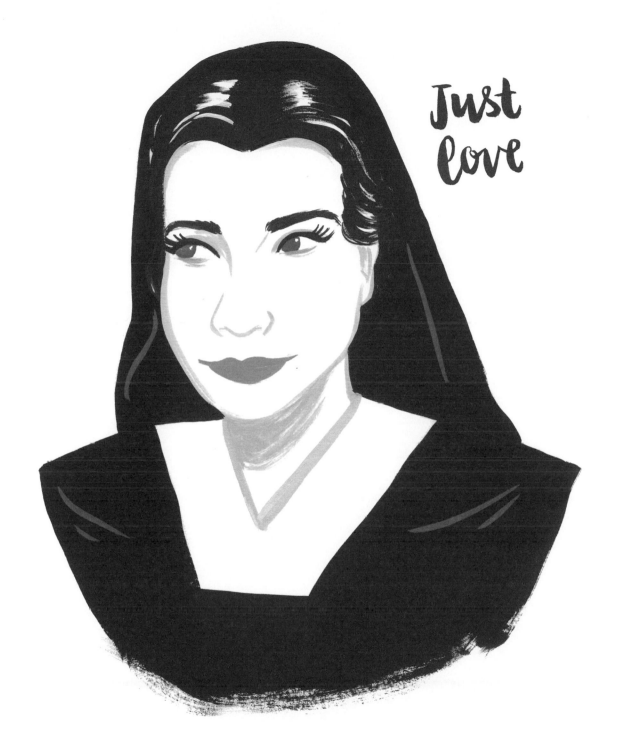
Just
love

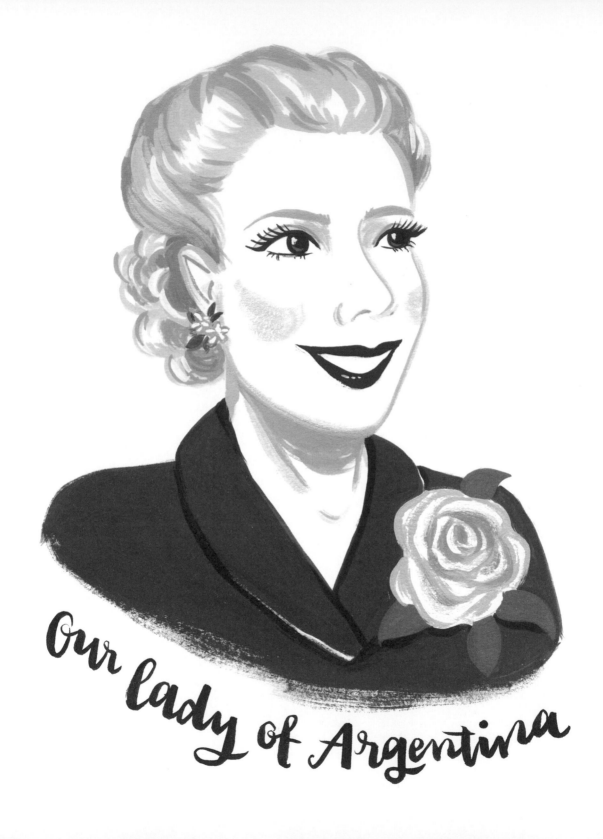

Our lady of Argentina

Eva Perón

Raised by a poor single mother of five, Eva Perón (1919–1952) left home at fifteen to pursue the limelight as an actress in Buenos Aires. The ambitious Eva found success in theater, radio, and film over the next decade, even eventually co-owning a radio company and becoming the highest-paid actress in Argentina in 1943. She met politician Juan Perón at a charity event in 1944, and they married the following year. Eva Perón became First Lady of Argentina when Juan was elected president in 1946, which ultimately became her most successful role.

She was a passionate advocate for trade unions, labor rights, and women's suffrage. As First Lady, she founded the Eva Perón Foundation and the Female Peronist Party, the first political group that served the interests of women in a time when women couldn't vote or run for office. The following year, the women of Argentina were given the right to vote. By 1951, women could also run for office, and twenty-four were elected to the Chamber of Deputies and seven to the Senate, making Argentina the country with the most female representatives at the time.

Perón was so active in the community and beloved by the people of Argentina that she and Juan announced her candidacy to run beside him for vice president in the next election. This was met with great opposition and resistance from the military and elite class, who vocally opposed her work. However, it was her declining health that led to her withdrawal, and she passed away at the age of thirty-three from cancer. Her influence is still so resonant in the Argentinian consciousness that her book, *The Purpose of My Life*, is mandatory school reading. A testament to the international reach of her legacy, her life was made into the musical *Evita*, which was later adapted into a film starring Madonna.

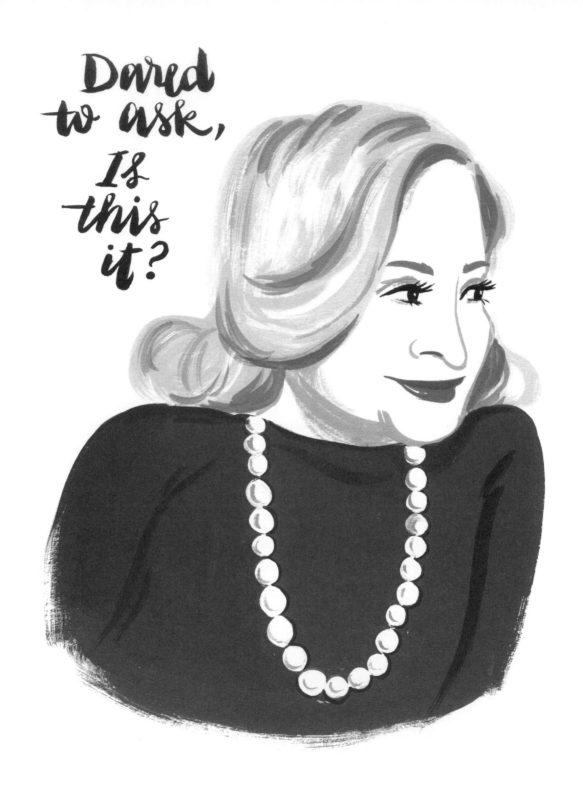

Betty Friedan

Betty Friedan (1921–2006) is often credited as the mother of the second wave feminist movement. With her 1963 book *The Feminine Mystique*, Friedan dared to ask: Now that women have had the right to vote for over forty years, what else do they want to do?

Born to Jewish immigrants in suburban Chicago, Friedan faced anti-Semitic treatment growing up, which later helped her identify with minority groups in her work. She became a journalist while in college at Smith; after graduation she moved to New York City to write for labor news syndicates. Friedan married and had three children, and it was at her fifteenth Smith college reunion, where she surveyed her fellow coeds-turned-housewives, that she started to put a name to that postwar, middle class woman's dissatisfaction that would be the subject of *The Feminine Mystique*. The book addressed "the problem that has no name": that women who were educated, married, and raising children still found themselves unsatisfied.

In 1966, Friedan cofounded and served as president of the National Organization for Women (NOW), which worked politically to give women fair opportunities and treatment in the workplace. The focus was to create a landscape where women could pursue a career outside the home; they also touched on issues of abortion, federal funding for child care services, poverty, and LGBT rights. In addition to NOW, Friedan also cofounded the National Women's Political Caucus (NWPC) and the National Association for the Repeal of Abortion Laws (NARAL). She was famously hot-headed, and her outspokenness led to her dismissal from two of the groups she helped found. Friedan wrote six more books, including memoirs and more nonfiction books on social issues.

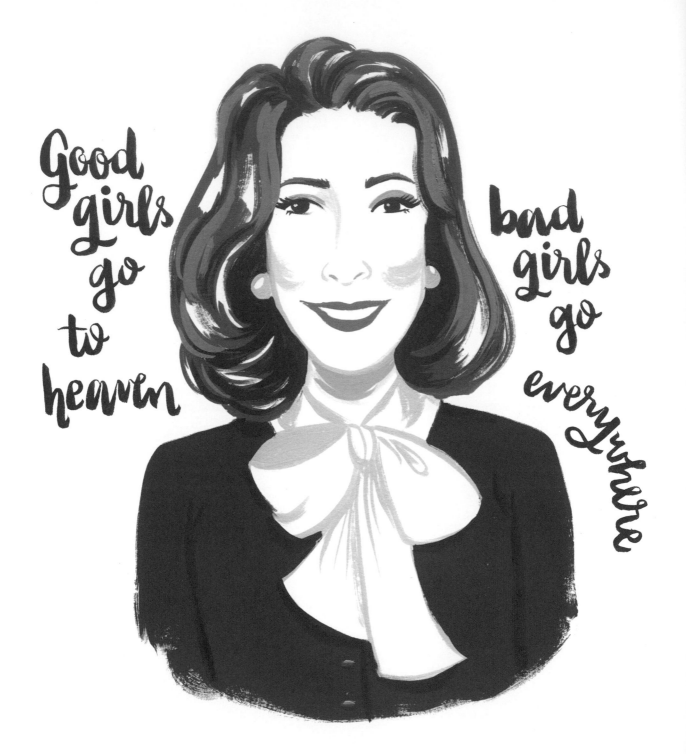

Helen Gurley Brown

Helen Gurley Brown (1922–2012) was editor-in-chief of *Cosmopolitan* magazine for more than thirty-two years, transforming it into the guide to a fun, sexy, fearless life for single girls. She worked at more than seventeen secretarial jobs before advancing as an ad agency copywriter; she was so good that she became one of the highest-paid copywriters in the 1960s—in a job few women held. In 1961, at the age of forty, she published her first book, *Sex and the Single Girl*, which openly encouraged single women to embrace careers, financial independence, and sex lives before marriage. It was the first of its kind.

In 1965, she made the leap to top dog at *Cosmopolitan*. Brown coined the term "mouseburger" to describe women like herself—who were born not particularly pretty, smart, or talented, and who didn't have a fancy education or highbrow family background—and she spoke to these women. Her message: the way to get what you want out of life is not through a man but through your career; set your mind to something, and work really hard to get it. Oh, and you should definitely have a lot of fun on the way up—and not wait for marriage to bring you that happy ending.

Dorothy Dandridge

Dorothy Dandridge (1922–1965) was a Hollywood actress and singer who became the first African-American to be nominated for a best actress Oscar. She broke into show business performing and touring around the United States with her sister and a friend as the Dandridge Sisters before becoming a solo act, singing in clubs that she wasn't even permitted to eat in due to segregation. Refusing to be pigeonholed into supporting maid roles, Dandridge got her first break in 1953 with MGM's *Bright Road*. She played a teacher struggling with a problem student—and, miraculously, the story didn't even revolve around race. In 1954, she became a megastar in *Carmen Jones*, the film adaptation of the opera *Carmen*, playing the brazen and sexy lead role, which earned her a historic first Oscar nomination and the cover of *Life* magazine. The starring lead and nomination changed America's perception of African-American actresses, and the shift was permanent. Unfortunately, Hollywood is slow to evolve, so while her films were a breakthrough, leading roles for African-Americans remained few. Dandridge never found another role that matched the success of *Carmen Jones*, and her personal challenges took a toll. She died of an overdose at the age of forty-two.

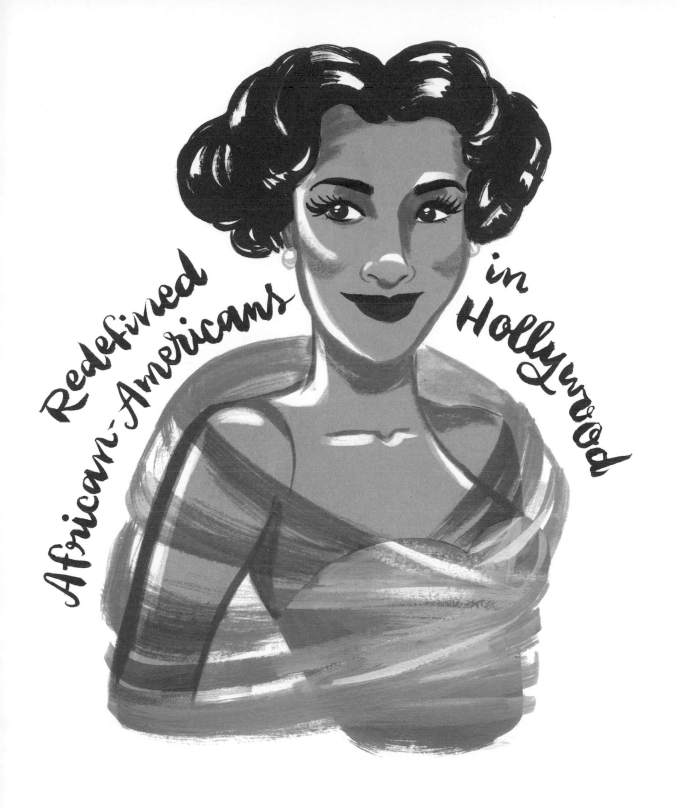

Redefined African-Americans in Hollywood

Bettie Page

Discovered on the beach at Coney Island, Bettie Page (1923–2008) went from salutatorian of her high school class to the most famous pinup girl in history. She grew up in poverty in Nashville; her single mom neglected Page and her two sisters, and they spent time in orphanages. After a brief marriage to a high school boyfriend that ended in divorce, Page moved to New York to pursue that 1950s single girl life. She tried her hand at secretarial work and modeling while attending acting classes. That's when Jerry Tibbs, a police officer and pinup photographer, discovered her and helped her assemble a modeling portfolio.

In 1952, she started working with sibling team Irving and Paula Klaw, who shot mail-order photos by request for the bondage and fetish world. She developed her "Dark Angel" look, debuting her sharp, signature U-shaped bangs and six-inch black fetish heels. With the Klaws, Page started appearing in the burlesque films that made her a star. Outside of their studio, she also started appearing in off-Broadway productions and shooting with Bunny Yeager, which ultimately landed her a gig as one of the first Playmates of the Month in *Playboy*.

At the height of her career in 1957, Page disappeared from the limelight. Some credit this to her conversion to Christianity; others cite the FBI investigation into pornography distribution. Although her work was originally made for men, Page developed a huge cult following of female fans, starting in the 1980s, because of her fuller figure and body-positive confidence; she always seemed to be in on the joke with a wink and a smile.

When reporters tracked her down in the '90s, she was surprised by the renewed interest but remained unashamed about her modeling career. Page said that being nude was nothing to be ashamed of, pointing out that even the Lord put Adam and Eve on earth without a stitch of clothing. Her unabashed confidence helped usher in the sexual liberation of women in the 1960s and beyond.

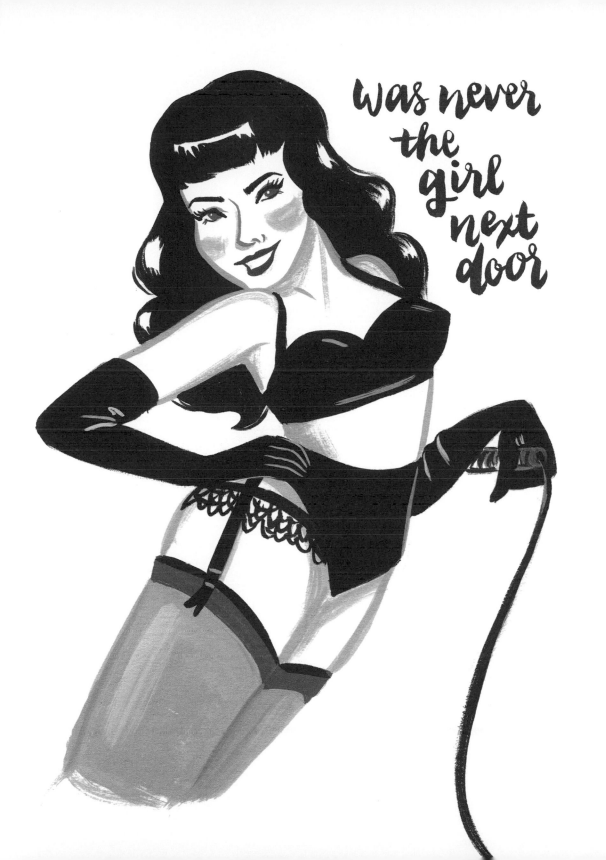

was never
the
girl
next
door

Margaret Thatcher

Margaret Thatcher (1925–2013) went from being the first person in her family to attend college to being elected the first female prime minister of the United Kingdom in 1979. She took an unconventional route there, and she was more proud of being the first prime minister with a science degree than of being the first woman. Thatcher was a leader of the Conservative Party and ran the government with uncompromising leadership and vision. Winning over the country despite an ongoing recession, Thatcher, with her iron fist, was especially strong in a crisis, such as during the 1982 Falklands War when Argentina invaded British territory. She struck back with such force that the war ended in seventy-two days. Her friendship with Ronald Reagan strongly influenced the Reagan-Gorbachev deal that destroyed new Soviet and NATO missiles and ended the Cold War—and the Soviet Union shortly thereafter. When Saddam Hussein invaded Kuwait and U.S. President George H.W. Bush was waffling on a next move, Thatcher called him on the phone and said, "This is no time to go wobbly!" Thatcher holds the record for the longest term as British prime minister in the twentieth century, being elected three times before resigning over her polarizing politics in 1990. Still a controversial figure today for her conservative policies and actions, Thatcher has earned her place in history among people who forged their own path by being an unstoppable force that redirected the course of the modern U.K.—and the world.

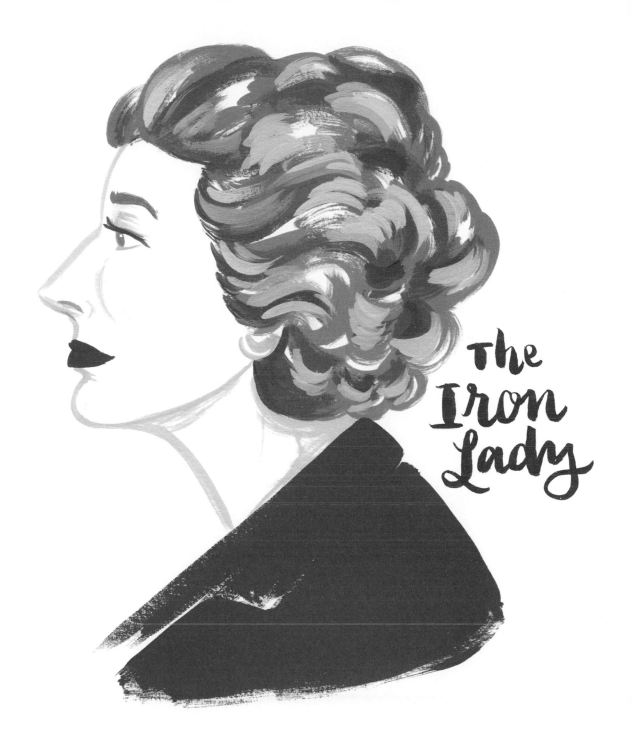

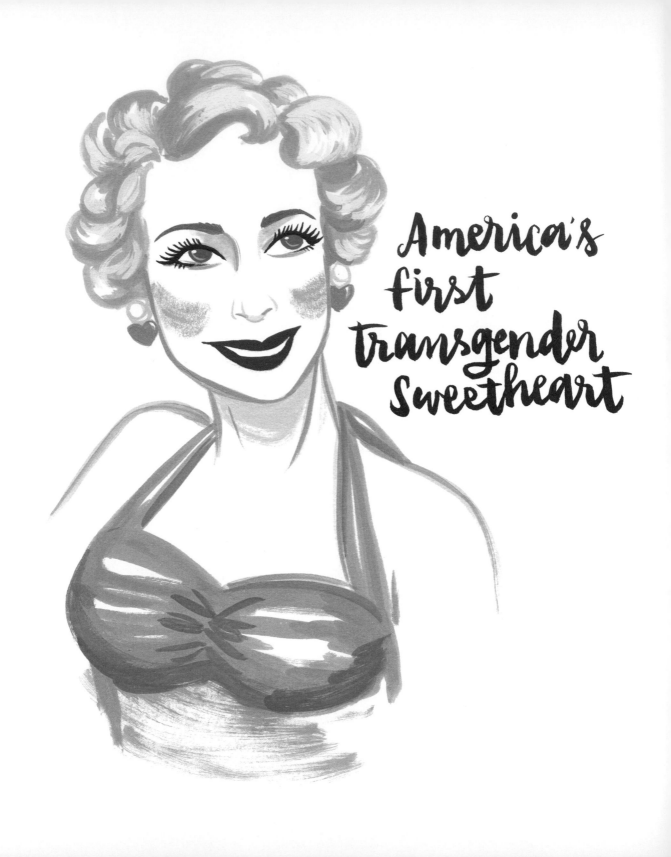

America's first transgender sweetheart

Christine Jorgensen

Actress and entertainer Christine Jorgensen (1926–1989) was the first publicly-known American trans woman. After serving in the army, Jorgensen moved to Copenhagen to work with doctors specializing in hormone therapy and transitional surgery. She did not originally intend to share her story publicly, but the *New York Daily News* outed her when they published private letters to her parents about her reassignment surgery. She took it in stride and accepted a twenty-thousand-dollar offer for the exclusive rights to share her story in *American Weekly* magazine. When she returned from Denmark in 1953, the media circus was already waiting for her at the airport. She had captured the fascinated curiosity of a nation, but she also opened the closet door for all those afflicted with gender dysmorphia. Jorgensen leveraged her popularity into a nightclub act, stating that if people wanted to see her, they would have to pay for it. She became a writer and speaker on the transsexual experience and allowed herself to be experimented on and studied by doctors in exploration of the field. Above all, Jorgensen handled all the discrimination and ignorance with great wit and sass, and in the year of her death, she stated that she had given the sexual revolution "a good kick in the pants."

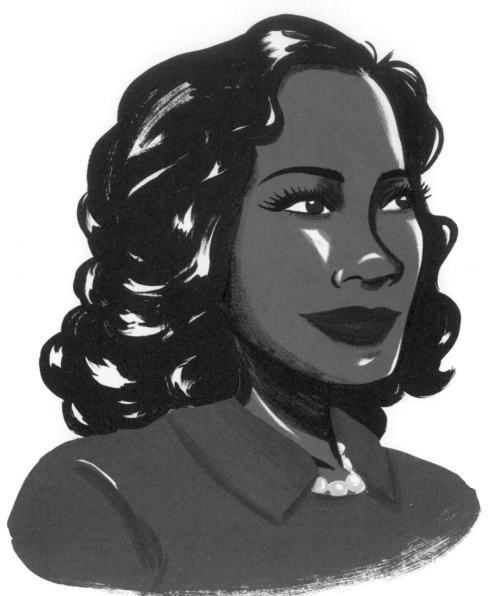

First Lady of the
Civil Rights Movement

Coretta Scott King

Born and raised in segregated Alabama, Coretta Scott King (1927–2006) defied society's constraints to become the first lady of the American civil rights movement. She graduated as valedictorian of her high school and won a scholarship to Antioch College, where she studied music and joined the NAACP. While continuing her studies in Boston, she met another doctoral student, Martin Luther King, Jr., who was two years her junior. He pursued her immediately, yet she was initially uninterested—and particularly put off by the fact he was not taller. Martin won her over with his confidence and intelligence, and the two married a year later. Their partnership was one of true equals from the start—she insisted that his father, who married them, remove the promise to obey her husband from the wedding vows. Together, they led the civil rights revolution, starting with the Montgomery Bus Boycott in 1955. They traveled internationally in support of nonviolent social change, including visiting Ghana in 1957 and making a pilgrimage to India in 1959. Coretta created her own events, hosting over thirty fundraising Freedom Concerts, and became an in-demand speaker. She was the first woman to deliver the Class Day address at Harvard and the first woman to preach at St. Paul's Cathedral in London. King also served as the delegate for the Women's Strike for Peace Conference in Geneva. After her husband was assassinated, she continued to work in the movement; before his body was even laid to rest, she took his place as leader of the march on Memphis. Eventually, she founded the Martin Luther King, Jr. Center for Nonviolent Social Change in Atlanta and campaigned for fifteen years to have his birthday honored as a national holiday. King remained active in social justice causes for the rest of her life, working for all human rights.

Ruth Westheimer

At four foot seven, German-born Orthodox Jew Ruth Westheimer (1928–) has been a sex education powerhouse since the 1960s. The journey that led her to break ground in a whole new world of broadcasting will make you love her even more. At the age of eleven, she was sent away by her parents to a Swiss Jewish girls' sanctuary to escape Nazi capture. Shortly thereafter, she became an orphan when her parents were killed in the Holocaust. Westheimer worked as a maid at a school and as a teen made her way to Palestine, where she was trained as a sniper and participated in underground warfare to establish a Jewish homeland.

After Israel declared its independence in 1948, Westheimer was injured in a bombing, so she moved to Paris with her new husband. There she studied psychology at the Sorbonne; after the dissolution of her first marriage, she moved to New York with another boyfriend, where she finished a master's in psychology from the New School and a doctorate in education from Columbia.

In the 1960s, Westheimer began working at Planned Parenthood as a sex educator, and her candid lecture work led to an offer of a fifteen-minute segment on a local WYNY radio station. Debuting in the 1980s, the show, *Sexually Speaking*, was a huge hit; it expanded to an hour-long segment, and Dr. Ruth became a household name. Her special brand of humor, sex-positive advocacy mixed with old-fashioned demureness (she still insists that people use the cover, "I'm asking for a friend"), and inimitable German accent made her a legend. In the past four decades, Dr. Ruth has appeared across multiple platforms, including writing over thirty-six books, and she remains a cultural icon representing a liberal and frank attitude toward healthy sexuality.

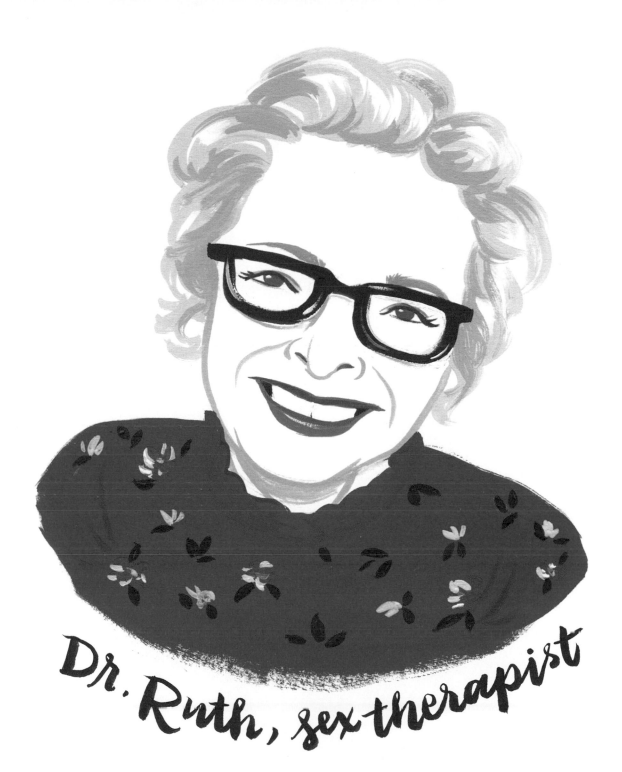

Dr. Ruth, sex therapist

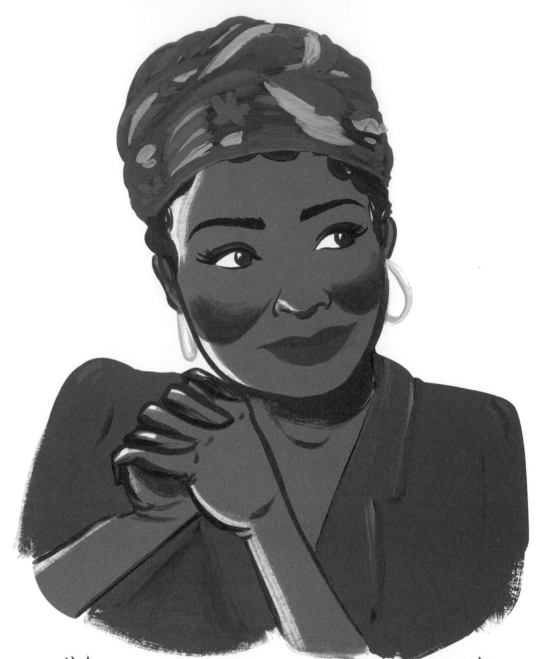

"You've got to go out
and kick ass."

Maya Angelou

Many consider Maya Angelou (1928–2014) a U.S. national treasure. A writer, activist, filmmaker, actor, and lecturer well into her eighties, Angelou transcended her humble upbringing in deeply racist Arkansas to create a vast body of work that helped to change the landscape of American culture. After a traumatic childhood event that she would later chronicle in her game-changing memoir, *I Know Why the Caged Bird Sings*, Angelou became extraordinarily gifted in arts and literature and earned a scholarship to a San Francisco high school. As a teen, she became the first African-American female cable car conductor in San Francisco. She became a mom at sixteen and married a Greek aspiring musician, flouting the existing laws forbidding interracial marriage. Angelou studied dance with legendary choreographer Alvin Ailey and became a staple on the calypso music and dance scene as a performer. She also toured Europe with a production of the opera *Porgy and Bess*.

After meeting novelist John Oliver Killens in 1959, she joined the Harlem Writers Guild and published her first written work. She became a civil rights activist and worked alongside Martin Luther King, Jr., and Malcolm X. Angelou would go on to write thirty-six books, earning the honor of both being on the banned books list and holding the record for the longest-running nonfiction book on the *New York Times*' bestseller list.

In addition to roles in producing, writing, and directing film and television, Angelou became the first African-American woman to pen a screenplay that was actually made into a film, the Pulitzer Prize–nominated *Georgia, Georgia*. She won three Grammys for her spoken word albums, served on two presidential committees, and became the first female poet to compose and recite a poem for a presidential inauguration (President Bill Clinton's in 1993). Showered with accolades at the end of her life, Angelou was awarded the Presidential Medal of Freedom, the highest civilian honor, by President Barack Obama in 2010. Angelou was fittingly recognized in her lifetime for her work that opened America's hearts and minds.

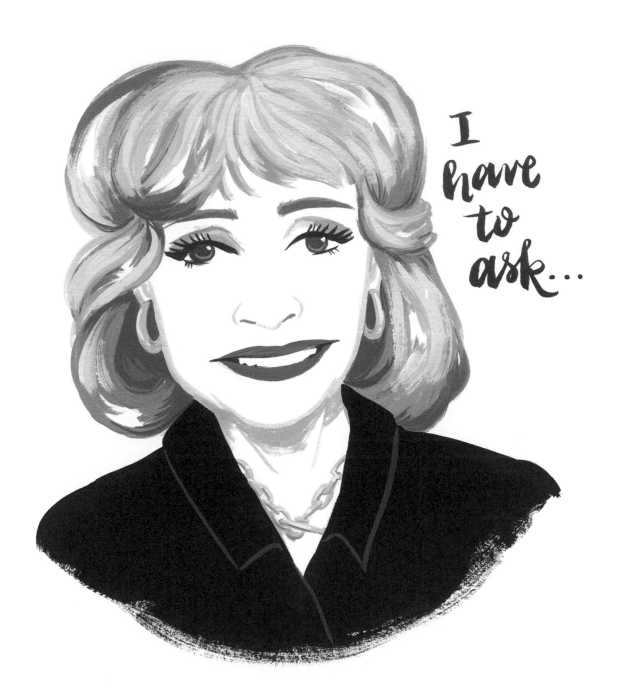

I have to ask...

Barbara Walters

American broadcast journalist Barbara Walters (1929–) has a reputation for always getting the inside scoop through her compassionate ability to ask anyone anything. She was so good at it that she even wrote the book on it, the 1970 publication *How to Talk with Practically Anybody About Practically Anything*. Walters became the first woman to officially co-anchor a network news program when she stepped into the role in 1976 on *ABC Evening News*. She had already served as a writer, segment producer, and segment host on the *Today Show* for over a decade. At ABC, she was a trailblazer for a new kind of news coverage dubbed "personality journalism," which walked the line between hard news and human interest. This was a different approach from Marlene Sanders's interest in serious journalism, which was also breaking news barriers at the same time. Walters's strength was her soft approach, and her specialty was on-air exclusive interviews, meeting with royalty, spiritual leaders, controversial heads of state, high-profile convicts, and the ten most fascinating people of the year. Struggling through many years of gender discrimination with cohosts and producers, Walters went on to co-anchor *20/20* for fifteen years before creating and starring on her own show, *The View*, for nearly another decade. Her forty-year-long career, which is still going strong, invented a whole new category of careers for women and reshaped the form of television news itself. And that is no small legacy.

Marlene Sanders

A serious leader in broadcast journalism, Marlene Sanders (1931–2015) became the first female face on television news in 1964 when she temporarily filled in for an ailing Ron Cochran. In a field where most women were hired for secretarial work, Sanders repeatedly knocked against the glass ceiling behind the camera, working as a writer and associate producer at local New York news stations before becoming a correspondent for ABC News. There she had to overcome being pigeonholed into hosting a segment called "News with the Woman's Touch," covering "feminine" topics like food, fashion, and child-rearing before she got any hard news assignments that she wanted. Once she did, she covered the assassination of Robert F. Kennedy and became the first female field reporter to cover the Vietnam War in 1966. Through her hard work and fearless news coverage, she finally broke through and became the first female vice president of the ABC News division. From that position, she went on to produce Emmy-award-winning documentaries, covering underserved voices in areas ranging from women's liberation to elder care. Early in her life, she even had to defy her own mother's admonition that "boys don't like girls who are too smart" because she excelled in school. Sanders knew that the traditional woman's role wasn't for her, and she made the world better for it.

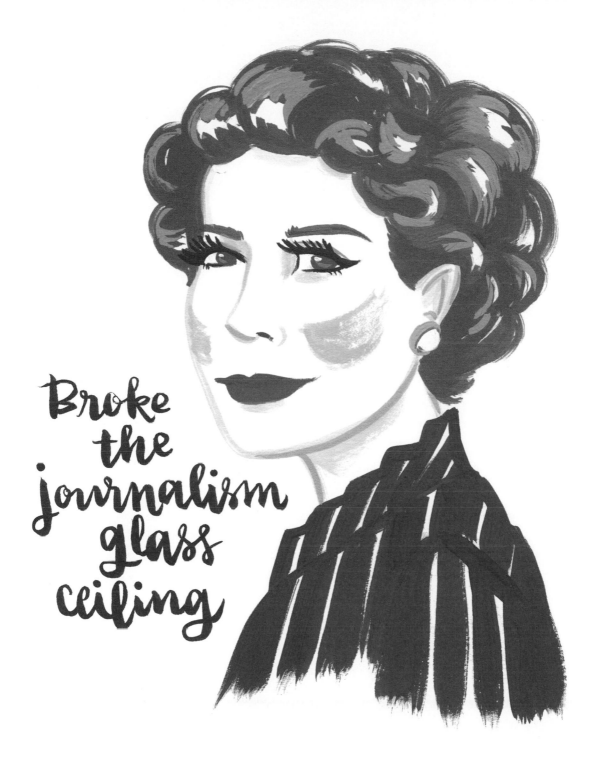

Broke the journalism glass ceiling

Ruth Bader Ginsburg

Ruth Bader Ginsburg (1933–) is the second woman ever appointed to the U.S. Supreme Court and a sharp-penned scriber of landscape-changing court decisions in the twenty-first century. She is one tough mother: during her studies at Harvard Law School, as one of nine women out of five hundred students, she cared for her two-year-old daughter and her cancer-stricken husband who was also in school with her. Bader took notes for both of them and typed his dictated papers, while also working on the *Harvard Law Review*. When her husband recovered and got a job at a New York firm, she transferred to Columbia Law School and graduated first in her class. That didn't make it any easier for her to find a job; after all, she was still a woman. Thanks in part to affirmative action, she became Columbia Law School's first female tenured professor. RBG, as she's now affectionately known on the Internet, went on to clerk for a district judge and direct the Women's Rights Project of the ACLU, arguing six landmark cases for gender equality before the Supreme Court. In 1993, President Bill Clinton appointed RBG to the Supreme Court. During her nomination process, she got wind that one of her law school classmates was telling everyone about her demeaning nickname in school, to which Ginsburg replied, "Better bitch than mouse." In her twenty-two years and counting on the Supreme Court, she has been in the majority of two historic rulings: *King v. Burwell*, which upheld the Affordable Care Act, providing health care for all U.S. citizens; and *Obergefell v. Hodges*, which legalized same-sex marriage in all fifty states. Not bad for a Jewish girl from Brooklyn who, upon her arrival at Harvard Law School, had been asked by the dean why she thought she deserved to be there, taking a spot away from a more-deserving male.

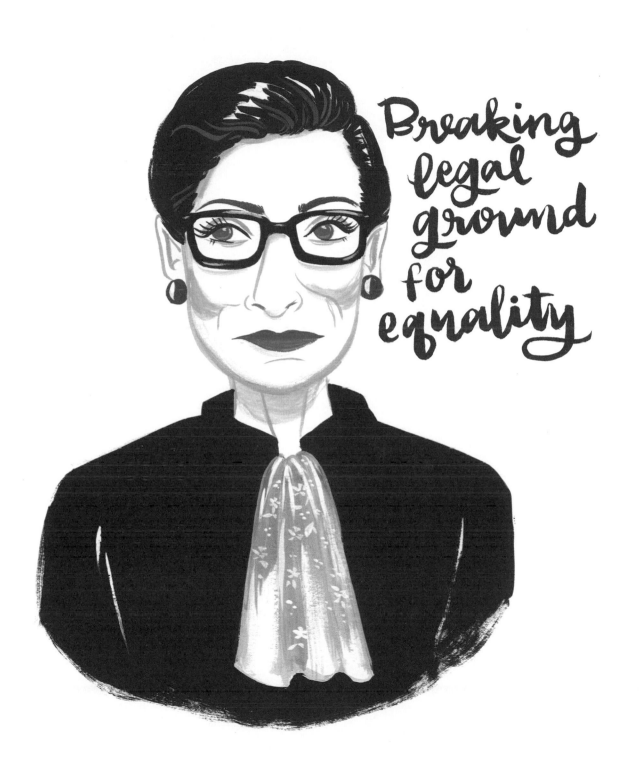

From "A Bunny's Tale" to Ms. magazine

Gloria Steinem

Gloria Steinem (1934–) is a feminist writer and all-around firecracker whose career started in the sixties when she went undercover as a Bunny at the Playboy Club and penned the notorious exposé "A Bunny's Tale" for *Show* magazine. She then became a staff writer at *New York* magazine, where she published the article that made her a feminist leader, "After Black Power, Women's Liberation." Steinem's career grew more focused when she covered an abortion hearing, and she joined forces with prominent figures like Betty Friedan and Bella Abzug to form the National Women's Political Caucus. In 1971, Steinem pioneered *Ms.* magazine, a liberal feminist publication created, owned, and operated by women. Publishing at a time when women couldn't even get a credit card without a man's signature, it boldly covered previously verboten territory, printing the names of women who acknowledged having an abortion when they were illegal, and featuring a woman with a bruised face on the cover of an issue about domestic violence. Of course, with more prominence comes more criticism, and Steinem was critiqued for everything from being too glamorous to be a feminist to focusing too much on self-help instead of social activism in her 1992 book *Revolution from Within: A Book of Self-Esteem*. Famously quoted as saying that a woman needs a man like a fish needs a bicycle, in 2000 she did the most surprising thing when she married environmental and animal rights activist David Bale. In recent decades she's founded the Women's Media Center and uses every birthday as a fundraising event, even stating that she expects her funeral to be a fundraiser. Steinem built a five-decade-long career on giving a voice to women's issues, and she continues to pursue her passion for social justice in her own groundbreaking way.

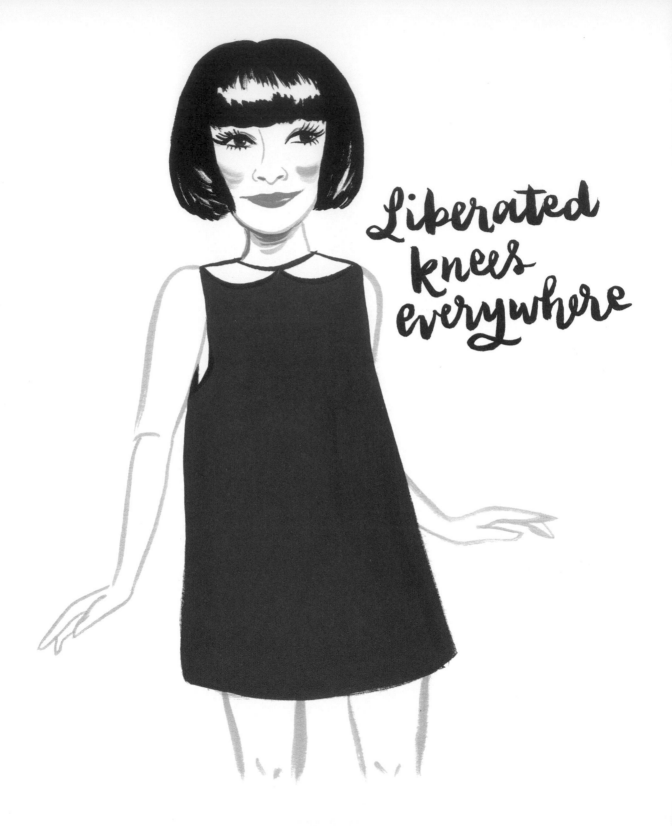

Mary Quant

London-based designer Mary Quant (1934–) was so in love with fashion that when she was six years old and sick with the measles, she passed the time by cutting up her bedsheets to make dresses. A visionary designer far ahead of her time, Quant grew up to invent the definitive mod look of the 1960s, creating miniskirts, colorful tights, and hot pants. She attended art school at Goldsmith's College of Art and made her official entry into the fashion world with her first job at a millinery boutique. She first met her husband at a costume ball, dressed in only mesh tights and strategically placed balloons. Quant was the living embodiment of the sexually liberated soul and style of the '60s. At the age of twenty-one she opened her first boutique, Bazaar, on King's Road and sold to teenagers. When she couldn't find clothes that she wanted to sell there, she hired a dressmaker and set up a studio in her apartment to start designing them herself. She deconstructed dress patterns, shortened hemlines, and added Peter Pan collars. Quant was the first designer to design for her generation—and she was great at it. She didn't care about making money; she wanted to create innovative, fun, affordable fashions for women, so everyone from typists to royalty dropped by her shop. While older generations thought her clothes were vulgar, Quant was honored with the prestigious *Sunday Times* International Fashion Award in 1963, which validated her wild imagination.

Valentina Tereshkova

Valentina Tereshkova (1937–) opened up the starry sky to girls in every corner of the world when she became the first woman in space on June 16, 1963. Her journey was an unconventional one, having helped her widowed mother in a textile factory and attended school for only about eight years before leaving at the age of sixteen to work full-time.

Tereshkova's turning point came when she joined a local aviation club to pursue her passion for skydiving. She completed 126 parachute jumps, which made her the ideal candidate for the Soviet space program when they were trying to recruit a woman to join the crew. At the time, astronauts had to parachute out of the space capsule on its return to earth. After eighteen months of training, at twenty-six Tereshkova passed all the tests and was chosen to pilot *Vostok 6*. She orbited the earth forty-eight times, logging over seventy hours in space—more than all the Americans' time in space combined up to that point. Upon her return, she became a national hero and a successful Soviet Union politician. She was given multiple awards, including the United Nations Gold Medal of Peace, and became the Soviet representative for international women's organizations. She has yet to return to space, but remains an adventurer: in 2013, at the age of seventy-six, she volunteered to take a prospective one-way trip to Mars.

First woman in space

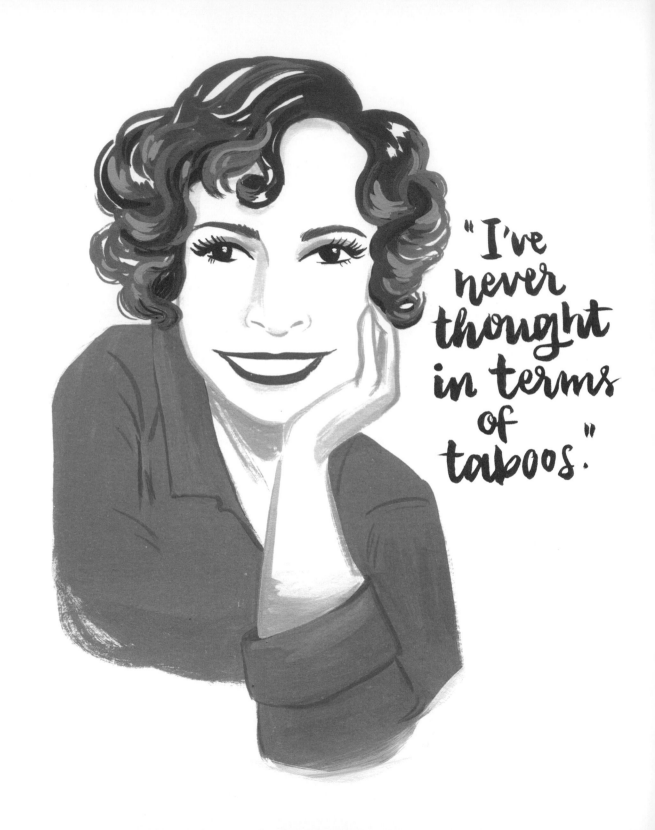

"I've never thought in terms of taboos."

Judy Blume

You might never think a sweet, diminutive author from New Jersey writing about tween girls would land so many times on the banned books list, but that's what makes Judy Blume (1938–) one serious bad girl. Blume didn't start writing until after she had married, at twenty-one, and had two babies, by twenty-five. She started by submitting rhyming stories to publishers that she had made up while doing her household chores. Then she took a writing course and produced her first two books, including *Iggie's House*, a coming-of-age novel dealing with racism. From there, Blume became prolific, producing a flood of young adult books dealing with controversial topics: puberty, masturbation, bullying, teen sex, and divorce, all from the teenager's perspective. Her most famous novels—including *Are You There God? It's Me, Margaret*; *Blubber*; *Deenie*; and *Forever*—were all banned from school libraries because of their frank discussions of teen sexuality. That didn't stop her. The books have also won her legions of young fans for answering burning questions in an honest and funny way that helped normalize the awkward stages of growing up. Blume became a huge champion for the National Coalition Against Censorship; and, to date, her books (she's written twenty-eight so far) have sold more than eighty-two million copies in thirty-one languages around the world.

Junko Tabei

Japanese mountain climber Junko Tabei (1939–2016) became the first woman to climb to the summit of Mount Everest on May 16, 1975. In a sense, her ascent began when she was ten years old, when she climbed Mount Nasu with a teacher. She continued climbing while she attended college to study English literature and become a teacher. After school, she formed the first Ladies Climbing Club (LCC) in Japan in a time when women had jobs but were expected to serve tea to their male coworkers.

In 1970, Tabei led the LCC on a climb of Annapurna III that inspired them to apply to climb Mount Everest. While she was on the waiting list, Tabei's story created a sensation, and she secured sponsorships from a newspaper and Nippon television while most people were telling her that she should stay home with her children. Her desire to mountain climb was contradictory to Japanese culture, which has a saying that the nail that sticks out gets hammered in. For the Japanese, asking questions or admitting you don't know something is considered an embarrassment. Yet Tabei asked questions and expressed moments of weakness because this was integral to becoming a successful climber. When you're on the mountain in extreme conditions, you have to be able to admit you need to go a little slower. When Tabei led her team of fourteen female mountain climbers up Everest, they were buried under an avalanche. Sherpas dug them out, and they continued the climb two days later, finally reaching the summit after twelve days.

In 1992, Tabei became the first woman to climb the Seven Summits— the highest point on every continent. In total, Tabei climbed almost seventy major mountains. She also defied the gravity of antiquated Japanese views of women by becoming a speaker, a nature conservationist, and an inspiration to all other women who dare to be the nail that sticks out.

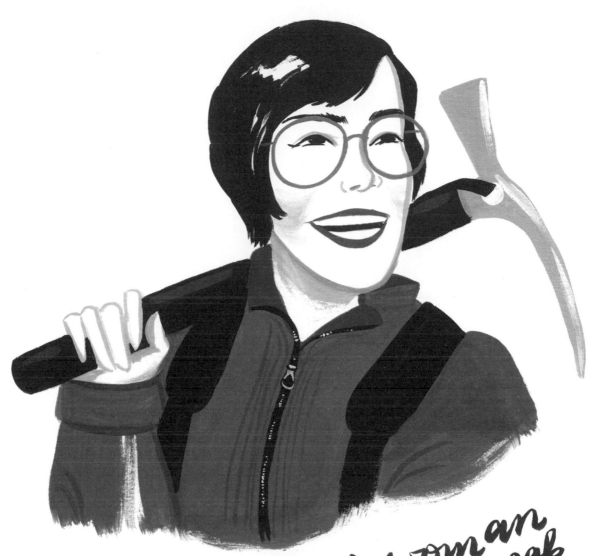

First woman to reach the peak of Mount Everest

Nora Ephron

The queen of romantic comedies, Nora Ephron (1941–2012) was a trailblazer for women in Hollywood. Ephron sharply observed the world around her and recreated the magic with a wry wit that resonated with a wide audience. She started off as a successful journalist, writing such a great satirical article about the *New York Post* that they turned around and hired her. Her career turned to screenwriting when her second husband, Carl Bernstein (of Watergate scandal fame), asked her to take a stab at rewriting the script for *All the President's Men*. Even though her version wasn't used, she made the leap to Hollywood. Ephron first spun heartache into gold with her novel-turned-screenplay *Heartburn*, which fictionalized her painful divorce from Bernstein after she discovered he was cheating on her when she was seven months pregnant. She went on to write eight more books, including the revolutionary *I Feel Bad About My Neck*, which candidly addressed the experiences of women getting older, and over a dozen films, including romantic comedies that set the standard for all others to come. These included *When Harry Met Sally*, *Sleepless in Seattle*, and *You've Got Mail*. At the age of fifty-one, Ephron took on the mantle of director, a job that few females have ever held. She earned three Oscar nominations—and two Razzie nods (Golden Raspberries, that is, which honor the *worst* in film). In fact, Ephron had almost as many film failures (does anyone remember *Michael*? Or *Bewitched*?) as she did successes, yet she kept going after each one. That may well have been the most inspiring thing about Ephron's life—that, much like her unlucky-in-love heroines, she was adept at getting back up and moving on.

"Above all, be the heroine of your own life, not the victim."

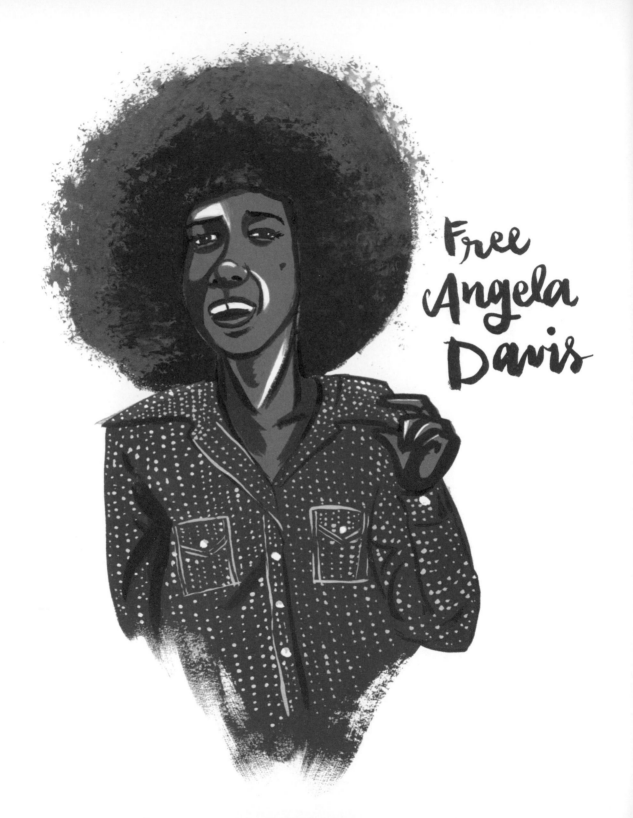

Angela Davis

Radical feminist, scholar, and speaker, Angela Davis (1944–) broke onto the political activist scene in the 1960s by joining the Che-Lumumba Club, an all-black wing of the Communist Party. Over the next four decades, she would be part of the civil rights movement, involved with the Black Panthers, on the FBI's Ten Most Wanted list, and a two-time candidate for vice president on the Communist Party ticket. Early on in her career, Davis was also a philosophy professor at UCLA. Because of her association with the Communist Party, then-governor Ronald Reagan strongly urged the University of California Regents to find a way to fire her. In 1970, Davis was incarcerated for sixteen months due to her involvement in a campaign to free fellow Black Panthers the Soledad Brothers. Since that experience, she's devoted her life to dismantling the prison industrial complex in the United States, which focuses more resources on incarceration than on rehabilitation. And despite Reagan's vow that Davis would never teach in California again, she has been teaching as a professor since the 1980s, first at San Francisco State University and more recently as a Distinguished Professor Emerita at UC Santa Cruz.

Dolly Parton

Dolly Parton (1946–) is an American country singer who has crossed genres, mediums, and generations, establishing herself as a living legend. She got her big break at eighteen on Porter Wagoner's variety show; after eight years there, she broke away from Wagoner's show to branch out on her own as a pop musician and actor. Her professional savvy and courage—she rejected Elvis Presley's offer to cover "I Will Always Love You" because his manager demanded that she hand over half the publishing rights—paved the way for more young female artists to have a say in their work. She is also one of the few artists to have a Top 10 hit in each of the last five decades. Parton has always maintained a tongue-in-cheek attitude about her blonde ambition and her larger-than-life persona, while trusting her heart and working hard to expand her empire so she never had to depend on someone else. No question about her bad girl status: how many people have their own theme park?

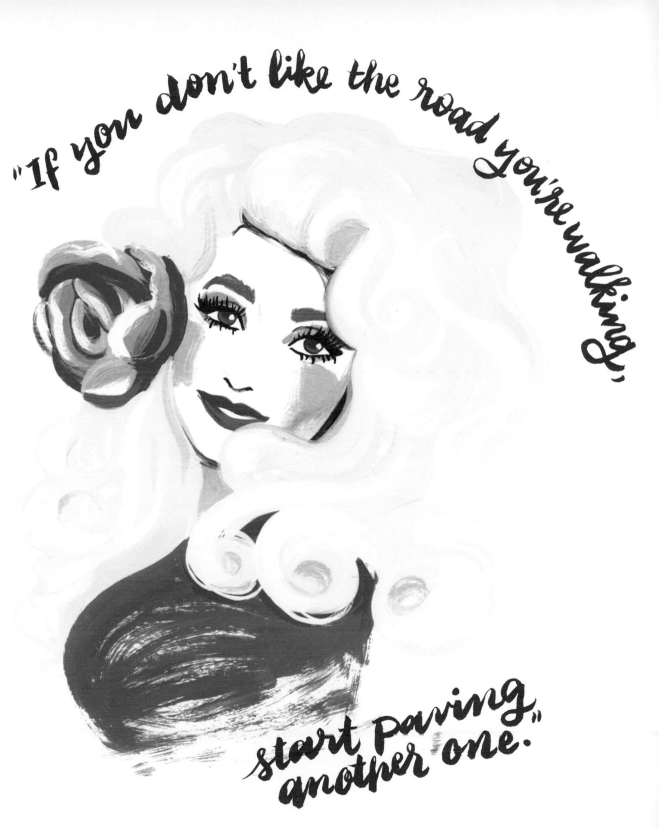

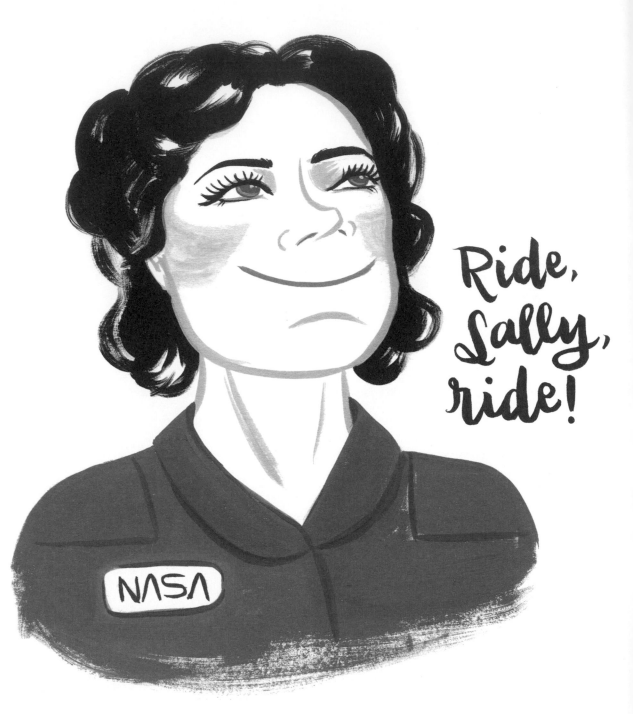

Sally Ride

In 1983, Los Angeles-born physicist Dr. Sally Ride (1951–2012) became the first American woman and youngest person in space at the age of thirty-two. While at Stanford, Ride was ranked number one as a women's singles tennis player and even considered a professional sports career—she joked that "a bad forehand" was behind her decision to pursue physics. She was one of the first six women admitted into NASA's space program, and the first to go into space—facing a media circus of sexist questions: Would she wear a bra or makeup in space? Did she cry on the job? How would she deal with menstruation in space?

After the *Challenger* explosion in 1986, Ride was the only representative from NASA appointed by President Ronald Reagan to investigate the accident. She was fearless in her pursuit of holding her employer accountable and became known for asking the tough questions. After the explosion, NASA had to reexamine their mission goals, and Ride was appointed to lead that effort. She worked with the new recruits and came up with four recommendations: a mission to Mars, exploring the solar system, creating a space station on the moon, and organizing a mission to focus more on Planet Earth. Though NASA favored the flashy, exploratory missions, her strongest passion was using their advanced space technology to further understand our own planet—one that she felt was the most in need of studying and saving. After retiring from NASA, she became a professor at the University of California, San Diego, and started her own foundation, Sally Ride Science, to bring science festivals and programs to young girls. Ride was an intensely private person; only after her passing in 2012 was it revealed publicly that she was also the first known LGBT astronaut.

Diana Nyad

On September 2, 2013, at the age of sixty-four, aquatic marathoner Diana Nyad (1949–) became the first person to swim from Cuba to Florida without the aid of a shark cage. It was her fifth attempt.

Nyad began her swimming career in seventh grade, training under a famed Olympian coach and winning three Florida state high school championships before she became a marathon swimmer. She has broken multiple world records, including a fifty-year-old one by swimming around Manhattan in under eight hours. Later in her life, Nyad revealed that she had been raped by her swim coach and had channeled her rage into her sport.

She attempted her first swim from Havana to Key West at the age of twenty-eight, but was derailed by strong winds that slammed her against the shark cage and pushed her off course. She hung up competitive swimming at thirty and became a broadcast sports journalist for the next three decades. But at the dawn of her sixtieth birthday and after the passing of her mother, with whom she had had a fragile relationship due to her rocky childhood, Nyad decided to put her goggles back on and realize her lifelong dream of completing that 110-mile swim. Four more attempts and four years later, Nyad finished the fifty-three-hour swim and walked onto the shores of Key West, crediting one motto: "Find a way."

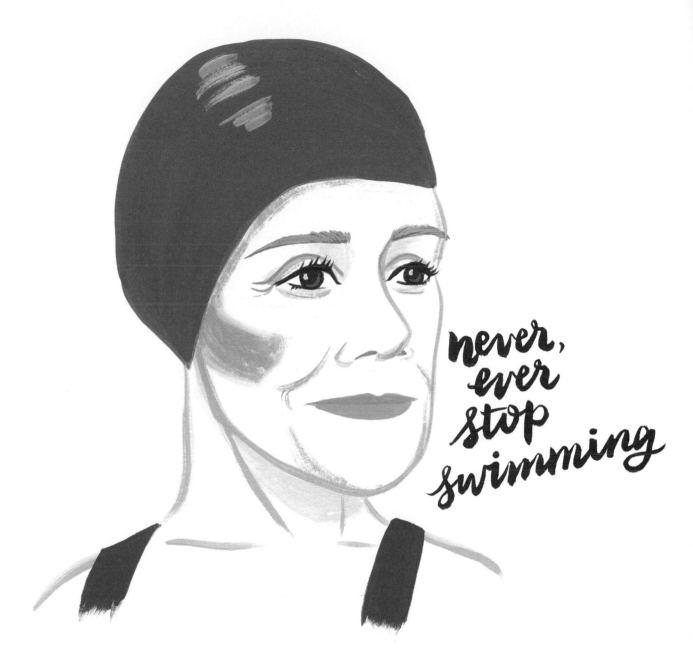

never,
ever
stop
swimming

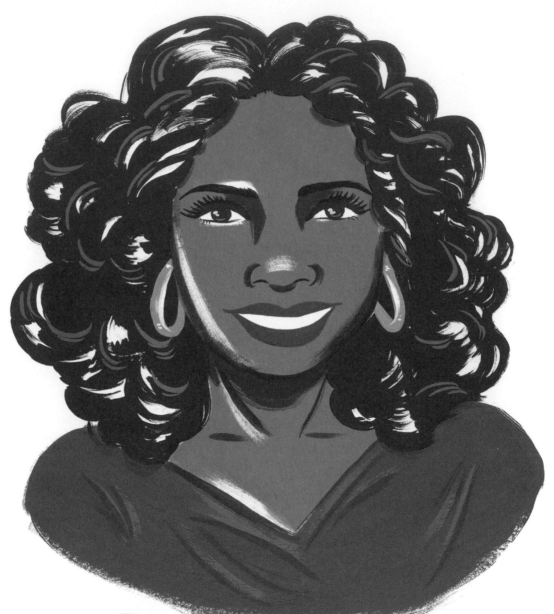

Runs this world

Oprah

Arguably the most powerful human on earth (it's estimated that her endorsement of Barack Obama in the closely contested 2008 election alone brought in one million votes), entertainment mogul Oprah Winfrey (1954–) was fired from her first evening news reporter job for being too emotional. So the girl who was raised in rural Mississippi so poor that she wore potato sacks to school brought all her emotional strength to bear and built a media empire that would shape our entire culture. When she was moved onto a flailing daytime talk show, Oprah flourished as the first female African-American television host; she invented an entire genre of confessional talk shows that a Yale University study showed broke twentieth-century taboos and brought topics like homosexuality mainstream.

Two years after her arrival, the show was renamed *The Oprah Winfrey Show* and made its first national syndication debut in 1986. Oprah became a household name and soon the head of an entertainment galaxy and America's first female self-made billionaire. There was no secret in her life too dark to share with her audience—from getting pregnant at fourteen and losing the baby to smoking crack cocaine with a man she was obsessively in love with in her twenties—and the world loved her for it. Her greatest strengths—her empathy and her humanity—became her greatest gifts to the world.

Along with being a spiritual guide for the twenty-first century through her television network OWN, Oprah is a generous philanthropist. In 2007, for example, she donated forty million dollars and her time to opening the Oprah Winfrey Leadership Academy for Girls in South Africa.

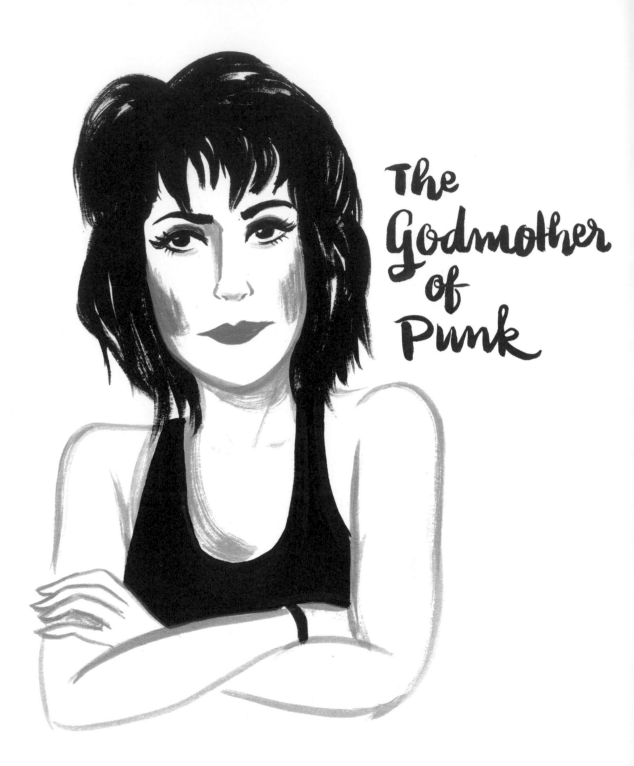

The Godmother of Punk

Joan Jett

Joan Jett (1958–) broke onto the music scene at the age of fifteen with the all-girl pop-punk band the Runaways. They recorded five albums, including one that became one of the biggest-selling imports in U.S. and U.K. history. After they broke up, Jett pursued a solo career but was rejected by twenty-three different labels before becoming one of the first female artists to start and have direct control over her own company, Blackheart Records, in 1980. Jett also formed her own band, Joan Jett & the Blackhearts, with which she recorded her most famous cover hit, "I Love Rock 'n' Roll." Their shows set records at the time for the fastest ticket sellouts. Meanwhile, Jett continued to produce other young punk and riot grrrl bands' records, like the Germs, Bikini Kill, and L7, earning her the nicknames "the Godmother of Punk" and "the Original Riot Grrrl."

Madonna

For many followers of pop music in recent decades, its timeline can be readily divided into pre-Madonna and Madonna. Widely considered one of the most influential musicians of all time, Madonna (1958–) can claim many industry chart achievements: bestselling female recording artist of all time, most Top 10 singles, most successful female solo artist of all time, and greatest number of image reinventions. Since her first number one single, "Like a Virgin," hit the U.S. airwaves in 1984, Madonna has been an entertainment juggernaut. All thirteen of her albums have been made it to the Top 10 Billboard charts. She founded her own record company, Maverick Records, in 1992. At age thirty-eight she won a Golden Globe for Best Actress for her leading role in *Evita*. She fearlessly tackles subjects of sexuality, nudity, religion, and feminism in a way that no one else in music has, and for that she has been both persecuted and celebrated. As famous for her wild personal life as for her music, Madonna was one of the first artists to invite her audience behind the scenes through her tour documentary *Madonna: Truth or Dare*. Her unapologetic and defiant attitude, combined with her fashion trendsetting and exquisite showmanship, make Madonna one serious bad girl.

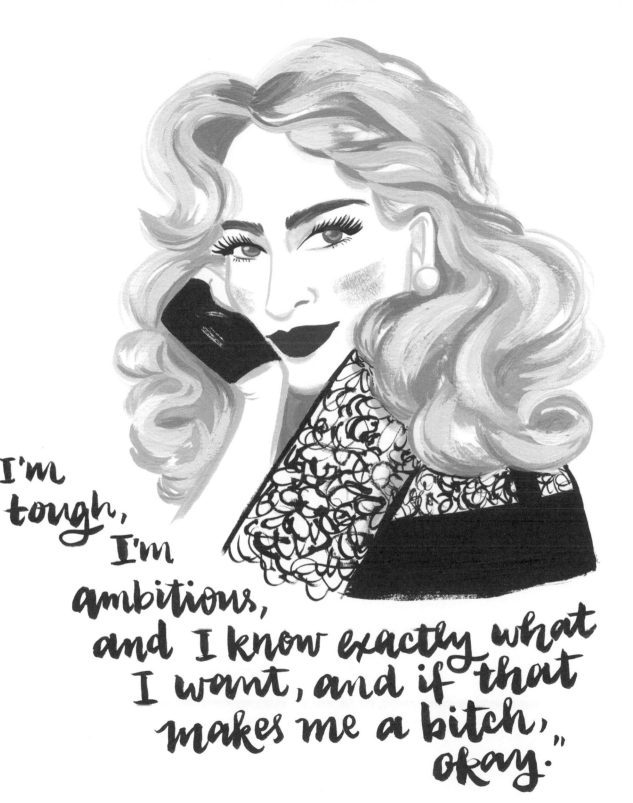

"I'm tough, I'm ambitious, and I know exactly what I want, and if that makes me a bitch, okay."

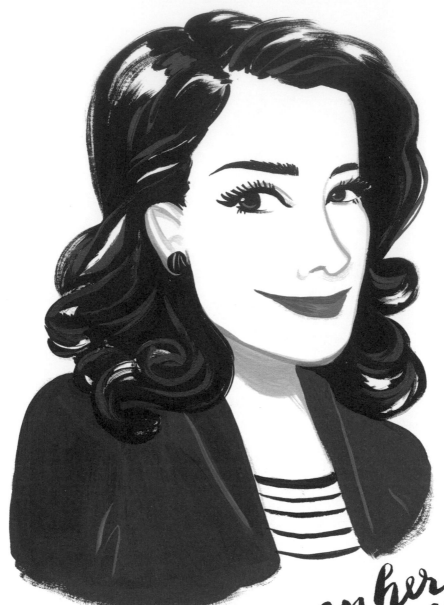

working on her night cheese all the way to the top

Tina Fey

A self-proclaimed good girl, comedy entertainer, writer, and producer, Tina Fey (1970–) wholly embraced her quirks before she made being geeky cool. And it is that complete and utter acceptance of herself that paved the way to her success in comedy.

She set her sights on the writer's table at *Saturday Night Live* while studying drama at the University of Virginia; after college, she joined Second City in Chicago. In 1997, Fey was hired by show creator Lorne Michaels to join *SNL*. Two years later, she became the first female head writer in the show's twenty-two-year history. The following year, she began co-anchoring *Weekend Update* with Jimmy Fallon. In the near-decade she was there, Fey pulled *SNL* out of its late-nineties stupor and made it a hip, must-see show again—in 2002, they even won an Emmy. At age thirty-six, Fey moved on to write, produce, and star in her own show *30 Rock*, which became a critical darling and established her megastar status—all while portraying the sloppily imperfect Liz Lemon, tapping into the humor of the humanness in all of us. In 2010, Fey became the youngest person ever to receive the Mark Twain Prize for American Humor. Most satisfyingly, Fey did this right around the time of a 2007 *Vanity Fair* article by a male writer declaring that women aren't funny. In the words of Fey's cinematic cultural monument *Mean Girls*: you go, Glen Coco.

Selena

Texas-born musical sensation Selena Quintanilla Pérez (1971–1995), known singularly as Selena, began performing professionally at the age of nine. Powered by her father's musical dreams, Selena and her two older siblings formed the band Selena y Los Dinos. At the age of six, Selena forced her way into the band when her dad wouldn't teach her an instrument, singing until he recognized her irrepressible talent. Touring relentlessly with the whole family, playing on street corners, weddings, and at restaurants, making barely enough money to buy gas, Selena soon became a star in the Tejano music world, winning the Tejano Music Award for Best Female Vocalist nine times.

She went from being a solely English-speaking, unknown female Mexican-American singer, denied access to venues in a male-dominated field, to the genre's first mainstream crossover superstar. Her album, *Ven Conmigo*, was the first Tejano album to reach gold status in 1990; four years later, she became the first Tejano musician to win a Grammy. Performing in sequined bustiers that she designed, Selena also became a fashion icon and role model to Mexican-American youth. At twenty-one, she rebelled against her father and followed her heart, eloping with her guitarist, Chris Pérez. Selena achieved her dream of mainstream success, with her album *Dreaming of You* breaking the record for fastest-selling album by a female artist at the time of its release. But sadly, she was not there to see it. Her greatest strengths—her warmth and accessibility—became her greatest liabilities when she was murdered by her fan club president. Selena's influence shone a spotlight on Latino Americans in the twenty-first century, and her breakthrough legacy lives on.

Lived the bicultural American dream

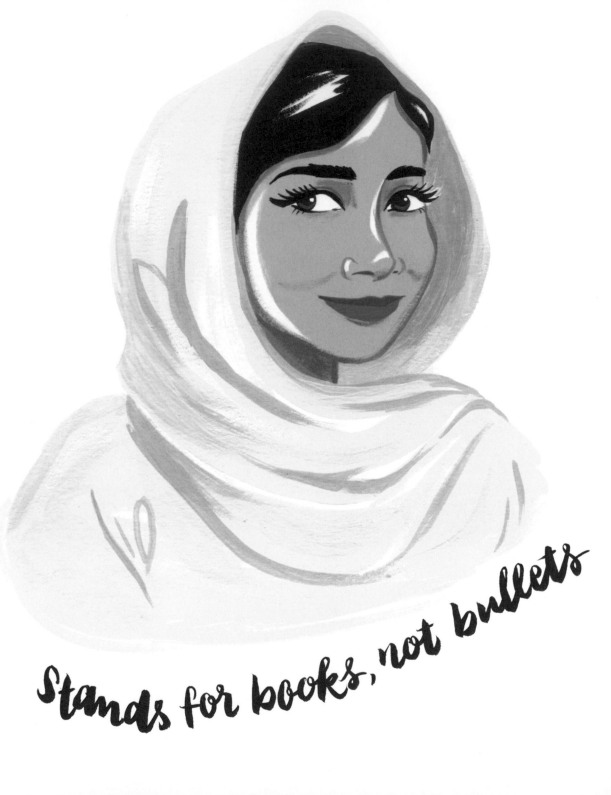

Stands for books, not bullets

Malala Yousafzai

At seventeen, Pakistani activist Malala Yousafzai (1997–) became the youngest Nobel Peace Prize winner ever for her work supporting girls' education rights. Raised in the northwest Swat Valley region of Pakistan, Yousafzai lived under increasing Taliban rule, which included banning girls from attending school. Her father is an education activist and operated a private girls' school in the region, which helped ignite her passion for equal access to education. At the age of eleven and using a pseudonym, Yousafzai wrote a blog for BBC Urdu about her life under Taliban occupation. In 2012, her story was featured in a *New York Times* documentary. When her identity was revealed, Yousafzai became a target of the Taliban, and a fatwā (an Islamic religious decree) was issued against her and her work. On October 9, 2012, while taking the bus home from school, Yousafzai was shot in the head by a masked Taliban gunman. She survived the assassination attempt, and after several months of recovery became an international advocate and speaker for children's rights to education. Her incredible courage inspired the rest of the world to act; the UN passed a petition in her name that led to Pakistan's ratifying its first Right to Education Bill. Yousafzai then started the Malala Fund, a non-profit that empowers girls to raise their voices and provides access to education, and on her eighteenth birthday she used the money raised to open a school in Lebanon for Syrian refugees. The journey of this powerhouse bad girl is just beginning.

Bibliography

LILITH

Schwartz, Howard. *Tree of Souls: The Mythology of Judaism*. New York: Oxford University Press, 2007.

Kvam, Kristen E., Linda S. Schearing, and Valarie H. Ziegler. *Eve and Adam: Jewish, Christian, and Muslim Readings on Genesis and Gender*. Bloomington: Indiana University Press, 1999.

TOMYRIS

Herodotus. *The History*, George Rawlinson translation. New York: Dutton, 1962.

CLEOPATRA

Trow, M. J. *A Brief History of Cleopatra, Last Pharaoh of Egypt*. Philadelphia: Running Press Book Publishers, 2011.

Roller, Duane W. *Cleopatra: A Biography*. Oxford: Oxford University Press, 2010.

Grant, Michael. *Cleopatra*. Edison: Castle, 2004.

BOUDICA

Collingridge, Vanessa. *Boudica: The Life of Britain's Legendary Warrior Queen*. Woodstock: The Overlook Press, 2006.

Donsbach, Margaret. "Boudica: Celtic War Queen Who Challenged Rome." Military History, April 2004. http://www.historynet .com/boudica-celtic-war-queen- who-challenged-rome.htm, accessed August 12, 2015.

EMPRESS WU ZETIAN

Paludan, Ann. *Chronicle of the Chinese Emperors: The Reign-by-Reign Record of the Rulers of Imperial China*. New York: Thames and Hudson, 1998.

Fitzgerald, Charles Patrick. "Wuhou: Empress of Tang Dynasty." *Encyclopedia Britannica*, August 19, 2014. http://www.britannica.com/ biography/Wuhou, accessed July 18, 2015.

Dash, Mike. "The Demonization of Empress Wu." *Smithsonian Magazine*, August 10, 2012. http://www.smithsonianmag. com/history/the-demonization- of-empress-wu-20743091/, accessed July 18, 2015.

Clements, Jonathan. *Wu: The Chinese Empress Who Schemed, Seduced, and Murdered Her Way to Become a Living God*. Albert Bridge Books, 2014.

LADY GODIVA

Donoghue, Daniel. *Lady Godiva: A Literary History of a Legend*. Malden: Blackwell Publishing, 2003.

Lacey, Robert. *Great Tales from English History: The Truth About King Arthur, Lady Godiva, Richard the Lionheart, and More*. New York: Little, Brown, 2004.

KHUTULUN

Weatherford, Jack. "The Wrestler Princess." *Lapham's Quarterly*, September 27, 2010. http://www .laphamsquarterly.org/roundtable /wrestler-princess, accessed August 12, 2015.

Weatherford, Jack. *The Secret History of the Mongol Queens: How the Daughters of Genghis Khan Rescued His Empire*. New York: Crown, 2010.

JEANNE DE BELLEVILLE

Klausmann, Ulrike, Marian Meinzerin, and Gabriel Kuhn. *Women Pirates and the Politics of the Jolly Roger*. Montreal. Black Rose, 1997.

Gosse, Philip. *The History of Piracy*. New York: Longmans, Green and Co., 1932.

Salmonson, Jessica Amanda. *The Encyclopedia of Amazons: Women Warriors from Antiquity to the Modern Era*. New York: Paragon House, 1991.

JOAN OF ARC

DeVries, Kelly. *Joan of Arc: A Military Leader*. Stoud, Gloucestershire: Sutton Publishing, 1999.

Pernoud, Regine. *Joan of Arc by Herself and Her Witnesses*. New York: Stein and Day, 1982.

GRACE O'MALLEY

Chambers, Anne. *Ireland's Pirate Queen: The True Story of Grace O'Malley*. New York: MJF Books, 2003.

Druett, Joan. *She Captains: Heroines and Hellions of the Sea*. New York: Simon & Schuster, 2000.

QUEEN ELIZABETH I

Hibbert, Christopher. *The Virgin Queen: Elizabeth I, Genius of the Golden Age*. Reading, MA: Addison-Wesley, 1991.

Price-Groff, Claire. *The Importance of Queen Elizabeth I*. San Diego: Lucent Books, 2001.

Erickson, Carolyn. *The First Elizabeth*. New York: St. Martin's Press, 1983.

Ronald, Susan. *The Pirate Queen*. New York: HarperCollins, 2007.

ARTEMISIA GENTILESCHI

"Gentileschi." *Bio*. A&E Television Networks, 2015. http://www.biography.com/people/artemisia-gentileschi-9308725, accessed August 23, 2015.

Bissell, Ward R. *Artemisia Gentileschi and the Authority of Art: Critical Reading and Catalogue Raisonne*. University Park: The Pennsylvania State University Press, 1999.

Garrard, Mary D. *Artemisia Gentileschi: The Image of the Female Heroine in Italian Baroque Art*. Princeton: Princeton University Press, 1989.

O'Connor, William. "Meet Artemisia Gentileschi, The Feminist Contemporary of Caravaggio." *The Daily Beast*, March 22, 2015.

http://www.thedailybeast.com/articles/2015/03/22/meet-artemisia-gentileschi-the-feminist-contemporary-of-caravaggio.html, accessed August 23, 2015.

APHRA BEHN

Woodcock, George. *The Incomparable Aphra*. London: Boardman, 1948.

Todd, Janet. *The Secret Life of Aphra Behn*. New Brunswick: Rutgers University Press, 1997.

Stiebel, Arlene. "Aphra Behn." *Poetry Foundation*. http://www.poetryfoundation.org/bio/aphra-behn#poet, accessed August 30, 2015.

CATHERINE THE GREAT

Rounding, Virginia. *Catherine the Great: Love, Sex, and Power*. New York: St. Martin's Press, 2007.

Madariaga, Isabel de. *Catherine the Great: A Short History*. New Haven: Yale University Press, 1990.

"Catherine the Great." *Bio*. A&E Television Networks, 2015. http://www.biography.com/people/catherine-ii-9241622, accessed November 18, 2015.

Maranzani, Barbara. "8 Things You Didn't Know About Catherine the Great." *Story in the Headlines*, July 9, 2012. http://www.history.com/news/8-things-you-didnt-know-about-catherine-the-great, accessed November 18, 2015.

ABIGAIL ADAMS

Holton, Woody. *Abigail Adams*. New York: Free Press, 2010.

Adams, John, Abigail Adams, and Frank Shuffelton. *The Letters of John and Abigail Adams*. New York: Penguin, 2004.

"Abigail Adams." *History.com*. A&E Television Networks, n.d. http://www.history.com/topics/first-ladies/abigail-adams, accessed September 4, 2015.

MARIE ANTOINETTE

Klein, Christopher. "10 Things You May Not Know About Marie Antoinette." *History in the Headlines,* October 16, 2013. http://www.history.com/news/10-things-you-may-not-know-about-marie-antoinette, accessed July 15, 2015.

Fraser, Antonia. *Marie Antoinette: The Journey*. New York: Nan A. Talese/Doubleday, 2001.

Covington, Richard. "Marie Antoinette." *Smithsonian Magazine*, November 2006. http://www.smithsonianmag.com/history/marie-antoinette-134629573/, accessed July 15, 2015.

Thurman, Judith. "Dressed for Excess." *New Yorker*, September 25, 2006. http://www.newyorker.com/magazine/2006/09/25/dressed-for-excess, accessed July 15, 2015.

ÉLISABETH VIGÉE-LEBRUN

"Elisabeth Vigée Le Brun." *Bio*. A&E Television Networks, 2015. http://www.biography.com/people/elisabeth-vigée-le-brun-37280, accessed August 23, 2015.

Goodden, Angelica. *The Sweetness of Life: A Biography of Elisabeth Louise Vigée Le Brun*. London: Andre Deutsch, 1997.

CHING SHIH

Murray, Dian H. *Pirates of the South China Coast*. Stanford: Stanford University Press, 1987.

Klausmann, Ulrike. *Women Pirates and the Politics of the Jolly Roger*. Montreal: Black Rose Books, 1997.

Szczepanski, Kallie. "Zheng Shi, Pirate Lady of China." *About Education*. http://asianhistory.about.com/od/modernchina/p/Zheng-Shi-Pirate-China.htm, accessed August 22, 2015.

JANE AUSTEN
Austen-Leigh, James Edward. *A Memoir of Jane Austen*. 1926. Ed. R. W. Chapman. Oxford: Oxford University Press, 1967.

Le Faye, Deirdre. *Jane Austen: A Family Record*. Cambridge: Cambridge University Press, 2003.

Fergus, Ian. *Jane Austen: A Literary Life*. London: Macmillan, 1991.

SOJOURNER TRUTH
Painter, Nell Irvin. *Sojourner Truth: A Life, A Symbol*. New York: W. W. Norton, 1997.

Ortiz, Victoria. *Sojourner Truth: A Self-Made Woman*. New York: HarperCollins, 1974.

History.com Staff. "Sojourner Truth." History.com, 2009. http://www.history.com/topics/black-history/sojourner-truth, accessed August 26, 2015.

"Sojourner Truth." *Bio*. A&E Television Networks, 2015. http://www.biography.com/people/sojourner-truth-9511284, accessed August 26, 2015.

ANNA ATKINS
Stein, Sadie. "Impressions." *The Paris Review*, March 16, 2015. http://www.theparisreview.org/blog/2015/03/16/impressions/, accessed August 26, 2015.

Gibbs, Jonathan. "Anna Atkins: This Is Why British Scientist Who Produced First Photographic Book Has Been Given a Google Doodle." *Independent*, March 16, 2015. http://www.independent.co.uk/news/uk/anna-atkins-google-doodle-celebrates-216th-birth-day-of-botanist-who-produced-first-photographic-book-10109935.html, accessed August 26, 2015.

Cavna, Michael. "Anna Atkins: Google Doodle Artfully Celebrates a True-Blue Photographic Pioneer." *Washington Post*, March 16, 2015. http://www.washingtonpost.com/news/comic-riffs/wp/2015/03/16/anna-atkins-google-celebrates-pioneering-photographic-author-with-blue-birthday-doodle/, accessed August 26, 2015.

HARRIET BEECHER STOWE
"Harriet Beecher Stowe Biography." The Harriet Beecher Stowe Center, 2015. https://www.harrietbeecherstowecenter.org/hbs/, accessed September 3, 2015.

Vonfrank, Albert J. "Harriet Beecher Stowe." History.com, A&E Networks. http://www.history.com/topics/harriet-beecher-stowe, accessed September 3, 2015.

Morgan, Jo-Ann. *Uncle Tom's Cabin as Visual Culture*. Columbia. University of Missouri Press, 2007.

Hedrick, Joan D. *Harriet Beecher Stowe: A Life*. New York: Oxford University Press, 1995.

ADA LOVELACE
Charman-Anderson, Suw. "Ada Lovelace: Victorian Computing Visionary." *Finding Ada*. http://findingada.com/book/ada-lovelace-victorian-computing-visionary/, accessed July 15, 2015

Morais, Betsy. "Ada Lovelace: The First Tech Visionary." *New Yorker*, October 15, 2013. http://www.newyorker.com/tech/elements/ada-lovelace-the-first-tech-visionary, accessed July 15, 2015.

MARIA MITCHELL
"Maria Mitchell." Bio.com. A&E Networks Television, n.d. http://www.biography.com/people/maria-mitchell-9410353, accessed September 13, 2015.

Mitchell, Maria, and Phebe Mitchell Kendall. *Maria Mitchell: Life, Letters, and Journals*. Boston: Lee and Shepard, 1896.

Gormley, Beatrice. *Maria Mitchell: The Soul of an Astronomer*. Grand Rapids, MI: W. B. Eerdmans, 1995.

"Maria Mitchell." National Women's History Museum, n.p., n.d. https://www.nwhm.org/education-resources/biography/biographies/maria-mitchell-bio/, accessed September 13, 2015.

SUSAN B. ANTHONY
Harper, Ida Husted. *The Life and Work of Susan B. Anthony*. Indianapolis: Hollenbeck Press, 1898.

United States v. Susan B. Anthony, 24 Fed. Cases 829–833.

FLORENCE NIGHTINGALE
Small, Hugh. *Florence Nightingale: Avenging Angel*. New York: St. Martin's Press, 1998.

Bostridge, Mark. *Florence Nightingale, The Woman and Her Legend*. London: Viking, 2008.

Swaby, Rachel. *Headstrong: 52 Women Who Changed Science—And the World*. New York: Broadway Books, 2015.

ANITA GARIBALDI
Valerio, Anthony. *Anita Garibaldi: A Biography*. Westport, CT: Praeger Publishers, 2001.

Sergio, Lisa. *I Am My Beloved: The Life of Anita Garibaldi*. New York: Weybright, 1969.

ELIZABETH BLACKWELL

Blackwell, Elizabeth, and Millicent Garrett Fawcett. *Pioneer Work in Opening the Medical Profession to Women*. London: J. M. Dent & Sons, 1914.

Chambers, Peggy. *A Doctor Alone: A Biography of Elizabeth Blackwell: The First Woman Doctor 1821–1910*. New York: Abelard-Schuman, 1958.

Klobuchar, Lisa. *Elizabeth Blackwell: With Profiles of Elizabeth Garrett Anderson and Susan La Flesche Picotte*. Chicago: World Book, 2007.

HARRIET TUBMAN

Clinton, Catherine. *Harriet Tubman: The Road to Freedom*. New York: Back Bay/Little, Brown, 2005.

Bradford, Sarah H. *Harriet Tubman: The Moses of Her People*. Mineola, NY: Dover Publications, 2004. Print.

"Harriet Tubman." History.com. A&E Television Networks, n.d. http://www.history.com/topics/black-history/harriet-tubman, accessed September 4, 2015.

AMALIA ERIKSSON

Berezin, Henrik. *Adventure Guide to Scandinavia*. Edison: Hunter, 2006.

Gamla Stans Polkagriskokeri. http://www.gamlastanspolka-griskokeri.se/English/, accessed September 4, 2015.

BELVA LOCKWOOD

Norgren, Jill. *Belva Lockwood: The Woman Who Would Be President*. New York: New York University Press, 2007.

"Belva Lockwood." *Bio*. A&E Television Networks, 2015. http://www.biography.com/people/belva-lockwood-9384624, accessed September 4, 2015.

ANNIE EDSON TAYLOR

Parish, Charles Carlin. *Queen of the Mist: The Story of Annie Edson Taylor*. New York: Empire State Books, 1987.

Rayner, Michelle. "'Not the Usual Carnival Show-Off': Annie Edson Taylor at Niagara Falls." *Hindsight*. RN, Australian Broadcasting Corporation. September 25, 2011. http://www.abc.net.au/radio-national/programs/hindsight/not-the-usual-carnival-show-off-annie-edson-taylor/2999524, accessed July 21, 2015.

FANNIE FARMER

Farmer, Fannie Merritt. "Feeding America: The Historic American Cookbook Project." n.d. http://digital.lib.msu.edu/projects/cookbooks/html/authors/author_farmer.html, accessed September 4, 2015.

"Fannie Merritt Farmer." Cook's Info. n.d. http://www.cooksinfo.com/fannie-merritt-farmer, accessed September 4, 2015.

"Fannie Farmer Biography." Encyclopedia of World Biography. n.d. http://www.notablebiographies.com/Du-Fi/Farmer-Fannie.html, accessed September 4, 2015.

"Fannie Farmer Opens Cooking School." History.com. A+E Networks, 2009. http://www.history.com/this-day-in-history/fannie-farmer-opens-cooking-school, accessed September 4, 2015.

ANNIE OAKLEY

"Annie Oakley." *Bio*. A&E Television Networks, 2015. Web. http://www.biography.com/people/annie-oakley-9426141#legacy-and-media-depictions, accessed July 21, 2015.

"Annie Oakley." *American Experience*. PBS, 2006. Web. http://www.pbs.org/wgbh/americanexperience/features/biography/oakley-annie/, accessed July 21, 2015.

EDITH WHARTON

Lee, Hermione. *Edith Wharton*. New York: Alfred A. Knopf, 2007.

Lewis, R.W.B. *Edith Wharton: A Biography*. New York: Harper & Row, 1975.

Benstock, Shari. *No Gifts from Chance: A Biography of Edith Wharton*. New York: Scribner's, 1994.

Armitage, Robert. "Edith Wharton, A Writing Life: Childhood." New York Public Library, May 6, 2013. http://www.nypl.org/blog/2013/05/06/edith-wharton-writing-life, accessed September 9, 2015.

NELLIE BLY

DeMain, Bill. "Ten Days in a Mad-house: The Woman Who Got Herself Committed." *Mental Floss*, May 2, 2011. http://mentalfloss.com/article/29734/ten-days-madhouse-woman-who-got-herself-committed, accessed July 22, 2015.

"Nellie Bly, Journalist, Dies of Pneumonia." *New York Times*, January 28, 1922.

Kroeger, Brooke. *Nellie Bly: Daredevil, Reporter, Feminist*. New York: Times Books, 1994.

BEATRIX POTTER

Lear, Linda J. *Beatrix Potter: A Life in Nature*. New York: St. Martin's, 2007.

"Beatrix Potter." Bio.com. A&E Networks Television, n.d. http://www.biography.com/people/beatrix-potter-9445208, accessed September 6, 2015.

MADAM C.J. WALKER

Bundles, A'Lelia Perry. *On Her Own Ground: The Life and Times of Madam C.J. Walker*. New York: Washington Square, 2002.

"Madam C.J. Walker." Bio.com. A&E Networks Television, n.d. http://www.biography.com/people/madam-cj-walker-9522174, accessed September 8, 2015.

Gates, Henry Louis, Jr. "Madam Walker, the First Black American Woman to Be a Self-Made Millionaire." *The African Americans: Many Rivers to Cross*. PBS, June 24, 2013. http://www.pbs.org/wnet/african-americans-many-rivers-to-cross/history/100-amazing-facts/madam-walker-the-first-black-american-woman-to-be-a-self-made-millionaire/, accessed September 8, 2015.

Latson, Jennifer. "How America's First Self-Made Female Millionaire Built Her Fortune." *Time*, December 24, 2014. http://time.com/3641122/sarah-breedlove-walker/, accessed September 8, 2015.

MARIE CURIE

Curie, Eve, and Vincent Sheean. *Madame Curie: A Biography*. Garden City, NY: Doubleday, Doran, 1937.

Goldsmith, Barbara. *Obsessive Genius: The Inner World of Marie Curie*. New York: W. W. Norton, 2005.

"Marie Curie - Biographical." The Nobel Prize in Physics 1903. The Nobel Foundation, 1903. N.p., n.d. http://www.nobelprize.org/nobel_prizes/physics/laureates/1903/marie-curie-bio.html, accessed September 9, 2015.

"Marie Curie." Bio.com. A&E Networks Television, n.d. http://www.biography.com/people/marie-curie-9263538, accessed September 9, 2015.

ALICE GUY-BLACHÉ

Acker, Ally. *Reel Women: Pioneers of the Cinema 1896 to the Present*. New York: Continuum Publishing, 1991.

Guy, Alice, and Anthony Slide. *The Memoirs of Alice Guy Blaché*. Metuchen, NJ: Scarecrow, 1986.

Simon, Joan, and Jane Gaines. *Alice Guy Blaché: Cinema Pioneer*. New Haven: Yale University Press, 2009.

MATA HARI

Shipman, Pat. *Femme Fatale: Love, Lies, and the Unknown Life of Mata Hari*. New York: Harper Perennial, 2008.

"Mata Hari." *Encyclopedia Britannica Online*. Encyclopedia Britannica, 2015. http://www.britannica.com/biography/Mata-Hari-Dutch-dancer-and-spy, accessed September 10, 2015.

LILIAN BLAND

Lebow, Eileen F. *Before Amelia: Women Pilots in the Early Days of Aviation*. Washington, D.C.: Brassey's, 2002.

Bland, Lilian E. "The 'Mayfly' Gets Its Engine." *Flight*, July 16, 1910. https://www.flightglobal.com/pdfarchive/view/1910/1910%20-%200563.html, accessed September 11, 2015.

"Lilian Bland Remembered." *BBC News*. BBC, August 31, 2010. http://news.bbc.co.uk/local/cornwall/hi/people_and_places/history/newsid_8956000/8956919.stm, accessed September 11, 2015.

MARGARET SANGER

Bachrach, Deborah. *The Importance of Margaret Sanger*. San Diego: Lucent Books, 1993.

Sanger, Margaret. *The Autobiography of Margaret Sanger*. Dover Edition. Mineola, NY: Dover Publications, 1971.

Chesler, Ellen. *Woman of Valor: Margaret Sanger and the Birth Control Movement in America*. New York: Simon & Schuster, 1992.

Gray, Madeline. *Margaret Sanger: A Biography of the Champion of Birth Control*. New York: Richard Marek Publishers, 1979.

HELEN KELLER

Keller, Helen, with Anne Sullivan and John A. Macy. *The Story of My Life*. New York: Doubleday, Page & Co., 1903.

"Helen Keller." Bio.com. A&E Networks Television, n.d. http://www.biography.com/people/helen-keller-9361967, accessed September 12, 2015.

Whitman, Alden. "Helen Keller, 87, Dies." *New York Times*, June 2, 1968. http://www.nytimes.com/learning/general/onthisday/bday/0627.html, accessed September 12, 2015.

ELEANOR ROOSEVELT

Fleming, Candace. *Our Eleanor: A Scrapbook Look at Eleanor Roosevelt's Remarkable Life*. New York: Atheneum for Young Readers, 2005.

Roosevelt, Anna Eleanor. *The Autobiography of Eleanor Roosevelt*. New York: Harper & Brothers, 1961.

Harris, Cynthia M. *Eleanor Roosevelt: A Biography*. Westport, CT: Greenwood Press, 2007.

Cook, Blanche Wiesen. *Eleanor Roosevelt, Vol. 2: 1933–1938*. New York: Viking Penguin, 1992.

GEORGIA O'KEEFFE

Drohojowska-Philp, Hunter, and Georgia O'Keeffe. *Full Bloom: The Art and Life of Georgia O'Keeffe*. New York: W. W. Norton, 2004.

"Georgia O'Keeffe." Brooklyn Museum. N.p., n.d. https://www.brooklynmuseum.org/eascfa/dinner_party/place_settings/georgia_o_keeffe, accessed September 10, 2015.

"Life and Artwork of Georgia O'Keeffe." C-SPAN, January 9, 2013. http://www.c-span.org/video/?310650-1/life-artwork-georgia-okeeffe, accessed September 10, 2015.

ELSA SCHIAPARELLI

Secrest, Meryle. *Elsa Schiaparelli: A Biography*. New York: Alfred A. Knopf, 2014.

Schiaparelli, Elsa. *Shocking Life*. New York: Dutton, 1954.

Fury, Alexander. "Italian Renaissance: The House of Schiaparelli Is Relaunching after 60 Years with a Haute Couture Collection." *Independent*. Independent Digital News and Media, January 22, 2014. http://www.independent.co.uk/life-style/fashion/features/italian-renaissance-the-house-of-schiaparelli-is-relaunching-after-60-years-with-a-haute-couture-9078494.html, accessed October 26, 2015.

MARY PICKFORD

Acker, Ally. *Reel Women: Pioneers of the Cinema 1896 to the Present*. New York: Continuum Publishing, 1991.

"About Mary Pickford." Mary Pickford Foundation, 2015. http://marypickford.org/home/about-mary/, accessed September 11, 2015.

Whitfield, Eileen. *Pickford: The Woman Who Made Hollywood*. Lexington: University of Kentucky Press, 1997.

MAE WEST

Chandler, Charlotte. *She Always Knew How: Mae West, A Personal Biography*. New York: Simon & Schuster, 2009.

Louvish, Simon. *Mae West: It Ain't No Sin*. New York: St. Martin's Press/Thomas Dunne, 2006.

Curry, Ramona. *Too Much of a Good Thing: Mae West as Cultural Icon*. Minneapolis: University of Minnesota Press, 1996.

West, Mae, and Lillian Schlissel. *Three Plays by Mae West: Sex, The Drag, The Pleasure Man*. New York: Routledge, 1997.

MARTHA GRAHAM

Freedman, Russell. *Martha Graham, a Dancer's Life*. New York: Clarion, 1998.

Bryant, Paula Pratt. *Martha Graham (The Importance Of . . . Series)*. Detroit: Gale, 1994.

Graham, Martha. *Blood Memory: An Autobiography*. New York: Doubleday, 1991.

EDITH HEAD

Chierichetti, David. *Edith Head: The Life and Times of Hollywood's Celebrated Costume Designer*. New York: HarperCollins, 2003.

Head, Edith, and Jane Kesner Ardmore. *The Dress Doctor*. Boston: Little, Brown, 1959.

King, Susan. "Edith Head, the Best Sort of Designing Woman." *Los Angeles Times*, August 2, 2014. http://www.latimes.com/entertainment/classichollywood/la-et-mn-ca-edith-head-classic-hollywood-20140803-story.html, accessed September 12, 2015.

AMELIA EARHART

Morey, Eileen. *The Importance of Amelia Earhart*. San Diego: Lucent Books, 1995.

Van Pelt, Lori. *Amelia Earhart: The Sky's No Limit*. New York: Forge Book, 2005.

Ware, Susan. *Still Missing: Amelia Earhart and the Search for Modern Feminism*. New York: W. W. Norton, 1993.

TALLULAH BANKHEAD

Bankhead, Tallulah. *Tallulah*. New York: Harper & Brothers, 1952.

Lobenthal, Joel. *Tallulah: The Life and Times of a Leading Lady*. New York: Regan, 2004.

Donnelley, Paul. *Fade to Black: A Book of Movie Obituaries*. London: Omnibus, 2000.

"Tallulah, The Original Hollywood Bad Girl." CBS News, March 14, 2010. http://www.cbsnews.com/news/tallulah-the-original-hollywood-bad-girl/, accessed July 27, 2015.

NORMA SHEARER
"Norma Shearer." Bio.com. A&E Networks Television, n.d. http://www.biography.com/people/norma-shearer-38357, accessed September 13, 2015.

Lambert, Gavin. *Norma Shearer: A Life*. New York: Knopf, 1990.

Quirk, Lawrence J. *Norma: The Story of Norma Shearer*. New York: St. Martin's, 1988.

ANAÏS NIN
Nin, Anaïs. *The Diary of Anaïs Nin*. New York: Harcourt, 1966.

Woo, Elaine. "The Ranger Who Told All About Anaïs Nin's Life." *Los Angeles Times*, July 26, 2006. http://articles.latimes.com/2006/jul/26/local/me-pole26, accessed August 23, 2015.

Doyle, Sady. "Before Lena Dunham, There Was Anaïs Nin—Now Patron Saint of Social Media." *The Guardian*, April 7, 2015. http://www.theguardian.com/culture/2015/apr/07/anais-nin-author-social-media, accessed August 23, 2015.

DIANA VREELAND
Stuart, Amanda Mackenzie. *Empress of Fashion: A Life of Diana Vreeland*. New York: Harper, 2012.

Dwight, Eleanor. *Diana Vreeland*. New York: HarperCollins, 2002.

"Diana Vreeland." *Diana Vreeland*. N.p., n.d. http://legacy.dianavreeland.com/, accessed September 13, 2015.

ANNA MAY WONG
Parish, James, and William Leonard. "Anna May Wong." *Hollywood Players: The Thirties*. New Rochelle, NY: Arlington House Publishers, 1976, pp. 532–538.

Hodges, Graham Russell. *Anna May Wong: From Laundryman's Daughter to Hollywood Legend*. Basingstoke, Hampshire: Palgrave Macmillan, 2004.

Chan, Anthony B. *Perpetually Cool: The Many Lives of Anna May Wong*. Lanham, MD: Scarecrow Press, 2003.

JOSEPHINE BAKER
Baker, Josephine, and Jo Bouillon. *Josephine*. Paris: Robert Laffont/Opéra Mundi, 1976.

Baker, Jean-Claude. *Josephine: The Hungry Heart*. New York: Random House, 1993.

Guild, Leo. *Josephine Baker*. Los Angeles: Holloway House, 1976.

Caravantes, Peggy. *The Many Faces of Josephine Baker: Dancer, Singer, Activist, Spy*. Chicago: Chicago Review Press, 2015.

RACHEL CARSON
Carson, Rachel. *Silent Spring*. New York: Houghton Mifflin, 1962.

Lee, John M. "'Silent Spring' Is Now Noisy Summer." *New York Times*, July 22, 1962.

"Rachel Carson Dies of Cancer. 'Silent Spring' Author Was 56." *New York Times*, April 15, 1964. http://www.nytimes.com/learning/general/onthisday/bday/0527.html, accessed July 15, 2015.

Lewis, Jack. "The Birth of the EPA." *EPA Journal*, November 1985.

Swaby, Rachel. *Headstrong: 52 Women Who Changed Science—and the World*. New York: Broadway Books, 2015.

CARMEN MIRANDA
Carmen Miranda: That Girl from Rio. Dir. John Cork and Lisa Van Eyssen. 20th Century Fox Home Entertainment, 2008. *YouTube*. Web. Accessed August 24, 2015.

Carmen Miranda: Bananas Is My Business. Dir. Helena Solberg. Brazil, 1995. Film.

Gil-Montero, Martha. *Brazilian Bombshell: The Biography of Carmen Miranda*. New York: D. I. Fine, 1989.

BONNIE PARKER
Guinn, Jeff. *Go Down Together: The True, Untold Story of Bonnie and Clyde*. New York: Simon & Schuster, 2009.

Jones, W. D. "Riding with Bonnie & Clyde." *Playboy*, November 1968.

"Bonnie and Clyde." *Famous Cases and Criminals*. FBI, https://www.fbi.gov/about-us/history/famous-cases/bonnie-and-clyde, accessed August 25, 2015.

Rosenberg, Jennifer. "Bonnie and Clyde." *About Education*. http://history1900s.about.com/od/1930s/a/bonnieandclyde.htm, accessed August 25, 2015.

MARY BLAIR
Canemaker, John. *Magic Color Flair: The World of Mary Blair*. San Francisco: Walt Disney Family Museum, 2014.

Canemaker, John. *The Art and Flair of Mary Blair*. New York: Disney Editions, 2003.

Cline, Fred. "The Catalyst." Moore Studios, August 2007. http://www.flipanimation.net/flipfissue4.htm, accessed September 14, 2015.

GYPSY ROSE LEE
Abbott, Karen. *American Rose: A Nation Laid Bare: The Life and Times of Gypsy Rose Lee*. New York: Random House, 2010.

Frankel, Noralee. *Stripping Gypsy: The Life of Gypsy Rose Lee*. New York: Oxford University Press, 2009.

Cosgrove, Ben. "Striptease Superstar: Rare and Classic Photos of Gypsy Rose Lee." *Time*, January 8, 2014. http://time.com/3638201/striptease-superstar-rare-and-classic-photos-of-gypsy-rose-lee/, accessed August 29, 2015.

LUCILLE BALL
"Lucille Ball." *Finding Lucy*. PBS, September 21, 2006. Web. http://www.pbs.org/wnet/americanmasters/episodes/lucille-ball/finding-lucy/477/, accessed August 21, 2015.

Kanfer, Stefan. *Ball of Fire: The Tumultuous Life and Comic Art of Lucille Ball*. New York: Alfred A. Knopf, 2003.

Brady, Kathleen. *Lucille: The Life of Lucille Ball*. New York: Billboard Books, 2001.

JULIA CHILD
Child, Julia, with Alex Prud'homme. *My Life in France*. New York: Anchor Books, 2007.

Smith, Emily. "10 Lesser-Known Facts about Julia Child." *CNN*, August 15, 2012. http://eatocracy.cnn.com/2012/08/15/10-lesser-known-facts-about-julia-child/, accessed September 15, 2015.

ROSA PARKS
Parks, Rosa. *My Story*. New York: Dial Books, 1992.

Gore, Dayo F., Jeanne Theoharis, and Komozi Woodard. *Want to Start a Revolution?: Radical Women in the Black Freedom Struggle*. New York: New York University Press, 2009.

Olson, Lynne. *Freedom's Daughters: The Unsung Heroines of the Civil Rights Movement from 1830 to 1970*. New York: Scribner, 2001.

HEDY LAMARR
Rhodes, Richard. *Hedy's Folly: The Life and Breakthrough Inventions of Hedy Lamarr, the Most Beautiful Woman in the World*. New York: Vintage Books, 2012.

"Hedy Lamarr Inventor." *New York Times*, October 1, 1941.

Swaby, Rachel. *Headstrong: 52 Women Who Changed Science—and the World*. New York: Broadway Books, 2015.

BILLIE HOLIDAY
Rothman, Lily. "Billie Holiday's Story Was Even More Complicated Than You Think." *Time*, April 7, 2015. Web. http://time.com/3769253/billie-holiday-100-john-szwed/, accessed September 16, 2015.

Davis, Francis. "Our Lady of Sorrows." *The Atlantic*, November 2000. Web. http://www.theatlantic.com/magazine/archive/2000/11/our-lady-of-sorrows/378438/, accessed September 16, 2015.

Szwed, John. *Billie Holiday: The Musician and the Myth*. New York: Viking, 2015.

IVA TOGURI D'AQUINO
Gunn, Rex B. *They Called Her Tokyo Rose*. Santa Monica, CA: Gunn, 1977.

Duus, Masayo. *Tokyo Rose, Orphan of the Pacific*. Tokyo: Kodansha International, 1979.

"Iva Toguri D'Aquino and 'Tokyo Rose.'" FBI, May 21, 2010. https://www.fbi.gov/about-us/history/famous-cases/tokyo-rose, accessed September 17, 2015.

PHYLLIS DILLER
Nachman, Gerald. *Seriously Funny: The Rebel Comedians of the 1950s and 1960s*. New York: Pantheon, 2003.

Diller, Phyllis, and Richard Bushkin. *Like a Lampshade in a Whorehouse: My Life in Comedy*. New York: J. P. Tarcher/Penguin, 2005.

Severo, Richard, and Peter Keepnews. "Phyllis Diller, Sassy Comedian, Dies at 95." *New York Times*, August 20, 2012. http://www.nytimes.com/2012/08/21/arts/television/phyllis-diller-sassy-comedian-dies-at-95.html, accessed September 16, 2015.

SISTER CORITA KENT
Kent, Corita, and Jan Steward. *Learning by Heart: Teachings to Free the Creative Spirit*. New York: Allworth Press. 2008.

"A Nun Inspired by Warhol: The Forgotten Pop Art of Sister Corita Kent." *All Things Considered*. By David C. Barnett. NPR, January 8, 2015. http://www.npr.org/2015/01/08/375856633/a-nun-inspired-by-warhol-the-forgotten-pop-art-of-sister-corita-kent, accessed July 20, 2015.

Dammann, April. "Sister Corita Kent, creator of LOVE stamp, world's biggest selling artist." *Off Ramp*. By Jon Rabe with Mark Pampanin. KPCC, Pasadena. June 3, 2015. http://www.scpr.org/programs/offramp/2015/06/03/43075/sister-corita-kent-creator-of-love-stamp-world-s-b/, accessed July 20, 2015.

Dammann, April. *Corita Kent: Art and Soul: The Biography*. Santa Monica: Angel City Press, 2015.

EVA PERÓN

Fraser, Nicholas, and Marysa Navarro. *Evita: The Real Life of Eva Perón*. New York: Norton, 1996.

Perón, Eva. *In My Own Words: Evita*. Edinburgh: Mainstream, 1997.

New York Times Staff. "Saga of Eva Perón: 12 Years to Power." *New York Times*, July 27, 1952. http://www.nytimes.com/learning/general/onthisday/bday/0507.html, accessed September 19, 2015.

BETTY FRIEDAN

Friedan, Betty. *The Feminine Mystique*. New York: W. W. Norton, 2013.

Ware, Susan. "Friedan, Betty." *American National Biography Online*, April 2014. http://www.anb.org/articles/16/16-03896.html, accessed August 30, 2015.

HELEN GURLEY BROWN

Scanlon, Jennifer. *Bad Girls Go Everywhere: The Life of Helen Gurley Brown*. New York: Oxford University Press, 2009.

Brown, Helen Gurley. *I'm Wild Again: Snippets from My Life and a Few Brazen Thoughts*. New York: St. Martin's, 2000.

Fox, Margalit. "Helen Gurley Brown, Who Gave 'Single Girl' a Life in Full, Dies at 90." *New York Times*, August 13, 2012. http://www.nytimes.com/2012/08/14/business/media/helen-gurley-brown-who-gave-cosmopolitan-its-purr-is-dead-at-90.html?_r=0, accessed September 18, 2015.

DOROTHY DANDRIDGE

Bogle, Donald. *Dorothy Dandridge: A Biography*. New York: Amistad, 1997

Gates Jr., Henry Louis, and Julie Wolf. "Dorothy Dandridge: A 1st for the Academy Awards." *The Root*, February 23, 2015. http://www.theroot.com/articles/history/2015/02/dorothy_dandridge_the_1st_african_american_to_get_an_oscar_nomination_for.html, accessed September 29, 2015.

LoBianco, Lorraine. "Starring Dorothy Dandridge." *Turner Classic Movies*, n.d. http://www.tcm.com/this-month/article/114172%7C0/Starring-Dorothy-Dandridge.html, accessed September 29, 2015.

BETTIE PAGE

Sahagun, Louis. "A Golden Age for a Pinup." *Los Angeles Times*, March 11, 2006. http://articles.latimes.com/2006/mar/11/local/me-bettie11, accessed August 30, 2015.

Rodriguez, Tori. "Male Fans Made Bettie Page a Star, But Female Fans Made Her an Icon." *Atlantic*, January 6, 2014. http://www.theatlantic.com/entertainment/archive/2014/01/male-fans-made-bettie-page-a-star-but-female-fans-made-her-an-icon/282794/, accessed August 30, 2015.

Talbot, Margaret. "From the Stacks: 'Chicks and Chuckles.'" *New Republic*, February 16, 2014. http://www.newrepublic.com/article/116626/margaret-talbot-bettie-page, accessed August 30, 2015.

McFadden, Robert D. "Bettie Page, Queen of Pinups, Dies at 85." *New York Times*, December 11, 2008. http://www.nytimes.com/2008/12/12/arts/12page.html?_r=1&hp, accessed August 30, 2015.

MARGARET THATCHER

Moore, Charles. *Margaret Thatcher: The Authorized Biography, from Grantham to the Falklands*. New York: Alfred A. Knopf, 2013.

Thatcher, Margaret. *Margaret Thatcher: The Autobiography*. New York: Harper Perennial, 2010.

Moore, Charles. "The Invincible Mrs. Thatcher." *Vanity Fair*. Vanityfair.com, December 1, 2011. http://www.vanityfair.com/news/2011/12/margaret-thatcher-201112, accessed September 19, 2015.

CHRISTINE JORGENSEN

Jorgensen, Christine. *Christine Jorgensen: A Personal Autobiography*. San Francisco: Cleis, 2000.

Docter, Richard F. *Becoming a Woman: A Biography of Christine Jorgensen*. New York: Routledge, 2008.

Hadjimatheou, Chloe. "Christine Jorgensen: 60 Years of Sex Change Ops." bbc.com. BBC World Service, November 30, 2012. http://www.bbc.com/news/magazine-20544095, accessed September 18, 2015.

CORETTA SCOTT KING

"About Mrs. King." The King Center. http://www.thekingcenter.org/about-mrs-king, accessed September 20, 2015.

King, Coretta Scott. *My Life with Martin Luther King, Jr*. New York: Puffin, 1994.

Applebome, Peter. "Coretta Scott King, a Civil Rights Icon, Dies at 78." *New York Times*, February 1, 2006. http://www.nytimes.com/2006/02/01/national/01king.html, accessed September 20, 2015.

RUTH WESTHEIMER

Westheimer, Ruth K., and Ben Yagoda. *All in a Lifetime: An Autobiography*. New York: Warner, 1987.

Westheimer, Ruth K. *The Doctor Is In: Dr. Ruth on Love, Life, and Joie de Vivre*. New York: Amazon Publishing, 2015.

Kaufman, Joanne. "Dr. Ruth Westheimer: Her Bedrooms Are Off Limits." *New York Times*, November 30, 2013. http://www.nytimes.com/2013/12/01/realestate/dr-ruth-westheimer-her-bedrooms-are-off-limits.html?_r=0, accessed September 30, 2015.

Fusion. "Dr. Ruth: Don't Go on a Date Sexually Frustrated." Online video clip. *YouTube*. YouTube, February 12, 2015. https://www.youtube.com/watch?v=jSg3ZHzV-VGg, accessed September 30, 2015.

MAYA ANGELOU

"Maya Angelou." The Poetry Foundation, 2014. http://www.poetryfoundation.org/bio/maya-angelou, accessed September 1, 2015.

"Maya Angelou." *Bio*. A&E Television Networks, 2015. http://www.biography.com/people/maya-angelou-9185388, accessed September 1, 2015.

Angelou, Maya. *I Know Why the Caged Bird Sings*. New York: Random House, 1969.

Lupton, Mary Jane. *Maya Angelou: A Critical Companion*. Westport: Greenwood Press, 1998.

BARBARA WALTERS

Lemann, Nicolas. "I Have to Ask." *New Yorker*, May 12, 2008. http://www.newyorker.com/magazine/2008/05/12/i-have-to-ask, accessed September 24, 2015.

Walters, Barbara. *Audition*. New York: Alfred A. Knopf, 2008.

MARLENE SANDERS

Grimes, William. "Marlene Sanders, Pathbreaking TV Journalist, Dies at 84." *New York Times*, July 15, 2015. http://www.nytimes.com/2015/07/16/business/media/marlene-sanders-pathbreaking-tv-journalist-dies-at-84.html, accessed September 22, 2015.

Colker, David. "Pioneering TV Journalist Marlene Sanders Dies at 84." *Los Angeles Times*, July 15, 2015. http://www.latimes.com/local/obituaries/la-me-marlene-sanders-20150715-story.html, accessed September 22, 2015.

Sanders, Marlene, and Marcia Rock. *Waiting for Prime Time: The Women of Television News*. Urbana: University of Illinois, 1988.

RUTH BADER GINSBURG

Toobin, Jeffrey. "Heavyweight: How Ruth Bader Ginsburg Has Moved the Supreme Court." *New Yorker*, March 11, 2013. http://www.newyorker.com/magazine/2013/03/11/heavyweight-ruth-bader-ginsburg, accessed September 29, 2015.

Totenburg, Nina. "Ruth Bader Ginsburg and Sandra Day O'Connor, 'Sisters in Law.'" *NPR*, September 1, 2015. http://www.npr.org/2015/09/01/436368073/ruth-bader-ginsburg-and-sandra-day-oconnor-sisters-in-law, accessed September 29, 2015.

Bazelon, Emily. "The Place of Women on the Court." *New York Times Magazine*, July 7, 2009. http://www.nytimes.com/2009/07/12/magazine/12ginsburg-t.html, accessed September 29, 2015.

GLORIA STEINEM

Steinem, Gloria. "After Black Power, Women's Liberation." *New York Magazine*, April 4, 1969. http://nymag.com/news/politics/46802/, accessed September 19, 2015.

Pogrebin, Abigail. "How Do You Spell Ms." *New York Magazine*, October 30, 2011. http://nymag.com/news/features/ms-magazine-2011-11/, accessed September 19, 2015.

"Gloria Steinem: Writer, lecturer, political activist, and feminist organizer." Gloria Steinem. http://www.gloriasteinem.com/about/, accessed September 19, 2015.

Collins, Gail. "This Is What 80 Looks Like." *New York Times*, March 22, 2015. http://www.nytimes.com/2014/03/23/opinion/sunday/collins-this-is-what-80-looks-like.html, accessed September 19, 2015.

MARY QUANT

Quant, Mary. *Mary Quant: Autobiography*. London: Headline, 2012.

Vare, Ethlie Ann, and Greg Ptacek, *Mothers of Invention: From the Bra to the Bomb: Forgotten Women & Their Unforgettable Ideas*. New York: Morrow, 1988.

Lodi, Marie. "Literally the Best Thing Ever: Mary Quant." *Rookie*, September 23, 2014. http://www.rookiemag.com/2014/09/literally-the-best-thing-ever-mary-quant/, accessed September 23, 2015.

VALENTINA TERESHKOVA

Kevles, Bettyann Holzmann. *Almost Heaven: Women on the Frontiers of Space*. New York: Basic, 2003.

Sharp, Tim. "Valentina Tereshkova: First Woman in Space." Space.com, June 14, 2013. http://www.space.com/21571-valentina-tereshkova.html, accessed September 29, 2015.

McKie, Robin. "Valentina Tereshkova, 76, First Woman in Space, Seeks One-Way Ticket to Mars." *The Guardian*, September 17, 2013. http://www.theguardian.com/science/2013/sep/17/mars-one-way-ticket, accessed September 29, 2015.

JUDY BLUME
Dominus, Susan. "Judy Blume Knows All Your Secrets." *New York Times Magazine*, May 18, 2015. http://www.nytimes.com/2015/05/24/magazine/judy-blume-knows-all-your-secrets.html, accessed September 30, 2015.

Flood, Alison. "Judy Blume: 'I Thought, This Is America: We Don't Ban Books. But Then We Did.'" *The Guardian*, July 11, 2014. http://www.theguardian.com/books/2014/jul/11/judy-blume-interview-forever-writer-children-young-adults, accessed September 30, 2015.

Cutter, Andrea. "Judy Blume on the Tiger Eyes Film, What She's Reading, and Why Moms Can't Get Their Daughters to Read Her Books." *Vanity Fair*, June 6, 2013. http://www.vanityfair.com/culture/2013/06/judy-blume-tiger-eyes-film, accessed September 30, 2015.

JUNKO TABEI
Horn, Robert. "No Mountain Too High for Her." *Sports Illustrated*, April 29, 1996. http://www.si.com/vault/1996/04/29/212374/no-mountain-too-high-for-her-junko-tabei-defied-japanese-views-of-women-to-become-an-expert-climber, accessed September 29, 2015.

Otake, Tomoko. "Junko Tabei: The First Woman Atop the World." *Japan Times*, May 27, 2012. http://www.japantimes.co.jp/life/2012/05/27/people/junko-tabei-the-first-woman-atop-the-world/, accessed September 29, 2015.

McLoone, Margo. *Women Explorers of the Mountains: Nina Mazuchelli, Fanny Bullock Workman, Mary Vaux Walcott, Gertrude Benham, Junko Tabei*. Mankato, MN: Capstone, 2000.

NORA EPHRON
Levy, Ariel. "Nora Knows What to Do." *New Yorker*, July 6, 2009. http://www.newyorker.com/magazine/2009/07/06/nora-knows-what-to-do, accessed September 17, 2015.

Ephron, Nora. *I Feel Bad About My Neck: And Other Thoughts on Being a Woman*. New York: Knopf, 2006.

ANGELA DAVIS
Davis, Angela. *Angela Davis, An Autobiography*. New York: Random House, 1974.

Morrison, Patt. "Angela Y. Davis on What's Radical in the 21st Century." *Los Angeles Times*, May 6, 2014. http://www.latimes.com/opinion/op-ed/la-oe-morrison-davis-20140507-column.html, accessed October 1, 2015.

"Angela Y. Davis." Feminist Studies. University of California, Santa Cruz, n.d. http://feministstudies.ucsc.edu/faculty/singleton.php?singleton=true&cruz_id=aydavis, accessed October 1, 2015.

DOLLY PARTON
Parton, Dolly. *Dolly: My Life and Other Unfinished Business*. New York: HarperCollins, 1994.

CMT.com Staff. "Dolly Parton Reflects on Her Greatest Moments." *CMT News*, July 7, 2006. http://www.cmt.com/news/1535871/dolly-parton-reflects-on-her-greatest-moments/, accessed July 20, 2015.

SALLY RIDE
Grady, Denise. "American Woman Who Shattered Space Ceiling." *New York Times*, July 23, 2012.

Sherr, Lynn. *Sally Ride: America's First Woman in Space*. New York: Simon & Schuster, 2014.

Swaby, Rache. *Headstrong: 52 Women Who Changed Science—and the World*. New York: Broadway Books, 2015.

DIANA NYAD
Nyad, Diana. "Never, Ever Give Up." TED talk. December 2013. Lecture. https://www.ted.com/talks/diana_nyad_never_ever_give_up, accessed October 2, 2015.

Krochmal, Shana Naomi. "The Swimmer." Out.com. Out, July 9, 2012. http://www.out.com/entertainment/sports/2012/07/09/Diana-Nyad-swimmer-cuba-lesbian, accessed October 2, 2015.

Nyad, Diana. *Other Shores*. New York: Random House, 1978.

OPRAH

Winfrey, Oprah. *What I Know For Sure*. New York: Flatiron Books, 2014.

"Oprah Biography." Academy of Achievement. February 26, 2010. http://www.achievement .org/autodoc/page/winobio-1, accessed October 1, 2015.

Zurawik, David. "Oprah—Built in Baltimore." *Baltimore Sun*, May 18, 2011. http://www.baltimoresun. com/entertainment/sun-magazine/ bs-sm-oprahs-baltimore-20110522- story.html, accessed October 2, 2015.

JOAN JETT

Oldham, Todd, and Kathleen Hanna. *Joan Jett*. Los Angeles, CA: Ammo, 2010.

Thompson, Dave. *Bad Reputation: The Unauthorized Biography of Joan Jett*. Milwaukee, WI: Backbeat, 2011.

MADONNA

Taraborrelli, J. Randy. *Madonna: An Intimate Biography*. New York: Simon & Schuster, 2001.

O'Brien, Lucy. *Madonna: Like an Icon*. New York: HarperEntertain- ment, 2007.

Dunn, Jancee. "Growing Older with Madonna." *New York Times*, June 24, 2015. http://www.nytimes .com/2015/06/25/fashion/ growing-older-with-madonna- jancee-dunn.html, accessed October 3, 2015.

TINA FEY

Fey, Tina. *Bossypants*. New York: Little, Brown, 2011.

Heffernan, Virginia. "Anchor Woman." *New Yorker*. November 3, 2003. http://www.newyorker .com/magazine/2003/11/03/ anchor-woman, accessed October 2, 2015.

Hitchens, Christopher. "Why Women Aren't Funny." *Vanity Fair*, January 2007.

SELENA

Patoski, Joe Nick. *Selena: Como la Flor*. Boston: Little, Brown, 1996.

Moreno, Carolina. "20 Reasons Selena Quintanilla Will Never Be Forgotten." *Huffington Post*, March 31, 2015. http://www .huffingtonpost.com/2015/03/31/ selena-quintanilla-legacy_ n_6976098.html, accessed October 3, 2015.

Harrington, Richard. "Slain Tejano Singer's Album Tops Pop Charts." *Washington Post*, July 26, 1995. http://www.washingtonpost.com/ wp-srv/style/longterm/movies/ review97/selenaalbum.htm, accessed October 3, 2015.

MALALA YOUSAFZAI

Yousafzai, Malala, and Christina Lamb. *I Am Malala: How One Girl Stood Up for Education and Changed the World*. New York: Little, Brown, 2014.

Class Dismissed: Malala's Story. Dir. Adam B. Ellick and Irfan Ashraf. *New York Times* Documentary, October 9, 2012. http://www .nytimes.com/video/world/asia/ 100000001835296/class-dismissed .html, accessed September 24, 2015.

"Nobel Laureates by Age." Nobel- prize.org. http://www.nobelprize .org/nobel_prizes/lists/age.html, accessed September 24, 2015.